This book is being published
in support of the aims and activities of the
World Wildlife Fund.
A contribution from its sales throughout the world
will be made to the Fund.

*Dedicated to my
beloved daughter-in-law
Jane*

ANIMALS AND MEN

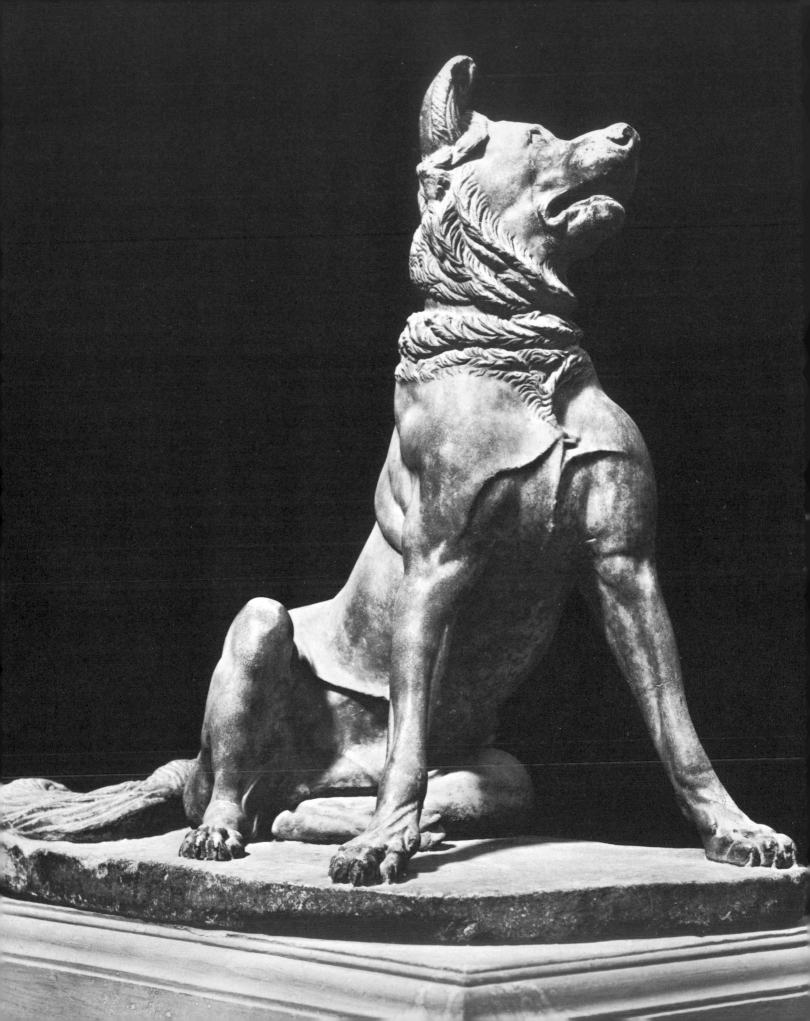

KENNETH CLARK

Animals and Men

*Their relationship as reflected in Western art
from prehistory to the present day*

with 219 illustrations, 84 in colour

THAMES AND HUDSON

Endpapers: decorated page by Tobias Stimmer from the *Biblische Figuren*
printed by Thomas Gwarin, Basle, 1576. Enlarged.
On the half-title page: blackbird from Bewick's *History of British Birds*.
Frontispiece: Antique Roman mastiff, once part of the Grand Duke of Tuscany's
collection.
On p. 8: fox, from Bewick's *General History of Quadrupeds*.

Text © 1977 Kenneth Clark
Plates and captions © 1977 Thames and Hudson Ltd, London
Phototypeset by Tradespools Ltd, Frome, Somerset
Printed in The Netherlands by Drukkerij de Lange/van Leer,
Deventer and London
Bound in The Netherlands by Van Rijmenam bv., The Hague

Contents

Foreword

THIS BOOK originated in an invitation from Fleur Cowles, International Trustee of the World Wildlife Fund, to write a book on animals in art. This by itself did not seem to me to constitute a subject, but on reflection it occurred to me that no one had ever given much thought to the relationship of animals and men, and that this might be a subject worth exploring.

My first thought was of the old myths of the Golden Age and the Garden of Eden, in which men and animals lived in harmony with one another. What allowed men to gain the upper hand to such an extent that they could almost exterminate a whole species? The question is complicated by the fact that primitive man worshipped animals and, quite early on in ancient Egypt and in Homeric Greece, men loved them as intensely as we do today. This dual relationship is the main theme of my book. But it has other aspects, curiosity and self-identification on the one hand, greed and sheer cruelty on the other. It soon became apparent to me that this was a vast subject which might occupy a scholar for many years. I had no time for the labour and research involved, and the International 'Animal in Art' Museum project was approaching. The only alternative was a short book in which some of the questions are asked and the reader's interest in the subject may be aroused.

How, for instance, did some animals acquire, and retain, their status as divine, or at least become symbols of the gods? Why did they come to be included among the signs of the zodiac? How did three animals, hitherto accepted as pagan gods, become symbols of the Evangelists? Questions like these prompted the section which I have called 'Sacred and Symbolic Animals'. They led me, in the end, to some unexpected conclusions. I might never, otherwise, have juxtaposed the White Hart of Richard II and an inn sign. Nor might I

have recognized the symbolic polarity of Landseer's *Monarch of the Glen* and Holman Hunt's *Scapegoat*.

Seeking to categorize the ways in which men have looked at animals, I called two further sections 'Animals Observed' and 'Animals Beloved'. With some artists, such as Stubbs, that may be an artificial distinction; with most others it serves its purpose as long as it is not pressed too far. Horses, cows and bulls have been observed by artists, and there can be no doubt that they loved painting them. Dogs, on the other hand, have surely been painted so often *because* they are loved. (One of the mysteries that remains is the relative scarcity of cats in European art.)

Many of the greatest animal paintings fall into none of these categories. The response to animals by artists as diverse as Assyrian sculptors, Gothic tapestry weavers, Leonardo, Géricault and Delacroix is better called admiration than love, and admiration can even include fear. I have therefore added a section called 'The Beauty and Energy of Animals', in which they are represented at the limits of physical stress – running, fleeing, wounded, fighting, dying – and reveal qualities which in a human subject would be called heroic.

And so, inevitably, I reach the point at which the whole project began: 'Animals Destroyed'. In some ways it is the most puzzling of all. Animal sacrifice was an obsessive preoccupation of the ancient world, and now that it has died out it is almost impossible for us to understand what gave it its religious authority. The slaughter of animals for pleasure, once widespread, is now confined to a few areas and may in time become equally incomprehensible. Hunting is still with us, and paradoxically can coexist with a sort of love of the animal hunted. All three are represented prolifically in art, and it is not, I think, unjustified to use such works as historical or even psychological documents.

It will be noticed at once that my examples are drawn only from Western and near Eastern art, and such arguments as I build upon them can relate only to Western culture. The limitation is deliberate. Were I simply assembling an album of animal pictures which have given me pleasure I should not omit the sculptured bulls of India, the camels and

elephants of Persian miniatures, the spirited brush drawings by Chinese and Japanese artists, or the multitude of terrifying animal presences created by primitive peoples all over the world. No lover of art or of animals can fail to be moved by these works, but I cannot use them in my thesis, because I cannot put myself into the minds of the men who made them. To have included them might have made the book more attractive, but I believe it would have deprived it of whatever intellectual focus it now possesses.

The captions were drafted by Ian Sutton and two researchers, Ronald Davis and Peter Harrison. They have expanded my ideas and given substance to my hints and guesses, and have also been able to find space for a number of quotations which I should like to have included in my text but thought might upset its balance.

I must record my gratitude to Fleur Cowles for initiating the whole project; to Professor Norman Porteous for his invaluable help on the questions of animal sacrifice and divination; and, as usual, to the Warburg Institute, which lays all scholars under contribution.

The pelican opening its breast to feed its young, from a
thirteenth-century Bestiary.

Sacred and Symbolic Animals

5, 7

3

8, 9

THERE IS in the Florentine Bargello a leaf of an ivory diptych which shows Adam accompanied by the animals. He sits a little apart from them, but smiles down at them with a dreamy expression on his face, and the animals seem perfectly at their ease. It must date from the fourth century, when representations of Orpheus were still common. The Golden Age, Orpheus singing to the beasts, the Garden of Eden, even Noah's entry into the Ark, these are necessary allegories of times when men and animals lived together in harmony. They filled an imaginative need; but, alas, they were no more than myths. Throughout recorded history man's feelings about animals have been complex, changeable and contradictory, made up of fear, admiration, greed, cruelty and love. But why did the harmony of the Golden Age never exist? The answer lies in that faculty which was once considered man's highest attainment, a gradual realization that the sounds he uttered could be so articulated as to describe experience. He discovered words, he could communicate with other men; and so when it came to satisfying his hunger, he could outwit the inarticulate animals. He could tell his fellow men how to dig pits and sharpen spears. We have no verbal evidence of this early stage in man's history, except for some traditions repeated by the African Bushmen and the Australian aboriginals. But we have a quantity of visual evidence, going back to the stone age, in the remains of painting on caves like those at Lascaux and Altamira. These are popularly known through dishonest reconstructions by archaeologists, which give an entirely false impression of them. In fact they are little more than blots and scratches; but amongst them are undeniable likenesses of bison and other animals. We may ask what induced man, who lived by hunting, to cover the walls of his caves with these most vivid and accurate depictions of his antagonists. Prehistorians give different explanations, usually based on material

arguments. These paintings, they say, were intended to give men power over the animals, and so increase their success in hunting. That the representation of a creature may be treated as a substitute for that creature, and confer magical powers, was, and has remained, true. Witches and witch doctors transfix models of the person they would destroy, and in at least one of the early caves, known as the Trois Frères, the animals are shown pierced with spears. But can this be true of the lively, energetic animals that can be dimly discerned on the uneven walls of Altamira? The few men who appear in Lascaux cut very poor figures compared to the vigorous animals. Can we seriously believe that they thought they were gaining power over their magnificent companions? Are they not rather expressing their envy and admiration? We must suppose, and Bushmen within living memory confirm it, that in prehistoric times the relationship between men and animals was closer than we can imagine. Man had barely learnt the use of tools, and his speech was rudimentary. Animals were in the ascendant, and distinguished from man less by their intellectual limitations than by their greater strength and speed. Personally I believe that the animals in the cave paintings are records of admiration. 'This is what we want to be like,' they say, in unmistakable accents; 'these are the most admirable of our kinsmen'; and my guess seems to be confirmed by the next stage in man's relationship with animals: the choice of an animal as the sacred symbol of their group: what is loosely called totemism. Hunting for their necessary food, and admiring to the point of worship a life-endowment greater than their own, from the earliest times there was established this dual relationship that has persisted to the present day.

Totemism has existed, perhaps spontaneously, all over the world. But it was strongest and most complex in Africa; and, in so far as the early Egyptians must have been in large part of African descent, it is in Egypt that we first see totemism turning into what we may call religion. So strong were the vestiges of totemism that in their art the Egyptians continually attempted to integrate man and animal. Men, whose bodies are models of human perfection, retain the heads of birds and animals throughout Egyptian history. These

animal heads, especially that of the wolf Anubis, are an obstacle to our admiration of Egyptian art: the reverse process of the Greeks, which produced the centaur and the harpy, seems both biologically and aesthetically a more acceptable form of integration. But at a very early date the Egyptians evolved the idea of the sacred animal, the equal and protector of the god-king; and sacred animals are the subject of the first pieces of sculpture that can, in the highest sense of the word, be described as works of art.

Of all sacred animals Horus was the most absolutely a god; the Horus relief in the Louvre has the air of finality, the commanding simplicity, of a great religious image. The other sacred animals of Egyptian art pass down a diminishing scale of sanctity. Hathor, the cow, was particularly favoured by certain pharaohs like Hatshepsut; the ram was sacred to Amun, as all visitors to Karnak will be painfully aware. Toth, the ape, was sacred but, so to say, localized, without the universal power of Horus; the same is true of the ibis, and of a much later arrival in the animal pantheon, also an incarnation of Toth, the cat.

We may easily feel that there are too many sacred animals in Egyptian art. Yet all of them produced images of great sculptural beauty which gain some of their power from the sacrosanct uniformity of the original idea. Small variations, which may have passed unnoticed by the believer, were due to the fact that these images were made by artists – the Egyptian artist was far from being the self-effacing craftsman of other early civilizations, and knew how to give a prototype the life-giving force of variety.

Apart from this greater life-endowment, there was another reason why animals were held sacred. Their inability to speak made them mysterious. All gods should be inscrutable. 'I am that I am.' If the Horus could have answered the questions addressed to him or Hathor commented on the sudden rise in her status in the Middle Kingdom, they would have lost some of their authority.

But beyond these godlike attributes the quantity of semi-sacred animals in ancient Egypt owes something to a state of mind that by no means always accompanies religious feeling: love. The Egyptians

loved animals. This statement will be dismissed by anthropologists as sentimental modern nonsense; but it is evident that the Egyptian feeling for animals was far closer to our own than that of any other ancient people. We can see this in the reliefs that decorate tombs *130* around Sakkara. High officials, like Ti and Mereruka, took so seriously the care of their flocks and herds that they covered the walls of their tombs with scenes of husbandry. These reliefs show that the Egyptians tried to domesticate animals of all sorts, but succeeded only with those which are our companions today, dogs and cats, and those which still occupy our farmyards. What a strange operation of nature that for five thousand years man has been able to domesticate sheep and cattle, and not roe deer? Cats were pets a thousand years before they were considered sacred, and the story in Herodotus that when a house is on fire the first thought of an Egyptian household is to save the cats – 'they pass them from one to another, while the house burns down' – is as much a reflection of love as of totemism. The reliefs of animal life in Old Kingdom tombs are inexhaustibly informative and touching. One of the most familiar shows a farmer carrying a calf on his back with the mother cow following and licking it. Where in the Graeco-Roman or the Semitic world could such an incident have been sympathetically observed and recorded?

Such were the feelings of harmony that could be developed in the secure, continuous pastoral life on the banks of the Nile.

In the harsher conditions of that other early civilization which for convenience we may call Mesopotamian such sentiments could not exist. The two great achievements of Mesopotamia, from Ur onwards, were the creation of cities and the invention of a written language. The cities accumulated wealth, traded and fought with one another, but, in so far as animals entered the Mesopotamian mind, they were symbols of strength and ferocity.★ This is how they appear *11* in the earliest cylinder seals, and they continue to confront one

★ The generalizing historian must always be prepared for surprises, none more peculiar than the discovery of a harp from Ur, now in the University Museum at Philadelphia, which shows a strip comic of animals enacting human roles, somewhere between Goya and Disney.

p23 another in a manner that we have come to call 'heraldic'. In later Mesopotamian art lions are the chief subject of sculptured friezes, and appear as guardians outside the doors of palaces and temples. The sense of kinship with animals has been superseded by an overawed recognition of their strength, which can be used to symbolize the terrible power of the king. Love has changed into an exploitation of fear.

There is no need to explain why lions and bulls were the semi-sacred animals of the Middle East. Their strength and potency made them the obvious symbols for a succession of warlike kingdoms. The bull illustrated in pl. 22 is Babylonian. In Persia they might have had wings which would have made them supernatural, but hardly more awe-inspiring. But it is worth recording two curious episodes in the history of the bull as a symbol of power, the first quite early in the history of the ancient world, the other very late.

18 The first is the introduction of the bull as a spectacle in Knossos, in about the year 1500 BC. Of this, of course, we have no information except what is provided by scanty, and often suspect, visual images. But there is no doubt that a bull was let loose in an arena, where athletes, both male and female, teased it with extraordinary agility. Anthropologists would no doubt wish to interpret this as some kind of religious ceremony; but the Cretans of the second millennium seem to have been less religiously minded than their contemporaries on the mainland, and, in spite of the legend of the Minotaur, I incline to think that this was simply a form of entertainment. If this be so the bull-ring at Knossos was something unique in the ancient world, and the forerunner of the Roman amphitheatre and the Spanish bull-ring, with the difference that we have no representation of the bull being killed, or, for that matter, one of the athletes being gored, although it is almost unthinkable that all of them survived. Perhaps the Cretan bulls were more formidable than the fragmentary representations of them in the frescoes from Knossos would indicate, for almost the most magnificent bulls in art are on a work of Cretan inspiration, although actually made in Greece: the superb gold cups (known as the

19 Vaphio Cups) found near Sparta.

The humanizing spirit of Greece treated bulls very differently. It was their potency rather than their ferocity that impressed the Greeks, and thus the bull became a favourite embodiment of Zeus, eloping

21 with the not unwilling Europa, as we see him on a Greek vase, and in Titian's masterpiece. Finally we must consider the confusing part played by a bull in the legend of Mithras. At first a god, he becomes a man, a barbarian soldier in a Phrygian cap, who is represented as

20 killing a bull with his sword. The sacred animal has become the victim of sacrifice. The importance of this concept is obvious. Although we have no written records of Mithraism, for it was an all-male freemasonry sworn to secrecy, there is no doubt that it was the most formidable rival to Christianity up to the time of Constantine. The sacrifice of the bull as the symbol of redemption and new life shows how profound were the spiritual needs of the late antique world, which were answered so differently by the sacrifice of Christ on the Cross.

Men had sacrificed animals for thousands of years. It seems to have been one of the most ancient human instincts. As we do not feel a trace of it today it is difficult for us to see why the practice became a necessity all over the ancient world. Many books have been written about the subject, in which the arguments are like vast bundles of thread beginning nowhere, ending nowhere, and practically impossible to unravel. But out of this confusing, and often contradictory, evidence a few skeins may be extracted: propitiation, atonement, the need to assert kinship. While men still felt a kinship with animals, to eat them was a crime against the group, and expiation could be achieved only by a ritual feast in which all were involved. Communion was the first basis of sacrifice. But quite soon the belief grew up that the gods were pleased by sacrifice, particularly by the smell of burnt offerings, in which the food was given solely to them. The more the gods had to be propitiated to avert disaster or secure the success of some enterprise, the more sacrifices they required. *Les dieux ont soif.* Finally, sacrifices could become an assertion of royal or priestly authority. The priest is seen as the visible mediator between the people and the god. Thus in the relationship of animals and

men what had at first been an act of atonement and an assertion of
kinship becomes an act of pure destruction, in which animals feed the
supposed appetites of a greedy god. And yet when we look at the
sacrificial cow from the Parthenon frieze, the 'heifer lowing
to the skies' of Keats' ode, we are conscious of a certain solemnity.

There will be more to say about the destruction of animals by men
later in this introduction; no doubt the massacre of animals in the
Roman arena simply to gratify the cruel instincts of the spectators
was the most revolting of all these destructions before the nineteenth
century. But the long history of animal sacrifice, stretching over more
than two thousand years, is a depressing aspect of animals' relationship
with men.

In Europe animal sacrifice ended with the establishment of
Christianity; and nothing could show more vividly the absolute
newness of the Christian religion than the choice of its symbolic
animal. After the lions and bulls of Mithras and Mesopotamia came the
lamb and the sheep. Innocent, gentle and docile, they are either the
symbol of sacrifice, or exist to follow the will of the Good Shepherd,
and to enjoy His protection. In the same spirit the dove takes the
place of the eagle or falcon. Although the lamb is alluded to as a
symbol of Christian humility in early Christian texts, it does not
appear in art till it can safely be substituted for the hermetic fish. The
sheep are the chief symbolic animals of the evolved Christianity of the
late fifth century, and inhabit the mosaics of Ravenna, beginning with
the beautiful representation of the Good Shepherd in the so-called
Mausoleum of Galla Placidia.

But ancient symbolic images are not easily suppressed. The
symbols of the bull, the lion and the eagle make their way back into
Christian iconography by a curiously roundabout route. The first
vision of the Prophet Ezekiel describes an image in terms which are
almost incomprehensible, both visually and philologically, but which
mention four faces, those of a lion, an ox, an eagle and a man. About
six hundred years later the author of the Apocalypse, who was so
frequently indebted to Ezekiel, speaks of the four beasts that are before
the Throne of God. 'The first beast was like a lion, and the second

132

1

16

15

beast was like a calf, and the third beast had the face of a man, and the fourth was like a flying eagle.' So here they are; our ancient symbolic animals, in a sacred book believed to have been written by one of the Evangelists, a book that had an overwhelming influence in the early Middle Ages; and what could be done with them? The question, like so many in early Christian doctrine, was solved by St Jerome. In his famous commentary on Ezekiel he lays it down that these animals are the proper symbols of the four Evangelists, the eagle for St John, the lion for St Mark, the bull for St Luke and the man for St Matthew.★ Why spend time on a theological fantasy in a book on animals? Because for over seven hundred years almost the only animals in art were representations of the Evangelists. They pass from the extreme
26 (but marvellously beautiful) stylization of the Echternach Gospels
27 and the Books of Kells to the magnificent realism of the bull on the
28, 30 façade of Siena Cathedral, and on Donatello's altar of the Santo
31 in Padua to the lion of St Mark on the Piazzetta, or Donatello's
Marzocco in Florence.

Three other categories of what may be loosely classed as symbolic animals occupied the attention of the Middle Ages, early and late.
32, 33 First, there were the monsters who appear frequently in Romanesque sculpture. They are represented biting and tearing their victims and symbolize with irresistible power the energy of evil. Then, at the
38–41 opposite pole, is the series of MSS. known as bestiaries. The sources of the bestiaries are unknown. The entries often quote the authority of a writer known as the Physiologus (which may mean no more than 'the natural historian'), about whom we may conjecture from internal evidence that he lived in late Antiquity, although probably in Christian times. The bestiary claimed to give information, and some of it did in fact go back to Pliny. But the greater part was based on legend and folklore. For example, a beautiful drawing in a MS. in

★ I am grateful to Dr Montague for pointing out to me that the identification of the symbolic animals with the Evangelists was first suggested by Ireneas of Lyons in the second century, although he distributes them differently. But it was through St Jerome's authority that the iconographical motif was finally accepted.

40 the University Library in Cambridge shows the eagle flying up to the sun in order to burn away its old plumage and the film over its eyes, after which it can take a rejuvenating plunge into the sea. No bestiary

39 is complete without the famous scene of sailors anchoring on the back of a whale which they had mistaken for an island. Another example of

38 the fabulous shows the dog seeing the reflection of its cake in the water, and losing it in his greedy attempt to get two.

This leads us on into Aesop. He is a figure almost as legendary as the Physiologus. The fables associated with his name grow naturally out of the moralizing element of the bestiaries; but they were addressed at first to a more popular audience, and illustrated with drawings and woodcuts much humbler than the decorative and imaginative illuminations of the earlier MSS. The concept that man can learn from the wisdom of animals has a widespread, almost a humorous appeal, and revives in a new form the sense of kinship; and fables continued to be popular till the mid nineteenth century. In the work of La Fontaine they even inspired great literature. The engraving on pl. 43 of Aesop (who was reputed to have been a hunchback) surrounded by the animals and drawing wisdom from them – a sort of inverted Orpheus – is from an English book of 1665. Its illustrations stand mid-way between the earlier and the later Aesops. The illustrator, Francis Barlow, used motifs already circulated in European prints and books, and in turn his designs became the basis of the last symbolic animals to gain currency, the animals on old-fashioned inn signs. Here, of course, there is also a heraldic origin;

37 the exquisite White Hart of Richard II was never forgotten. I do not know how many of these encouraging symbols have survived the 'takeover' of the big brewers, so have illustrated them by three

34–36 admirable drawings for inn signs in an album by a pupil of Wooton that must have served as the sample book of some itinerant painter.

Finally, I must mention three pictures of animals done after the age of symbolic art was over, but which make their effect as symbols with unforgettable power. The first represents an enraged swan, and is the masterpiece of a relatively obscure Netherlandish painter, Jan Asselijn. It stands out from the ordinary bird and animal pictures of

the seventeenth century – a somewhat monotonous genre at the best of times – by its heroic ferocity; and we at once recognize it as a symbol of the defiance of tyranny. The second, painted at the high

46 noon of naturalism, is Landseer's *Monarch of the Glen*. Nothing in Victorian literature expresses so completely the commanding self-satisfaction of the period. This was no doubt the sentiment of a vast majority. But a small minority, the Pre-Raphaelites, took the opposite view, and one of their number, Holman Hunt, expressed it in what is

47 one of the few religious pictures of the age, *The Scapegoat*. It was painted with incredible difficulty, on the shores of the Dead Sea, and Holman Hunt described in detail how he wished to make his goat a symbol of sacrifice, using both the Bible and the Talmud as his sources of inspiration. When it was exhibited a few critics were disturbed by the expression of Christlike resignation on the goat's face. The majority thought it was just a silly old goat, and could not imagine why Mr Hunt had gone all that way to paint it. Men had ceased to think symbolically, and their feelings about animals had changed from veneration to curiosity. It was a loss to the human imagination. Whether it will ultimately be a gain to the understanding of animals remains to be seen.

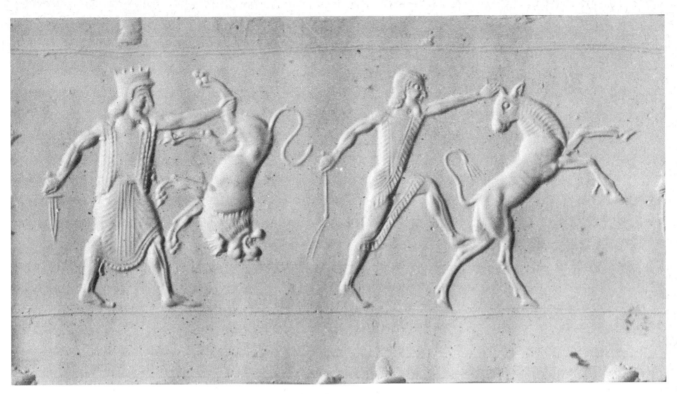

Impression from an Achaemenid cylinder seal, showing gods or heroes
fighting a lion and a bull.

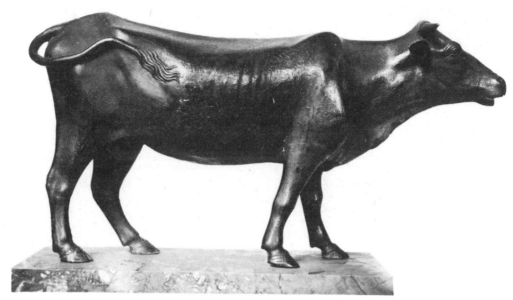

Greek bronze of a cow found at Herculaneum.

Animals
Observed

IN REPRESENTING their fellow men and women artists have tended to idealize them. Style, fashion, status and the need to flatter have intervened, and the works of art in which men have been observed impartially are relatively rare. Perhaps the fact that men and women have to be represented clothed is partly responsible, for the head is insensibly adapted to the fashionable character of the dress; and the most penetrating observations of human beings are those like Roman busts, in which the head is shown in isolation. None of this applies to the representation of animals. They do not need to be flattered or conform to the dictates of fashion. The artist can indulge his curiosity with so little regard for style that a bird by Giovannino de' Grassi of the late fourteenth century can be almost identical with one by Thomas Bewick of the late eighteenth.

The impulse to represent animals as accurately as possible was widespread in Hellenistic art, and dates back to earlier Greek times if, as is usually supposed, the admirable bronze of a cow (opposite) in the Cabinet des Médailles in Paris is really fifth-century BC. Animals were amongst the most popular examples of antique sculpture simply because their realism came as a pleasant change from the monotonous idealism of Hellenistic figure sculpture; and the great collectors of the *frontispiece* Renaissance competed for them. The Grand Duke of Tuscany won the prize with his enormous dog, which still greets the exhausted sightseer who has climbed the stairs of the Uffizi. But the Vatican won on numbers, and could present a complete Sala degli Animali, where I confess I linger with more amusement than in some of the corridors of idealized humanity. I even enjoy those aesthetically disreputable works of Renaissance craftsmanship, the small bronzes which are casts of an actual animal.

The first attempt to represent an unusual animal (the naïve

49 precursor of Dürer) is Matthew Paris's drawing of the elephant given by St Louis to Henry III, in which he has been sufficiently curious to draw a detail of the trunk. But in the mid-thirteenth century a painter was not capable of very accurate representation, and it is only in the late fourteenth century that one finds real precision. It appears chiefly in the representation of birds. They had an inexhaustible fascination for the medieval mind and eye, because they were free, decorative and relatively unencumbered by symbolic associations. They were simply objects of delight. Birds abound in the margins of fourteenth-century MSS., the most beautiful being in the

51, 52 Sherborne Missal; and amongst the source-books which were circulated to the various scriptoria were drawings of the various birds and beasts that might be thought appropriate to the margin of a book, or on a piece of *opus Anglicanum* embroidery. At least two of these so-called sketch books have survived. The first is in the Pepysian

50 Library at Magdalene College, Cambridge, apparently English and datable before 1400, and is itself clearly a compilation from other source-books. The most accomplished pages it contains are covered higgledy-piggledy with representations of birds. They were probably not drawn from life, but were derived from life drawings done with great accuracy and power of observation. The variety of birds is astonishing. Clearly there existed in the Middle Ages a number of bird-watchers almost as patient and observant as those of today.

 The birds in the Pepysian MS. are not copied by a very skilful hand. But a few years later an artist of much greater distinction set himself to the same task. This was Giovannino de' Grassi, whose

59, 61 'sketch book' is in the Communal Library of Bergamo. As before, I
p52 think we have to do with a compilation, but one done with such taste and precision that the drawings qualify as works of art. Giovannino de' Grassi also includes a number of other animals – lions, leopards, hares – which occupied man's curiosity at the beginning of the fifteenth century, and it was from this fashion, centring on Verona, that conjunction of Gothic and Italian culture, that there emerged the first great observer of animals of the Renaissance, Pisanello.

 Pisanello's eye rested impartially on animals and human beings.

The portraits on his wonderful medals leave us in no doubt that they are exact likenesses, done with sharp human insight. But on the versos of the medals there is, in practically every case, an animal. By some instinctive sympathy Pisanello seems to have felt that they must be made complementary to the men and women on the obverse. So it is not surprising to find among his drawings in his sketch book in the *54–56* Louvre studies of animals more accurate than any which had preceded, *p33* or than most that were to follow, them. He looks without prejudice. *62* His drawings of horses are far from the proud rotundities of Antiquity or the Baroque. They are tired, thin and knobbly, and their heads show an almost human resignation. His other animals – the seated cow, most delicately observed, the dog, the fox – are drawn with an equal detachment. Yet we cannot avoid the feeling that this tireless observation of animals expresses a deep conviction, and this feeling is supported by the fact that several of the drawings were used in a *6* picture of St Eustace in the National Gallery, London. St Eustace, as we learn from the *Golden Legend*, was a Roman soldier passionately devoted to hunting. One day, when following a splendid stag, it turned to face him, and 'when he looked upon it carefully he saw between its antlers a holy cross, that shone more brightly than the sun, and on it the image of Jesus Christ'.★ In the *Golden Legend* this is made the instrument of his conversion to Christianity but Pisanello has transformed it into a parable of the unity of God's creatures. He has filled his small panel with other animals, so that the whole scene has the character of a Garden of Eden.

How little we know about the art of the fifteenth century! By chance one or two sketch books have survived, including that of Pisanello in the Louvre. But what about Paolo Uccello, whose very name commemorates his love of birds? Hardly an animal by Uccello *58* survives except for his powerfully stylized horses in the *Rout of San*

★ The same story is told of St Hubert, but this version did not gain currency till the late fifteenth century; it is included in the *Acta Sanctorum*, and there are said to be parallels in Persian literature. Without doubt Pisanello was inspired by Voragine's *Golden Legend*.

Romano pictures, and in an engraving which must unquestionably derive from him. The enchanting arabesque of hounds and deer prancing through a dark wood in the Oxford picture shows us how much we have lost. But by the end of the century painters were more conscious of their personalities, and ready to exploit their gifts; and none more so than Albrecht Dürer. His skill in setting down exactly what he saw was at the command of an insatiable curiosity. He was like the amassers of those early collections of curiosities that were to grow into our modern museums; only he did not need to keep them, only to draw them. From his early period comes a
67, 68 monumental crab, a meticulous beetle and a rhinoceros in full
66 armour; from his last years a walrus with spiny snout, which he saw when he went in search of a gigantic whale that had been washed up in Zeeland, but unfortunately had disintegrated by the time he got there. But his curiosity was sometimes satisfied by animals nearer home, as
65 in one of his most famous drawings, the hare, in the Albertina which, after we have recovered from our delight in its skill, prompts the question, how did he ever persuade a hare to sit still long enough for him to record all that detail?

Only one artist has ever been as curious as Dürer: Leonardo da Vinci. So it is rather surprising that he did not make more drawings of animals, other than horses. The horses are marvellous enough, not
110–112 only the classically beautiful horses to be mentioned in the next section, but the horses drawn direct from life. But apart from them there are only a few small dogs, several studies of a bear and a famous
72 sheet of cats. Leonardo's note makes it clear that he was interested chiefly in the cat's power of twisting its body, and to this he has done full justice, so that some of the animals hardly look like cats at all. Others are perfectly observed. I suppose the reason why Leonardo so seldom turned his curious eye on to animals is that they did not fit into the classical scheme of High Renaissance art.

There was no room for the close observation of animals in the ideal world of Michelangelo; and Raphael's splendid horses are more a tribute to Antiquity than to nature. Man, at the summit of his self-confidence, forgot those ties of feeling and physical need that had

once established his kinship with the animals. Even Giulio Romano's once famous portraits of the Duke of Mantua's horses in the Palazzo del Tè are curiously flat and lacking in animal life. During these years it was only in Venice that art retained its necessary warmth, and the dogs of Titian and Paolo Veronese show that animals were still loved and understood.

In the second half of the sixteenth century Venice also saw the appearance of pictures in which animals are the real subject. The rise of this new, and as it turned out, very popular genre was due to the Bassano family. To some extent they are the ancestors of the successful *animaliers* of the nineteenth century, Troyon or Rosa Bonheur. Many of their pictures, from Jacopo's large *Jacob's Return* in the Ducal Palace downwards, were honourable commercial undertakings. But running through the work of the Bassani is a genuine feeling of the unity of men and animals in the landscape (and they are much under-rated as landscape painters). One finds it in a
71 beautiful picture in the Doria Gallery of the *Earthly Paradise* by Jacopo, where the subject alone reveals his true feelings; and in a picture by his son Francesco in Vienna, in which God indicates to
70 Abraham the way to the Promised Land, and a rustic patriarch sets off with his family and all his animals.

The nature-loving art of the Netherlands is full of animals observed. Sometimes they are the pretext for a Baroque composition, as in the innumerable canvases of Snyders, which must have given satisfaction in their day, but are wearisome to us; and sometimes they
75 are pieces of unpretentious naturalism, like those of Adriaen van de Velde, in which the animals are part of the landscape. In this genre one
76 painter is outstanding, Aelbert Cuyp, whose cows are observed with so much pleasure in their placid way of life that I have been tempted to classify them as Animals Beloved. Two Dutch painters who loved animals observed them from antithetical points of view. They are Rembrandt and Paul Potter. Rembrandt in his drawings rendered the
79 vital force of lions in a few vivid strokes, and caught to perfection the
78 shambling gait of the elephant. Paul Potter's minute observation of every hair in an animal's coat was almost an obsession. For over a

century his *Young Bull* in The Hague was one of the most famous pictures in Holland, and I must confess that the accuracy with which he has rendered the bull's wet nose has an irresistible attraction for me. It was painted in 1647, when Potter was only twenty-two (he died at the age of twenty-nine), and is evidently the product of a young man's intensity of gaze. When he comes to the human figure on the left this intensity vanishes.

The genre of *animalier* flourished in Rococo art, but the concoctions of Desportes and Oudry become monotonous, and it was left to an English artist to look once more at animals with a clear and steady gaze. This of course was George Stubbs, perhaps the only English painter to whom the word classic may be correctly applied. Unlike Potter he had a sensitive understanding of the human head; but inevitably we think of him first as a painter of animals. Just as the artists of the High Renaissance, passionately observing the human body, wished to go beyond observation to knowledge, and studied the science of human anatomy, so Stubbs expended an infinity of labour, physical as well as mental, on studying the anatomy of the horse, and produced a series of beautiful drawings now in the Library of the Royal Academy. But this knowledge is never allowed to intrude into his pictures (as the knowledge of human anatomy so often does into Italian art of the sixteenth century). Perhaps only an expert could

86 realize how anatomically accurate is his portrait of Mambrino. Stubbs's earliest portrait of an animal seems to have been the zebra in the Mellon Collection. Horses were his bread and butter; but throughout his life Stubbs continued to take an interest in exotic animals. He could

69, 88 not resist the rhinoceros, or the cheetah, and his monkeys are amongst the most moving of his works. To some extent these observations reflected the encyclopaedic curiosity of the later eighteenth century, and many of them were commissioned by the Royal College of Surgeons. Compared to the sentimental *animaliers* who succeeded him, his work may seem detached, but, viewed more closely, one finds in it some of that feeling of kinship with animals (for example in the green monkey), which has been the chief theme of this essay; and for this reason I have included several of his pictures in the section Animals Beloved.

Stubbs was employed by swells and royalty. Apart from his designs for Wedgwood, his work hardly dawned on the popular mind. But his characteristics – curiosity, a love of animals and a patient accuracy in recording them – were diffused by an artist who must, I suppose, be described as a minor artist, simply because he always worked on a small scale. This is Thomas Bewick, who in the 1770s perfected the technique of engraving on wood, and used it to record the whole range of birds and animals, ending with the duck–billed platypus a few months after it had been discovered, and before it was named. Bewick was a Stubbsian character, a stubborn, independent North Countryman, with an equal passion for truth. He went to London as a young man, and observed 'I would rather be herding sheep on Mickley bank top than remain in London, although for doing so I was to be made premier of England'. He did not go there again till the year of his death. He was soaked in the countryside, and thus was able, like Stubbs, to place his informative records of animals in landscapes, which are not only exquisite in themselves, but which enhance the meaning of the subjects. He began this practice in his *History of Quadrupeds* (1790) and carried it further in his most

half title successful book *The History of British Birds* (1797). I have limited

p8 myself to two reproductions of Bewick, one animal and one bird. I would gladly have reproduced a hundred. In company with Wordsworth, Charlotte Brontë, Ruskin and Carlyle I too find him irresistible, and few English books can have done more to further man's observation of animals.

In the mid-nineteenth century new patrons of art began to lose patience with the mythological and historical subjects that had formed no part of their education, and, as had happened before in Rome, they turned gratefully to the representation of animals. Animal painters made fortunes for themselves and their dealers. The royal admiration of Landseer was only to a small extent the origin of

83 this fashion. Landseer was in fact a brilliant observer of animals, as we can see from his drawings. But a mixture of sentiment and romanticism, much to the taste of the time, tended to cheapen his observations, and gave his work a bad name, from which it is only just

beginning to recover. The real successor to Landseer was Rosa
Bonheur. She too sometimes compromised her remarkable powers of
observation by concessions to popular taste. But she achieved one
vastly successful picture, which is a sort of masterpiece, and will
appear in a later section. Finally, there were the respectable *animaliers*,
inspired by the Dutch, of whom Troyon was undoubtedly the ablest,
admired and collected not only by industrialists but by the Louvre.
This school completely exhausted the genre. Manet, Monet and
Cézanne never painted animals, but their successors, variously referred
to as post-Impressionists or Expressionists, saw animals with a character
horribly similar to men, but transcending human complexity by their
single-mindedness. This vision produced some splendid lithographs by
Munch, done when he was in a mental hospital in Copenhagen and
was allowed to draw only in the Zoo lest concentration on a human
head should unhinge him; and several pictures by Kokoschka which
make one feel what alarming characters animals really are. They go
beyond the title of Animals Observed, but they cannot be classified as
either 'beautiful' or 'beloved'. The observation is there, of course, but
used to express the painter's sense of violence.

89

81, 82

90

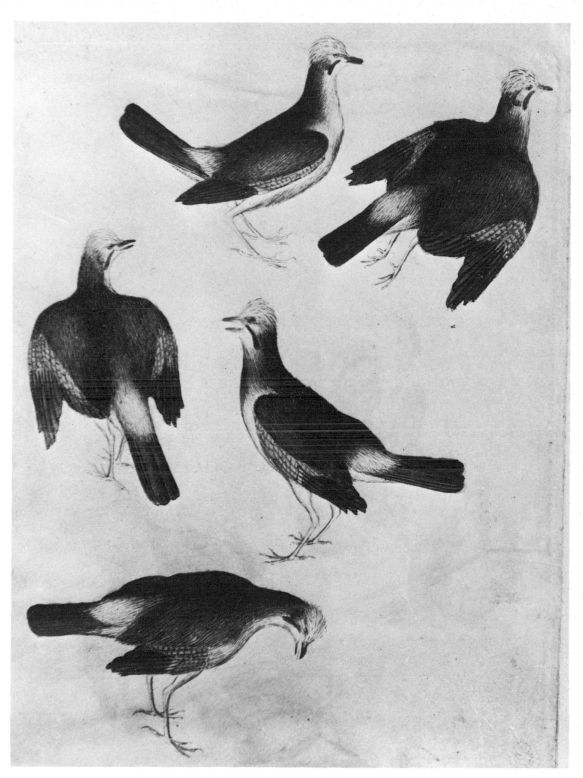

Page of coloured drawings of jays, from the Pisanello album in the Louvre.

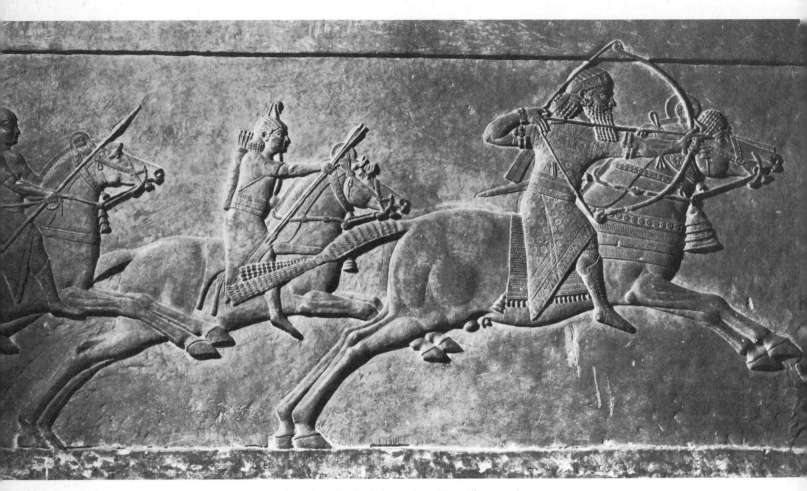

Horsemen from Assurbanipal's hunt, from Kyunjik, seventh century BC.

The Beauty and Energy of Animals

PRIMITIVE MAN's admiration for the beauty and strength of animals never died out, and in more evolved societies became the inspiration of great works of art. From about the year 1500 BC sculptors have found in certain animals a grace, a delicate balance and a smooth relationship of the part to the whole which we have come to describe as beautiful. An undefinable word; but since it expresses the difference between our feelings when we look at a gazelle or a horse and those aroused by a crocodile or a wart-hog, it is worth preserving in our limited vocabulary of criticism as the description of a precious human experience.

There are plenty of beautiful animals in early Egyptian art, but they were, so to say, incidental. In Greece beauty, as I have described it, became the artist's main objective, and was applied to the human face and body with such a mania for perfection, that for centuries the words 'beauty' and 'Greek' were practically interchangeable. The Greeks, although much less interested in animals than the Egyptians, had one superb vehicle for their sense of beauty, the horse.

The horse had arrived in the countries of the eastern Mediterranean at some time in the second millennium, brought there from Asia during one of the warlike migrations, and had been largely responsible for the overthrow of the Egyptian Empire by the Hyksos in about 1500 BC. We may suppose that these horses, 'the tanks of the ancient world', were more formidable than beautiful. But quite early they were evolved from instruments of aggression into objects of pride. On reliefs of the Ramassid period we can see that the Egyptians, having taken them over from their conquerors, had cultivated their beauty as well as their strength, and we can find the same feelings in the Assyrian reliefs from 1000 BC. A pride in the beauty of horses, which appears repeatedly in the Homeric poems, was to continue

through the ancient world, and survive till it became the root of the word 'chivalry'. The Dauphin's speech about his horse in Shakespeare's *Henry V*, although partly intended as satire, expresses the feelings of most young men of spirit (and means) up to 1914.

> When I bestride him, I soar, I am a hawk: he trots the air; the earth sings when he touches it; the basest horn of his hoof is more musical than the pipe of Hermes . . . It is a beast for Perseus: he is pure air and fire; and the dull elements of earth and water never appear in him, but only in patient stillness while his rider mounts him: he is indeed a horse; and all other jades you may call beasts.

Today a young man might pronounce the same rhapsody on his motor-bike, but I doubt if it would prove equally inspiring to artists.

Archaic Greek art produced small bronzes of horses, stylized to the point of abstraction. Charming as they are, they do not show any feeling for beauty in the narrow sense I have suggested. This first *97* appears on the frieze of the Siphnian Treasury in Delphi of about 525 BC. They display all the elements which, a century later, were to be developed and given livelier movement in what are arguably the *96* most beautiful horses in art, those which cavort round the frieze of the Parthenon. Although they tug at their vanished reins, and long to break into a gallop, they seem conscious of the fact that they are taking part in some great ceremonial; they are proudly vigorous, and beauty still predominates.

No wonder artists have been inspired by horses. The splendid curves of energy – the neck and the rump, united by the passive curve of the belly, and capable of infinite variation, from calm to furious strength – are without question the most satisfying piece of formal relationship in nature: so much so that good photographs of horses have the same effect on me as works of art (and of course a well-bred horse is to some extent the result of art). How much the Greeks valued *100–103* the beauty of horses is shown by their coinage: a chariot drawn by four horses of unequalled elegance is the reverse of the most beautiful coin in the world, the dechadrem of Syracuse; a proud, gigantic horse

commemorates the prowess of the Macedonian cavalry on the reverse of a coin of Philip II; and the horse's head, that was to influence Leonardo da Vinci, is the reverse of a dechadrem of Alexander the Great.

95 There is on the Acropolis the fragment of a marble horse of the fifth century, which must originally have been one of the most beautiful pieces of animal sculpture in the world, and was probably the inspiration of a small bronze horse in the Metropolitan Museum of questionable date, but unquestionable charm. The most famous life-size horses of Antiquity still exist undamaged, thanks to the predatory instincts of the Venetians, who were prepared to commit
99 any crime to decorate their Basilica. The horses of St Mark's are so familiar, and so much a part of the marvellous show-case of the façade, that we forget what extraordinary survivals of antique sculpture they are. Whether or not they are copies made to fob off the Emperor Nero, they certainly go back to fifth-century originals, and have never been surpassed.

 Horses play relatively little part in early medieval art. Their curves could not be assimilated into the angularity of Gothic. The horse of the Bamberg rider is an art-historical curiosity but not a joy to the eye. However, the later Middle Ages invented one of the most beautiful of all animals, which in fact never existed, that exquisite white pony with a goat's beard, a flowing tail and a long horn growing straight out of the middle of its forehead, known as the unicorn. Everything about the unicorn is mysterious, and leads to a string of unanswerable questions. What does it really signify? Students of allegory and iconography give contradictory answers. What were its origins? It is said to have originated in India, and it appears in Pliny, who says that it is a fierce and dangerous animal, but when it sees a virgin it lays its head submissively in her lap. In consequence the Physiologus (see p. 20) makes the unicorn one of the supporters of the Virgin Mary. It plays a minor role in the early Middle Ages; then, in the fifteenth century, it comes to fill some imaginative need, and inspires two of the greatest
104–109 masterpieces of late Gothic art. These are the tapestries of the *Hunt of the Unicorn* in the Metropolitan Museum (the Cloisters) in New York,

and the slightly later tapestries in the Musée de Cluny, known as the *Lady and the Unicorn*. Looking at these marvellous works of art we cannot help asking more questions. Where were they made? For whom were they made? Above all, what is their subject? Nobody knows. The catalogue of the Cloisters states with bland confidence 'The subject of the tapestries is an allegory of the Incarnation in which the Unicorn, a symbol of purity representing Christ, is hunted and captured.' It sounds convincing; but what about the last of the series in which the Lord and Lady, by whom, presumably, the tapestries were commissioned, come out of their castle and watch with complacency the brutal slaughter of the unicorn? In the rest of the series the unicorn does indeed seem to have some sacred quality, especially when it kneels and places its horn in a stream. This horn is almost certainly derived from the horn of a marine mammal known as the narwhal, which was greatly valued in the Middle Ages for many magical properties, especially as a deterrent to poison; and it is possible that the unicorn

104 is shown purifying the fountain of life, while other animals sit contentedly before it. But, just as we are persuaded of the unicorn's benevolence, he gores a hound with its horn. So we give up all attempt at logic, and enjoy the shining grace of this fabulous animal, which shows that, whatever his official programme may have been, the designer of these tapestries wished to show that beauty is an attribute of the divine.

The Cluny series, being less dramatic, can be enjoyed without worrying too much about its subject. But all the same, one would like to know what the unknown designer had in mind; and once more interpretations have varied from mystical to emblematic or social. Whatever the meaning, we feel that the unicorn, by its gentleness, has given the series its character. The lion is equally the Lady's supporter, but we do not remember him because the whole world of animals that fills the area of each tapestry seems to be under the influence of the unicorn's beauty. And as he kneels to lift up the flap of her tent, he seems to be admitting her into the Earthly Paradise.

After the sixteenth century this poetical allegory of beauty, with all its baffling associations, disappears from art. We say goodbye to it in

108

the Galleria Farnese, where the lady with the unicorn by Domenichino is perhaps the only scene in that splendid ensemble that really touches our hearts.

110–114

In the same years that the Gothic north was creating this ravishing variation on a horse, Leonardo da Vinci was studying its beauty from an almost exactly opposite point of view. At almost every point in his career as an artist, until his last years, he was at work on some commission that involved a horse; first the *Adoration of the Magi* for San Scopeto; then, for fifteen years, the giant horse of the Sforza monument; then the *Battle of Anghiari*; and finally the monument to Marshal Trivulzio. No one has ever observed horses more sympathetically, and also more scientifically, for he wrote a treatise on the anatomy of the horse, now lost, and did measured drawings in which he tried to apply to the proportions of a horse the same kind of complex mathematical progressions that he and Dürer were applying to the human body. Apparently this horse was the 'Gianecto Grosso' of Messer Mariolo, and I am inclined to think that this is the same animal

112

who appears in the most beautiful of all Leonardo's drawings of horses. This drawing was done in about 1490. Both before and after Leonardo did studies of horses with an intention different from this living naturalism. The earlier ones, grouped round the *Adoration of the Magi* for S. Donato a Scopeto, are reflections of that dream which haunted the imagination of Renaissance antiquity. Leonardo has used reliefs and coins to nourish his ideal: in fact the closest parallel is a series of carvings that he can never have seen, the frieze of the Mausoleum. These dream horses continued into the first period in Milan, and appear in such a drawing as that on pl. 111, which is evidently intended as a project for an equestrian monument, although technically it could not have been carried out as sculpture. This Leonardo recognized, and for thirty years he worked on a series of drawings of horses that are directly concerned with his sculptural projects. They are admirable drawings, but they lack the magic of the lunar apparitions in the

114
113

Adoration. In the years between his two monuments he did the studies for his great battle of horses, the *Battle of Anghiari*, which I shall return to when I consider how beauty gives way to energy. But meanwhile I

must notice that three artists came very close to Leonardo in their direct response to the beauty of horses. One of them, of course, is Stubbs. I have spoken of him as an observer; in some of his pictures of mares

117 and foals he is so touched by the sheer beauty of the subject that his detached observations are transformed; and in one painting he leaves his deliberate naturalism behind, and sets out to create an ideal horse.

116 This is *Whistlejacket*, surely one of the greatest pictures of an animal ever painted, and something of which an Englishman should be proud.

The second is Géricault. His love of horses was an obsession which
87 led him to visit England, where he admired the dray horses as much as the thoroughbreds; and ultimately it led him to his death. He not only depicted the classic contours of the horse which I have described, but he painted a horse's head with a love for its beauty that is almost disturbing. For years he worked on a celebration of the free horse, the
123 race of riderless Barberi horses that he had witnessed in Rome in 1817. In fact he worked on the subject till it died on him, and the point at which he abandoned it gives us less pleasure than some of the related sketches.

The third great master of the horse was Degas. He had almost Leonardo's technical skill as a draughtsman, and his drawings of horses are sometimes so like Leonardo's that one might, in memory, confuse them. Two things in the world gave him pure aesthetic pleasure, the
127 ballet and the racecourse, and, although he could sometimes be cruel to dancers, he always looked with admiration at *les purs sang*. He never painted a horse in isolation, or insisted on its plastic qualities, as Stubbs and Géricault had done. In the age of the camera, his horses are part of the general scene, at the beginning or the end of a race, often confused with other horses but observed with an unequalled sense of their grace and energy.

From the beginning the beauty of animals has been linked with admiration for their energy. 'Energy,' said Blake, 'is eternal delight.' And it was this, presumably, that induced Leonardo, to whom war was 'a most beastly madness', to choose as the subject of the greatest painting of his Florentine years a battle of horses. *The Battle of Anghiari* was destroyed, or overpainted, when Vasari remodelled the interior of

the Palazzo Vecchio in Florence, but it was so powerful an invention that it has survived in many versions, some of them done by artists who had never seen the original, but recreated it from earlier copies. The one that seems most vividly to suggest the original is a drawing of

113 Rubens's in the Louvre, which is an amazing piece of clairvoyance, for it was done from a mediocre engraving. We see that Leonardo's cartoon was the ancestor of all those works of romantic painting, from Rubens to Delacroix, in which artists have celebrated the heroic energy of animals. None of them has combined ferocity with the

115 extraordinary concentration of Leonardo. Rubens' great lion-hunts are not destructive as are the lion-hunts of the Assyrian kings, because they are above all expression of energy. We look at them with exhilaration.

'The tigers of wrath are wiser than the horses of instruction': Blake again, and he was, as usual, forestalling that new direction in human feeling which we call Romanticism. Man in his relationship with animals began to sympathize with the ferocity, the cruelty even, that he had previously dreaded and opposed. Barye, that unequalled

118 sculptor of animals, gave his tiger a purposeful dignity and sympathized with the panther devouring a roe deer. The greatest

121, 122 exponent of this new religion of violence was Delacroix. Rubens had admired the energy of wild animals, but was at the furthest remove from a wild animal himself. But almost everyone who met Delacroix saw in his powerful jaw and narrowed eyes an unmistakable resemblance to a tiger. Delacroix did not disguise his sympathy with *les fauves*. At feeding time in the Paris Zoo he was, he tells us, '*pénétré de bonheur*'. He felt a personal sympathy with the pride and aloofness of the tiger,

120 and realized it in the magnificent early painting in the Louvre of a tiger playing with its mother. But this quiet dignity did not satisfy him as much as did the glory of carnage. The pictures in which he celebrates it

124, 125 are usually described as 'lion-hunts', but there is no evidence that the men have had the insolent courage to go out hunting lions. These are simply episodes in a war between men and animals in which, for the first time in art, the outcome is uncertain. The greatest of these scenes must, I think have been in Bordeaux, destroyed in a fire, of which part of

the surviving fragment is on pl. 124. It has a weight and concentration which, in the splendid picture in Chicago, is sacrificed to movement.

The horse plays a large part in Delacroix animal battle pieces, but it is far from being the horse of instruction. Usually it is the wretched victim. But occasionally it too is made to participate in the

196

general frenzy, as in the famous watercolour in the Louvre of a horse

121

frightened by lightning, which, as I have said elsewhere, 'is Delacroix's doodle, his automatic writing, occurring again and again in his work, whenever his unconscious took command'. Delacroix noted in his *Journal*, 'Art does not consist in copying nature, but in recreating it, and this applies particularly to the representation of animals'; and he adds a comment on horses 'One mustn't aim at the perfection of the naturalists'. The words come to our mind in front of his picture of

122

horses fighting in a stable, which is certainly *not* painted from nature, but is a superb arabesque of animal energy.

Delacroix's vision of animals and men locked in a conflict where magnificent energy and strength might succumb to the weapons of a more evolved humanity, was too strong a draught for the growing humanitarianism of the nineteenth century. Decent people thirsted for an opiate which would make them forget the merciless destruction that is described in the last chapter; and they turned with relief from Delacroix's bloody encounters to the cheerful energy of Rosa

126

Bonheur's *Horse Fair*, which for almost fifty years remained one of the most widely admired pictures of its time. It deserved to be popular. It is composed with great skill by a genuine lover of animals. But it adds nothing to our thoughts on man's relations to animals; it merely confirms the popular view that all is well as long as strength is controlled by skill.

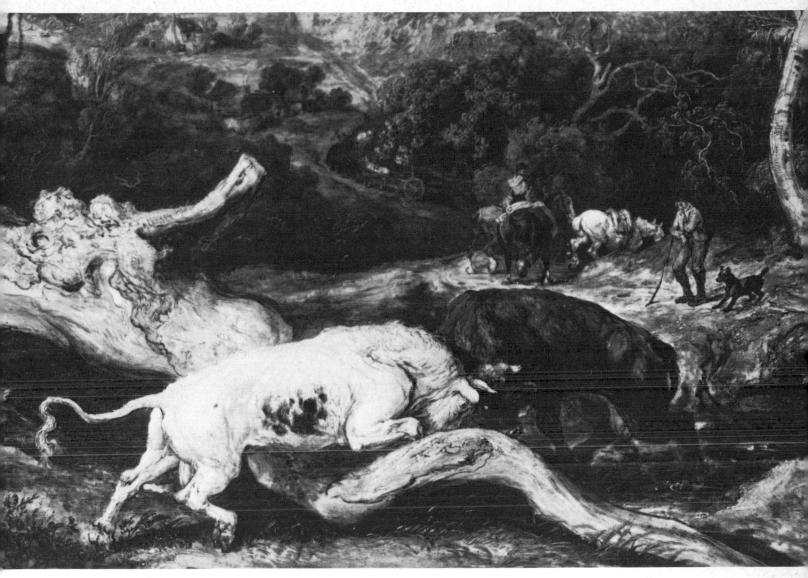

James Ward: *Bulls Fighting* (detail)

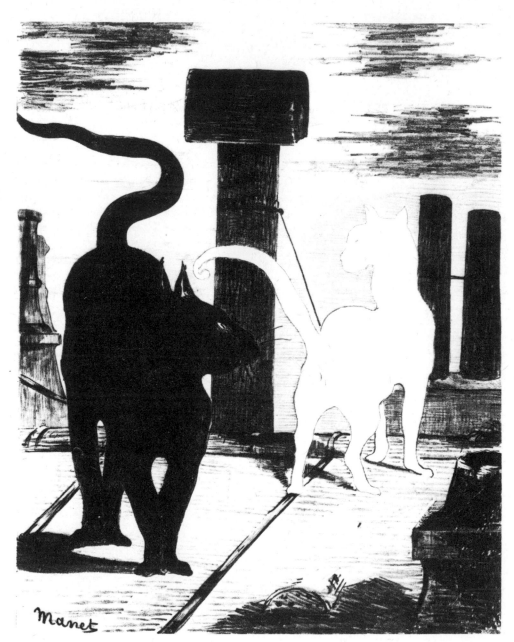

Edouard Manet: *Cats on the Roof*, lithograph illustrating Champfleury's *Les Chats*, 1869.

Animals Beloved

THE LOVE OF ANIMALS is often spoken of by intellectuals as an example of modern sentimentality. I may therefore begin this section by quoting the feelings of a man the greatness of whose mind is not in doubt, Leonardo da Vinci. 'He greatly delighted in horses, and in all other animals, which he controlled with the greatest love and patience, and this he showed when often passing by places where birds were sold, he would take them out of their cages, and having paid those who were selling them the price asked, would let them fly into the air, giving them back their lost liberty.' This well-known passage in Vasari is confirmed by notes in Leonardo's MSS., and particularly by a reference in a book by an early traveller named Corsali who, writing in Leonardo's lifetime of a gentle savage tribe, says that they will not eat the flesh of any living thing, like our Leonardo Vinci. So Leonardo not only loved animals, but, with a consistency rather rare among animal lovers today, was a vegetarian.

But to discriminate in pictures of animals between observation and love may seem too delicate, or at least too subjective, an undertaking. This is outstandingly true in the case of Stubbs, whose Green Monkey and *Hambletonian* could both have been in this section. Nevertheless there is a perceptible difference between the little dogs of Carpaccio or Titian and the drawings of Pisanello, and it is one of some importance in man's relationship with animals. If horses were the heroes of the preceding section, dogs are the heroes of this one. And why not cats? It is a mystery. The number of cat-lovers probably equals the number of dog-lovers, and surpasses them in the intensity of their affections. They play a large part in literature; cats have inspired good poems, dogs bad ones. Cats are also beautiful to look at, and would seem to offer the painter an irresistible subject. But the fact remains that, since the time of ancient Egypt, the number of loving representations of

88
84

72 cats in art is extremely small. Leonardo da Vinci's cats are drawn with more curiosity than love. Chardin's cats are depicted with positive

p44 malice, and Manet's *Cats on the Roof* are scarcely more amiable.

170 Géricault enjoyed depicting the movements of cats, but less as domestic animals than as small specimens of the tribe which includes the leopard and the lioness; and the same is true of a matchless

119 drawing of a cat's head by Delacroix. Almost the only cats that are

162 seen as family friends are the eager, cockney cat in Hogarth's *Graham*

172 *Children*, and a sensuous cat in a picture by Renoir, who felt an affinity between cats and girls. The Franco-Swiss graphic artist, Steinlen, seems to be the only talented artist of the late nineteenth

171 century who has devoted himself to cats. Otherwise they were left to nonentities like Henrietta Ronner. That cats are evasive, independent and in many ways foreign to the human environment which they occupy for their own advantage is possibly true. But why should they have inspired poets, and not painters, except in China?

Dogs, however, do not enter this section until fairly late, and the first masterpiece of sculpture to be illustrated is the sixth-century BC

131 carving of a calf-bearer in the Acropolis Museum. The motif of a herdsman with a calf over his shoulders makes visible the unity of man and animal by a formal integration much more sympathetic than the animal-headed gods of Egypt. Although this is almost the only calf-bearer of Antiquity that has come down to us, there must have been others, for the motif was revived by Christianity, and produced one of

132 the most moving pieces of early Christian sculpture, the *Good Shepherd*, formerly in the Lateran Museum. Several similar representations of the Good Shepherd exist, usually carved by more rustic hands. Then, for no reason that I can discover, the motif disappeared. Was it tainted by pagan associations? Did the close communion of animal and man seem to threaten the Christian doctrine of the unique superiority of the human soul? We do not know, and can only deplore the loss of a theme which could so greatly have enriched the art of sculpture.

From great things I pass to small; because man's affection for animals often expresses itself in minor works of art; what in effect are toys for grown-ups. There is a strong element of play in our relation-

ship with animals. In playing with them we forget the difference that separates us – the faculty of speech. Children would rather play with a teddy-bear than with a small model human being, and they put long imaginary speeches into the bear's mouth. Thus the barrier between animals and men is broken down. This natural communication lasts till adolescence, and sometimes later. How many children going to boarding school mind more about leaving their teddy-bears than their parents? (I am told that they are now allowed to take them.) And how many grown-up people still read Kenneth Grahame's *Wind in the Willows*, and the works of Beatrix Potter, in which they can enjoy the illusion that animals can talk as they do!

Out of innumerable examples of 'animals beloved' as toys I have *133* space only for three, the hippo in blue faience, which was a favourite *134* in ancient Egypt; the Greek sixth-century owl in terracotta; and a *135* bronze piglet from Herculaneum, which, by its vitality and joy, gives me more pleasure than the Hellenistic bronzes of academically perfect young men in the Naples Museum.

There are two unforgettable passages in the Homeric poems which show that the love and understanding of animals goes back to Antiquity. The first, in the *Iliad*, describes the horses of Achilles when they learnt that their charioteer 'had been brought down to the dust by the murderous Hector'. Automadon coaxed them and lashed them freely but the pair refused to move. 'Firm as a gravestone planted on the barrow of a dead man or woman they stood motionless, with their heads bowed down to the earth. Hot tears ran from their eyes to the earth, as they mourned their lost driver.' The other is the moment in the *Odyssey*, when Odysseus, disguised from Penelope and her suitors, is recognized by his old dog: 'There, full of vermin, lay Argus, the hound. But directly he became aware of Odysseus' presence he wagged his tail and dropped his ears, though he lacked the strength now to come any nearer to his master. Yet Odysseus saw him out of the corner of his eye, and brushed a tear away.'

There are beautiful epitaphs of animals in the Greek anthology; but I fancy that the love of animals increased in the Middle Ages, when the arrogance of human reason was confined to clerics, and the

majority of laymen were illiterate. That the contemporaries of St Francis should have been glad to hear him talk of animals as his brothers and sisters must surely predicate, among the simple people to whom the *Fioretti* were addressed, a feeling of kinship with animals which was, and continues to be, repudiated by official Roman Catholic opinion. The story of how he spoke to the fierce wolf of Gubbio and took his paw and make him swear not to molest the people of the town if they in their turn gave him his keep, has an appeal beyond the limits of dogma, or common sense.

We know that a medieval gentleman, when he went to bed, had a *137–139* dog at his feet to keep them warm, and dogs keep that position when their masters have attained the final chill of death. And we know that the Duke of Burgundy, with his usual self-indulgence, had fifteen *140* hundred dogs; and, in the *Très Riches Heures*, two puppies have been allowed on to the banquet table, and are eating out of the plates. In almost the first full-length portrait a small dog occupies the *144* foreground, and Jan Arnolfini's dog introduces us to a new inhabitant of the animal world, the fluffy pet dog, which has continued to share man's affections with the mastiff, or the Great Dane, until the present day. One of them appears, predictably, on one of the unicorn tapestries *143* in Cluny, with the superscription *Mon seul désir*, the most favoured, it would seem, of all the beloved animals in that enchanting series.

142 A fluffy dog has even been allowed into St Augustine's study, where he sits, most unexpectedly, among the armillary spheres and astrolabes, watching the Saint as he sees a vision of St Jerome's death. Who but Carpaccio would have put him there? One could perhaps deduce from Carpaccio's whole approach to life that he loved dogs, and he has left us one of the most completely realized dogs in painting, who sits at *141* the feet of a seated courtesan, in the picture in the Correr that Ruskin praised so extravagantly.

The other predictable dog-lover in Italian art is Paolo Veronese. In at least six of his magnificent compositions, including the *Last Supper*, a dog – usually a large dog – is much in evidence. When Armstead carved his admirable frieze of painters on the podium of the Albert Memorial, Paolo Veronese was the only one to be allowed his dog.

The best-loved dog of the Renaissance is in Piero di Cosimo's
147 picture known as the *Death of Procris*. The dead girl lying on the
ground is mourned by two creatures, a faun with goat's legs, half
animal, half man, who touches her tenderly, and a dog, who looks at
her with a human sorrow and gravity. Of all Renaissance painters the
misanthropic Piero di Cosimo seems to have had the greatest sympathy
with animals, and he has left us one picture in which animals are the
145 sole protagonists. This is the *Forest Fire* in Oxford, one of a series
illustrating the early history of mankind, which Piero had deduced
from Lucretius and Vitruvius, and perhaps from his own reflections.
But, although man has not yet fully emerged, one finds among the
bulls and bears some deer and pigs with human faces. The integration
of animals and men that had obsessed the Egyptians is working in
Piero di Cosimo's mind, and led him to paint a cruel and violent vision
of the *Battle of Centaurs and Lapiths* in the National Gallery. These are
the fierce centaurs of early Greek mythology, who still appear on the
metopes of Olympia; but through the influence of Homer, and his
description of the wise centaur, Chiron, the tutor of Achilles,
Antiquity and the Renaissance began to take a kindlier view of this
half human animal, and nowhere is this given more touching
expression than in Botticelli's picture in the Uffizi of a centaur being
146 instructed by Minerva. The goddess, gravely beautiful, touches the
hair of his human head, and he looks back at her with an expression
in which gratitude and awe are troubled by some fear that the gift of
reason, flowing from the goddess's fingers, may complicate his animal
nature.

Jan Arnolfini's decision that his portrait should include his little
dog who, unlike his wife, was obviously painted from life, was to
appear in many portraits of the next century. I offer as examples
155 Titian's portrait of Clarice Strozzi where (as in the Graham children's
cat) the little dog shows more animation than the child, and the
154 superb portrait of Giovanni dell' Acquaviva in Kassel. The practice,
continued into the next century, produced in the work of Velasquez
some of the best portraits of dogs ever executed, the hunting dogs that
157, 159 accompany the Cardinal Infante Don Fernando and Prince Balthasar

Carlos. No dog in painting is more confident of being loved than the small, bright companion of the Infante Felipe Prospero. But Velasquez could see further than that. The saturnine animal that sits in front of

160 the dwarfs in *Las Meninas* is not only the greatest dog in art but a somewhat disturbing commentary on the gentle, courtly scene depicted. He seems to echo the contempt of the disdainful dwarf (Maribárbola) behind him. As usual, that inscrutable artist leaves us in doubt about his true meaning. English eighteenth-century portrait painters, no doubt inspired by Titian, continued the practice of giving their sitters dogs as companions. The most stylish is the foxy

163 white animal in Gainsborough's *Perdita Robinson*. I cannot fit it into any modern classification of dogs – it comes nearest to a White Spitz – but it has an air of breeding and we feel that it could win an award at Crufts. But was it really Perdita's dog? It appears again in

164 Gainsborough's double portrait known as the *Morning Walk*, and is the

165 subject of a picture in the Tate Gallery that must be one of the earliest portraits of dogs on their own and seem to have belonged to Gainsborough's friend Abel. At any rate, he loved painting it so much that he could not keep it out of his most important commissions.

167 By contrast the dog in Reynolds' *Miss Jane Bowles* really belongs to, and is deeply loved by, its owner. This enchanting picture realizes perfectly the close, warm-hearted relationship between an animal and a child.

Sentimentality, in which feelings are exaggerated and cheapened to increase their popular appeal, was not unknown in the eighteenth century, but in the nineteenth century, with the growth of a wider public, sentimentality became rampant, and naturally made itself felt in the representation of animals. It was accompanied by the rather irritating habit of investing animals with human characteristics. This was sometimes attempted with horses, but of course the chief victims were dogs, and the most successful practitioner was Landseer. In the

168 mid-nineteenth century *Dignity and Impudence* was statistically the most popular animal picture ever painted. It is vulgar. But left to himself Landseer was a fine artist, and even one of his most sentimental

169 pictures, *The Old Shepherd's Chief Mourner*, seems to me, at a certain level, a moving work.

It is sometimes said that the love of dogs is more intense in England than anywhere else; but this is an illusion. There are many passages in Turgenev's *Sportsman's Sketches* which go at least as far as anything to be found in English literature in their love of dogs and horses. Nevertheless there are countries where, for no clear reason, dogs are despised. In Semitic countries they are considered unclean – 'Is thy servant a dog that he should do this thing?' – and the little dog that accompanies Tobias on his journey is a proof that this folk-tale is of Persian origin. In India and most Moslem countries they lead a dog's life. And even in Catholic countries they come in for harsh treatment from simple people who have been told that they are without souls. As the Neapolitan says when reproved for beating his donkey, 'Perche no? Non e christiano.' I have also known some very intelligent Englishmen who rebel against the Anglo-Saxon obsession with dogs. They would be shocked by that remarkably intelligent and unsentimental woman, Edith Wharton. Asked to draw up a list of the seven 'ruling passions' in her life, she put second, after 'Justice and Order', 'Dogs'. 'Books' came third. But in a diary entry she wrote a beautiful modification of her feelings: 'I am secretly afraid of animals – of all animals except dogs, and even of some dogs. I think it is because of the *us-ness* in their eyes, with the underlying *not-usness* which belies it, and is so tragic a reminder of the lost age when we human beings branched off and left them: left them to eternal inarticulateness and slavery. Why? Their eyes seem to ask us.'

The death of the boar, from the Giovannino de' Grassi sketchbook.
The same original model was used by the Limbourg Brothers for their illustration
to December in the *Très Riches Heures* (pl. 187).

Animals Destroyed

WE LOVE animals, we watch them with delight, we study their habits with ever-increasing curiosity; and we destroy them. We have sacrificed them to the gods, we have killed them in arenas in order to enjoy a cruel excitement, we still hunt them and we slaughter them by the million out of greed.

174 I mentioned animal sacrifice in the first section, because it is inseparable from our early view of animals as sacred or symbolic counterparts to ourselves. But I may remind the reader of the enormous scale on which it took place from early times. In the *Odyssey* no feast, no landfall, no hospitable welcome, no gift-laden departure, is conceivable without the sacrifice of animals. When Telemachus came to Pylos he found people on the shore, sacrificing jet-black bulls to Poseidon. There were nine companies present, and every company had nine bulls to offer. Even allowing for poetic symmetry it is clear that Homer's audiences were used to sacrifice on a considerable scale. The Emperor Julian, an intelligent and philosophically-minded man, when he sought to reintroduce paganism in place of Christianity, tried to please his gods by greater and still greater sacrifices, so that even his followers were disturbed to see their Emperor come from the altars streaming with blood; and the Parthenon is said to have stunk like a slaughterhouse.

Animal sacrifice is one of those human institutions that turn out to have been a complete delusion. It had continued for thousands of years. It had seemed to be inevitable. Pious men thought that without it all relationship with the divine would collapse. Then in about fifty years it ceased, and no one was a penny the worse. It was soon forgotten and anyone who sacrificed an animal today would be considered a madman.

But hunting is a different matter. It seems to satisfy some

ingrained human instinct and has persisted in various forms till the present day. It started as a necessity; primitive man hunted in quest of food. But when, through animal husbandry, man's appetites could be satisfied in a more reliable manner, hunting became what it has remained ever since, a ritualized display of surplus energy and courage. It has always been closely identified with social status. The greatest hunters were emperors and kings, who annexed vast areas, like the New Forest, for their sport; then we gradually descend the social ladder, through dukes to great landowners, till finally we come to Jorrocks. It remained, even at its lower levels, an excuse for dressing up and showing off. However much one loves animals one cannot altogether reject hunting; it has given vent to so much that has enhanced the quality of human life. But we may argue that it has varied throughout history in the degree of cruelty it has inflicted. The visible records of hunting sometimes revolt one by their brutality, sometimes delight one by their gay and elegant conviviality.

The early Egyptians were not great hunters. There are very few hunting scenes in the Old Kingdom reliefs, except those undertaken
177 to obtain food. There are frequent attacks on the hippo, but perhaps he would have become a nuisance if his numbers had not been controlled; and, as we have seen, he was also regarded with humorous affection. Hunting does not seem to have been an obligatory part of the pharaoh's assertion of power, as it was to be with so many later rulers. Was it not a pharaoh, albeit a very eccentric one, who wrote of animals with a piety never equalled till the time of St Francis? There are a few wall paintings of conventional hunting scenes, like that of
176 Userhet, and one beautiful relief in Abydos, where Seti and his son pursue a bull, with more grace than ferocity. Ramasses II, whom one would have expected to be as devoted to hunting as Louis XIV, seems to have had no time for it. Among the interminable reliefs of Karnak I cannot recall a single hunting scene. Ramasses III, on the other hand, together with the other characteristics of imperialism,
175 hunted like an emperor; and at Medinet Habu appears in a hunting scene which antedates and surpasses in splendour those of Mesopotamia and Persia.

In the Mesopotamian countries hunting was an assertion of power greater, perhaps, than in any other early civilization. 'Nimrod was a mighty hunter.' The words were obviously written with admiration, and by an extraordinary chance we have, from Nimrud itself, the greatest series of hunting scenes ever executed, the lion-hunt reliefs of Assurnasirpal, and those of Assurbanipal from Kyunjik.

p34

173

178–179

No one knows the origin of Assyrian art, or can explain why for over two hundred years it produced relief carvings that far excel in richness and vitality the carvings of Persepolis. The sculptors who executed these reliefs were employed to depict the invincible power of the Assyrian kings, whose armies fell like a deluge on their enemies, destroying, with brutal expertise, everyone who opposed them. But, from the first, they are mysteriously obsessed by lions. I say 'mysteriously' because the lion had been one of the sacred animals of the Mesopotamian countries, and to make its destruction the chief motif of these reliefs is hard to explain. Had it, as is sometimes maintained, changed its status from protector to symbolic enemy? Or was lion-hunting simply the accepted royal occupation? The fact remains that on these Assyrian reliefs, executed over a period of more than two hundred years, the depiction of lion-hunts produced a series of masterpieces unsurpassed in the ancient world. The lions of Assurnasirpal still maintain some of their symbolic majesty. But those in the lion-hunts of Assurbanipal achieve a realism which is terrifying and tragic. There must have been some individual artist of genius in charge of the workshop that produced these miracles of pitiless observation. Assurbanipal is on record as saying that there were too many lions in Mesopotamia, and it was his duty to exterminate them (in fact the last lion killed there was in 1897). However, this did not prevent him from having them captured, caged and released for him to kill like a visiting grandee shooting a tiger in India, although it is doubtful if a distinguished personage was ever so closely assailed by tigers as Assurbanipal is depicted as being by his lions (nor, perhaps, was Assurbanipal).

After the great hunting scenes of Assyrian art the subject ceased to be a source of inspiration to artists. Although there are references to

hunting in the *Odyssey*, I cannot think of a single representation of a hunt in Greek art. In Roman literature it inspired a famous passage in the *Aeneid*, the royal hunt of Dido and Aeneas; but in the visual arts it appears only in coarse routine mosaics, of which the most extensive are at Piazza Armerina in Sicily. As hunting, save for the mystic experience of St Eustace, plays no part in Christian legend, it is excluded from Byzantine or early medieval art. Then, in the first decade of the fifteenth century, the Occupations of the Months came like a fresh breeze into the enclosed world of Christian iconography, giving a pretext for the depiction of ordinary life. The most marvellous of all Occupations of the Months are in the *Très Riches Heures* of the Duke of Berry, illustrated by the Limbourg brothers between about 1410 and the year of their death from a plague, 1416. One of these, December, represents the climax of a hunt, where the dogs, beautifully realized, savagely devour a boar. The boar is almost entirely hidden by his attackers, and we do not feel pity for him; only rather disturbed by the violence of the dogs.

And here I may be allowed a short digression to point out how often in the visible record of animals destroyed the destruction is practised by one animal on another. No doubt it came from a deep layer in the human consciousness and did not merely express pleasure in violence. The motif of a lion devouring a roe deer appears almost as a matter of course at the corners of Roman sarcophagi not simply as an allusion to the death but a symbol of the power of the soul, which triumphs over the feeble apathy of the body; and it is in this sense that the motif was revived in the thirteenth century by the Pisani. There are two devouring lions by Nicolo, at the bases of his pulpits, in the Baptistry and the cathedral of Pisa, but they are surpassed by the marvellous image of devouring in Pisa by his son Giovanni, where that great artist (the closest parallel in the visual arts to Dante) leaves us in no doubt that he has understood the inner meaning of what might, at first sight, look like a cruel assertion of strength. Indeed the devouring lion, however Christianized, cannot be altogether dissociated from the sacred lions of Persia or Mesopotamia, who owed their sanctity to their strength. We can see how deeply this

emotional attachment to the physical power of animals lay dormant in the human mind when we find the subject revived by the hard-headed Stubbs, and we remember Blake's proverb of almost the same date 'The wrath of the lion is the wisdom of God.'

191 The complete antithesis of Assurbanipal's lion-hunt is a picture in Oxford of a stag-hunt by Paolo Uccello. There is no oppressive grandeur. The hunters are gay young Florentines and their retainers, as sprightly and energetic as the figures on a Greek vase. There is no hint of brutality and only the remotest evidence that a stag has been killed. The hounds bound along beside the stags in and out, as if performing some exquisite dance, till they vanish into the darkness of the thick green wood. If hunting were really like that we could not fail to love it. The equivalent scenes by Lukas Cranach are grander and more formal, and presumably represent the hunts of his patrons, the Electors of Saxony. Several versions came from Cranach's workshop,

190 and in one of them we see that the ladies have been allowed to witness the pleasures of the chase. It was all a kind of pageant, and I doubt if their compassion was aroused by the sight of the dying animals, as Dürer's was when he drew the wounded stag on pl. 189.

 The most moving of all representations of a hunt is the series of tapestries already referred to, representing the hunt of a unicorn. After appearing as an almost sacred animal and a symbol of purity, he

188 is done to death with singular brutality. In general, however, hunting was considered a festive occasion, in which the pursuit and death of a few animals was of little importance compared to the pleasure it gave to a quantity of human beings, and there arose a much quoted paradox that hunters are the only men who really love animals. We remember the beautiful passage in Turgenev where he describes how the sportsman enjoys a communion with nature denied to those who simply roam the fields or work in them. No doubt the painter

200 Desportes saw himself in this light when he depicted himself *en chasseur*, with his two adoring dogs beside him, and a pile of dead game, several partridges, a duck and a hare at his feet. In the same

199 spirit Oudry depicted two dead animals of singular beauty, a roe deer and a swan, watched over by the master's dogs. We see that the

picturesque aspect of hunting survived long after guns had replaced bows and arrows. The Musée de la Chasse in Paris is filled with beautiful examples of craftsmanship and charming decorative pictures. Visiting it the word 'barbarous', as applied to hunting, dies on one's lips.

In England the fox, rather than the stag or the boar, became the national object of hunting, and, although an English fox-hunt is less gorgeous than the courtly hunts of the Continent, it produced a brisk, jolly, extrovert style of its own and involved considerable courage.

192–194 It also produced a school of painting and at least one artist of real distinction, Ben Marshall. But, whatever their merits, English sporting painters were a provincial phenomenon, segregated from the main course of European art. One cannot imagine a hunting scene in the work of Turner or Constable, Monet or Cézanne. But one great painter in the middle of the century expressed with gusto the love of hunting which by his time had descended from the aristocracy to the common man. This was the omnivorous Gustave Courbet, who not

198 only enjoyed painting dead animals in the snow, but entered heartily into the moment of the kill. Courbet certainly exemplifies the paradox of the animal-loving hunter, for his beautiful picture of stags by a stream in the Louvre was painted in the same year as the *Hallali du*

206 *Cerf* in Besançon, which Courbet said he much preferred. Perhaps no pictures like that will ever be painted again. The artist has become, almost by definition, the man of sensibility, and Courbet's hearty appetite for every aspect of life must seem to us an enviable anachronism.

Of all the ways in which animals have been destroyed, the most revolting has been when made the victims of a cruel public spectacle. This form of commercial sadism seems to have survived in Rome till the fourth century, that is to say, till long after Christianity had become the official religion. Perhaps only the sack of Rome by Alaric in 410 put an end to it. It would not be tolerated now; but we need not be smug about this change. To witness cruelty and take pleasure in it lies deep in the human psyche, and, although crowds can no longer enjoy the spectacle of bear-baiting, they can watch the

increasing and ever more ingenious cruelties shown on the movies.

The chief surviving example of conflict between men and animals is, of course, the Spanish bull-fight. It seems to represent such a fundamental need of the Spanish people that they have given it an almost religious significance. It is tempting, but unhistorical, to relate the Spanish bull-fight with the Cretan festival or the Mithraic sacrifice. Apparently bull-fighting was introduced into Spain by the Moors, who held *corridas* in the half-ruined Roman amphitheatres of Andalusia. The sport became a ceremony as early as the eleventh century, and a source of rivalry between Moorish and Christian warriors. It was so highly considered that the Emperor Charles V personally killed a bull to celebrate the birth of his son Philip, and, although it later became a popular spectacle in which the bull-fighters were usually professionals, it retained the formalities of an aristocratic ritual. It was essential that somebody should be (or, at least, could be) killed, either the matador or the bull (the disembowelled horse was an accessory). In places where the kill has been prohibited, Portugal and southern France, the bull-fight is not only less popular, but loses its quasi-religious character. I share the conventional English feelings about bull-fighting, but I recognize that it expresses more seriously than pheasant-shooting or fox-hunting the ancient, two-sided relationship with animals as symbols of life and death. No one has ever been killed by a pheasant or a fox, but every bull-ring has its hospital for the wounded, and its chapel where the *toreros* receive the Holy Eucharist.

We have a vivid record of bull-fighting, since two great Spanish artists, Goya and Picasso, have been *afficionados*. Lovers of art who *201–202* glance through the prints in Goya's *Tauromaquia* are often surprised to see how much more prosaic they are than his other etchings. This is because it was not intended for lovers of art but for lovers of bull-fighting. It is a serious study, illustrating stages in the early history of the art, giving due prominence to its Moorish origins, and recording the most memorable feats of skill and daring. Only occasionally does he indulge that zest for cruelty which marks so much of his other work. In one of them the defiant bull, who has already killed a few

of his tormentors, is surrounded by men with lances intent on hamstringing him. The men are ugly, cunning and cruel – real Goya characters. Our sympathies are with the bull. In another a bull has gored a horse, and the scene has moved Goya to the kind of dramatic presentation that we find in his *Disparates*. Goya concentrates on the bull. Picasso is interested almost entirely in the *toreros*, and he looks with interest only at the bull's head, but he has left some lively

203 sketches of bull-fights which reveal his spontaneous delight in the dramatic ritual.

The last and far the largest element in the destruction of animals is comprised under the heading Greed. There is defensible greed, and conspicuous greed. Animals eat each other, and we eat animals. It seems to be a law of nature, and those who refuse to conform to it, from Leonardo da Vinci downwards, are an honourable, if inconvenient, minority. The overwhelming majority eat their kinsmen without a thought. They do not think of the stockyards and slaughter-houses which, in most places, are kept decently out of sight. They look with rapture at the new-born lambs without considering why in the end they are there. 'Little lamb, who eat thee, Dost thou know who eat thee?' Almost the only great picture of an animal being

205 slaughtered is Jean François Millet's *Death of a Pig*. It was complemen-
207 tary to his touchingly beautiful *Birth of a Calf*; and we share his feelings of horror and love. But on reflection we realize that the calf in its turn will be slaughtered. In these matters we are governed solely by our feelings, and not by our reason. There is no rational explanation why in England it is considered unkind to shoot any small bird except the snipe, whereas in Italy small birds are fair game.

But when we pass from the destruction of animals for food, to their destruction as a source of money-making, we may be permitted a different stance. Perhaps the oldest and most enduring of these activities has been the slaughter of elephants for their tusks, which in Africa has almost led to their extinction. But in the seventeenth and eighteenth centuries the fur trade began to take toll of a wide variety of animals; and in the nineteenth century took place the most colossal

204 slaughter of all, the attack on the American buffalo. It is said that sixty

million buffalo were reduced to three thousand. Buffalo Bill became a folk hero. As mechanical skills increased, the harpooning of whales became equally menacing to the survival of these intelligent and, for the most part, harmless animals.

The relations of men and animals, which had been a haphazard mixture of love, exploitation and destruction, provided some natural balance such as existed in the animal world itself. In the nineteenth century it became an all-out war. At the same time, those who did not profit directly from killing animals became more sentimentally attached to them, and the knowledge of animal behaviour increased to a point undreamed of by earlier naturalists. People became aware that whole species of animals were in danger of being wiped out. The idea of animal conservation appeared just in time; and it will need more than knowledge and devotion if it is to succeed. In spite of all our researches, observations and statistics, we are still capable of making, with the best intentions, disastrous mistakes. The balance of animal life, evolved over many thousands of years, cannot be re-adjusted in half a century. Man's new role as neither the worshipper nor the destroyer of animals, but as a kind of governess, is beset by dangers, and often reminds one of charity in the nineteenth century. What is needed is not simply animal sanctuaries and extensive zoos, but a total change in our attitude of mind. We must recognize that the faculty of speech, which has given us power over those fellow creatures whom we once recognized as brothers, must carry with it a proper measure of responsibility. We can never recapture the Golden Age; but we can regain that feeling of kinship which will help us establish a feeling of the unity of creation. It is a faith we all may share.

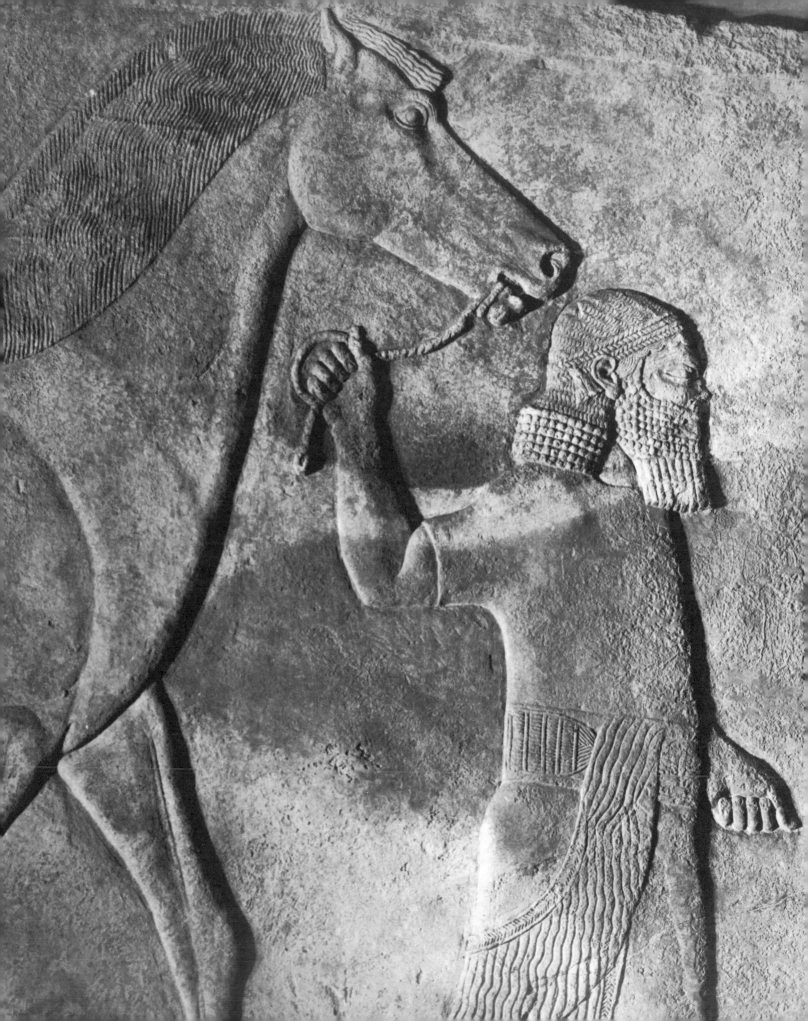

The plates

Horse led by a groom, Assyrian relief from Kyunjik, seventh century BC.

Sacred and Symbolic Animals

1

A Golden Age

in which man lived in harmony with all creation is a myth that has a universal and largely unconscious appeal. It is found in many cultures, and lies behind the story of Adam in Paradise. To the medieval Christian, animals belonged to a world of primeval innocence; hence, perhaps, their unexpected and sometimes (in our eyes) incongruous appearance in the margins of manuscripts. Since God did nothing without a purpose, each animal carried a moral lesson for man to learn or carried a symbolic message. 'Christ is represented in the form of a lamb,' wrote St Paulinus in the late fourth century; 'the voice of the Father thunders from Heaven; and through the Dove the Holy Spirit is poured out . . . The Cross and the Lamb denote the Holy Victim.' This detail (left, *1*) is from a sarcophagus of about 500 in Sant' Apollinare in Classe, Ravenna. In the page from the Holkham Bible Picture Book (*2*), God the Father with an imperious gesture calls forth an assortment of birds, mammals and fish. The mammals are less sharply characterized than the birds, which include goldfinch, parrot, swan, crane, peacock, owl, pigeon and magpie. Each is carefully drawn, but is probably taken not from life but from a sketch book like that illustrated on p. 106.

...res be e laus le n n... nonu Car purlui tut efet. Ceel ז tere fundu ז cil
Ci... ue efeit faunluf nonu Car purluf tut efet. Ceel ז tere fundu ז cil
Cum ele penfoit ז le voufit. Beeu tot fu feet ceo dint lescrit. Rien ne fift de
fa mefu ffors home ז femme ceo forez certein. Tutes chofeſ ſi feſoit fluriſt
Et tut ele feſoit pur home ſeruir

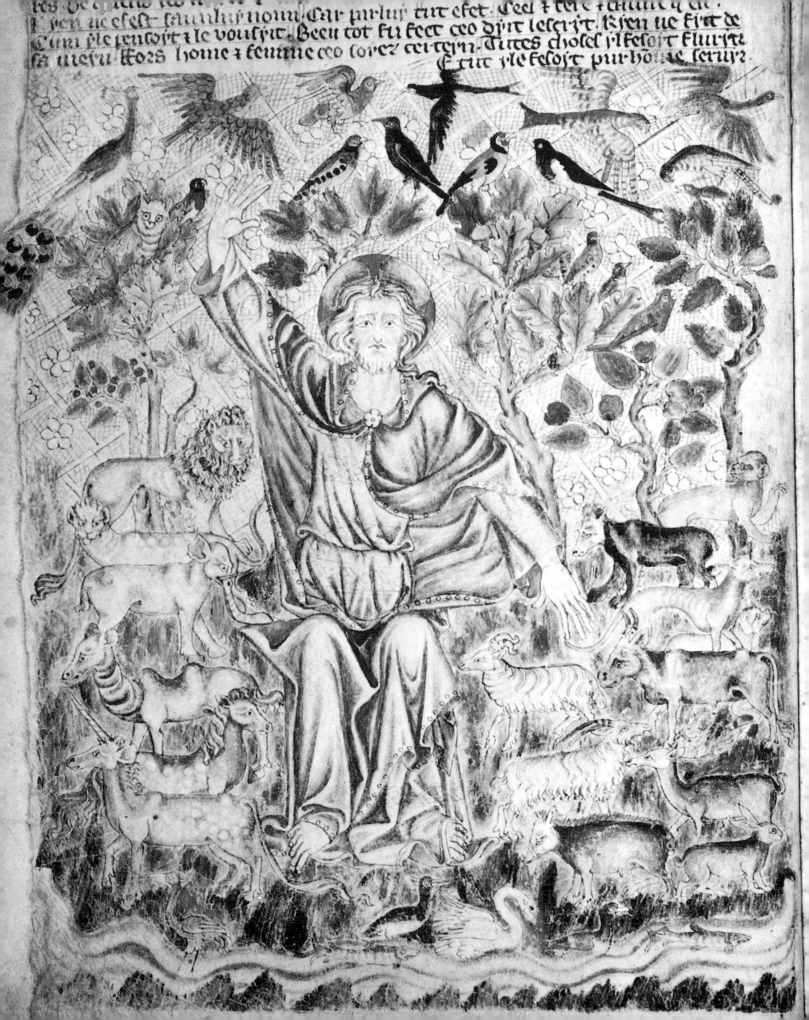

The Flood

is one of those events which stress the fact that man and animals share the same world and the same fate. Jacopo Bassano, a painter who was naturally drawn to animal subjects and whom we shall meet again later, seizes the opportunity to paint what is in effect a hymn of celebration to that common world. Bassano and his family have been underrated because they concentrated so much on animal painting. Seen in longer perspective, however, it is clear that they were among the pioneers in the movement to free Renaissance art from historical and religious subjects and allow artists to look at the real world around them. They were among the first outstanding landscape painters. (3)

3

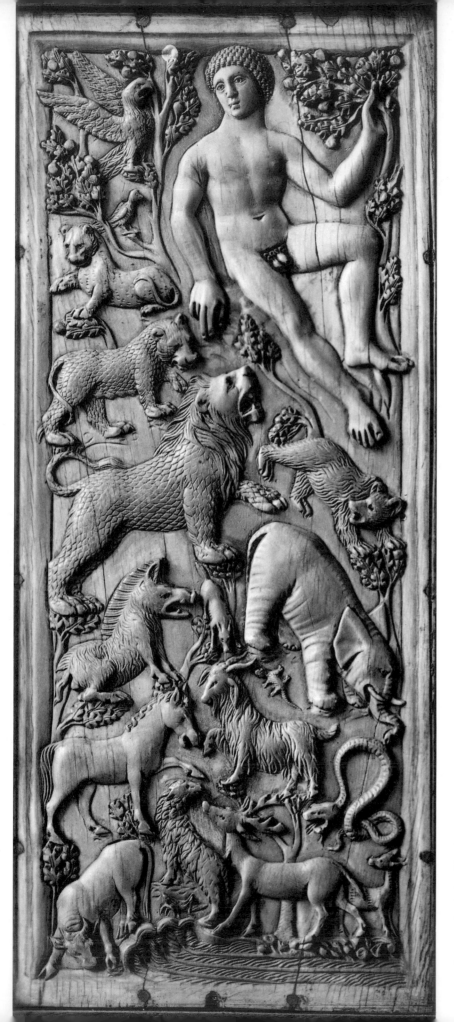

A lost paradise

to which man might hope to return through faith and merit, was one of the myths that passed almost intact from paganism to Christianity. In Greek religion it was the central belief of the Orphics, a sect going back to the sixth century BC, who worshipped Orpheus, the legendary Thracian bard. Orpheus' singing and playing on the lyre was so enthralling that savage beasts (including the dragon that guarded the Golden Fleece) were charmed and became docile. The mosaic on the right (5) dates from the third century AD and was discovered in Sicily. In the period when Christianity was slowly attracting the adherents of other religions, Christ took over some of the attributes of Orpheus, and the myth of the Golden Age was associated with Adam in Paradise. This fourth-century ivory (4) has the same feeling of the harmony of all creation and of dreamy happiness. It represents the scene of Adam naming the animals, 'and whatsoever Adam called every living creature, that was the name thereof'. The emphasis on language is significant, for it was above all through speech that man became separated from the rest of the animal world.

4

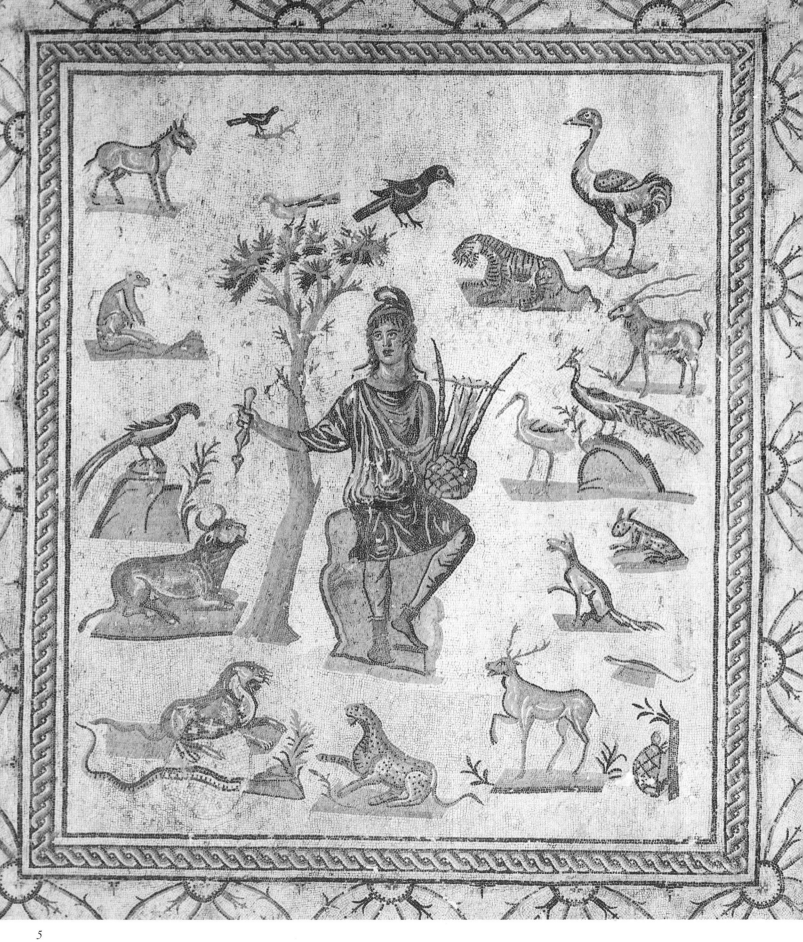

5

6

The strange story of St Eustace

has roots that probably go further than the
meaning given to it by Christianity. Eustace
was a pagan Roman soldier addicted to
hunting. One day the stag that he was
chasing turned, 'and when he looked upon it
carefully, he saw between its antlers a holy
cross . . . and on it the image of Jesus Christ'.
Eustace thereupon embraced Christianity, but
this brought down on him the wrath of the
Emperor Hadrian. With his wife and family
he was ordered to be thrown into a den of
wild beasts, but the animals would not touch
them. Pisanello's painting of about 1440 gives
the scene of the confrontation an added
meaning by including a host of other animals
in the dark depths of the forest: it becomes a
parable of the unity of God's creatures. (6)

Animals share

in the universal harmony that prevails before
Adam eats the apple; they will share too in
the discord that succeeds it. Lucas Cranach
the Elder follows medieval precedents in
almost all respects in his composition, which
places Adam and Eve on each side of the Tree
of Knowledge, in whose branches lurks the
snake. Around them animals and birds play
peacefully, and the hart, as we are told in the
Psalms, 'panteth after the water brooks'.
It is easy to forget that in 1526, when this
picture was painted, the nature of the Fall, of
man's guilt and of his ultimate redemption
were hotter issues than at any time since
Constantine. Cranach was a Protestant, court
painter to the Elector of Saxony and a close
friend of Luther. (7)

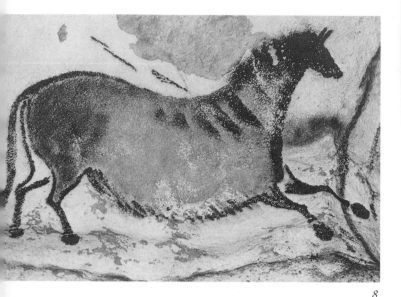

8

The first record

of man's reactions to the animal world is in
the cave-paintings. Not surprisingly, animals
were the most important element in human
life. At Lascaux, the most extensive and
best-preserved site, vivid though by now
almost indecipherable representations of
bison, horses, deer, mammoth and other
animals cover the walls in their hundreds.
Why? Were the images intended to bestow
power over the animals, like the wax models
that witches stick pins into? That has been the
favourite explanation of archaeologists, but
there is nothing to prove it. It is surely just as
likely that the men of Lascaux were express-
ing a sense of admiration for animals, of
humility in the face of their strength and
speed. If animals are seen as man's superiors
rather than his prey, the cave-paintings lead
naturally to totemism, the worship of an
animal as the symbol of a human tribe. (*8, 9*)

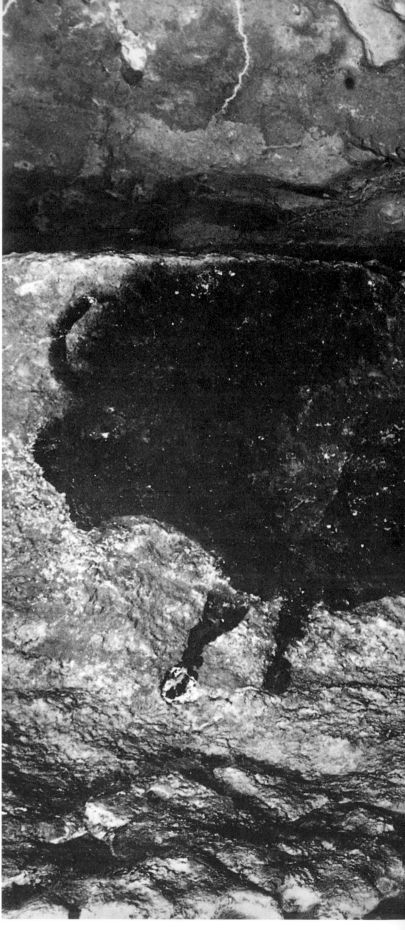

9

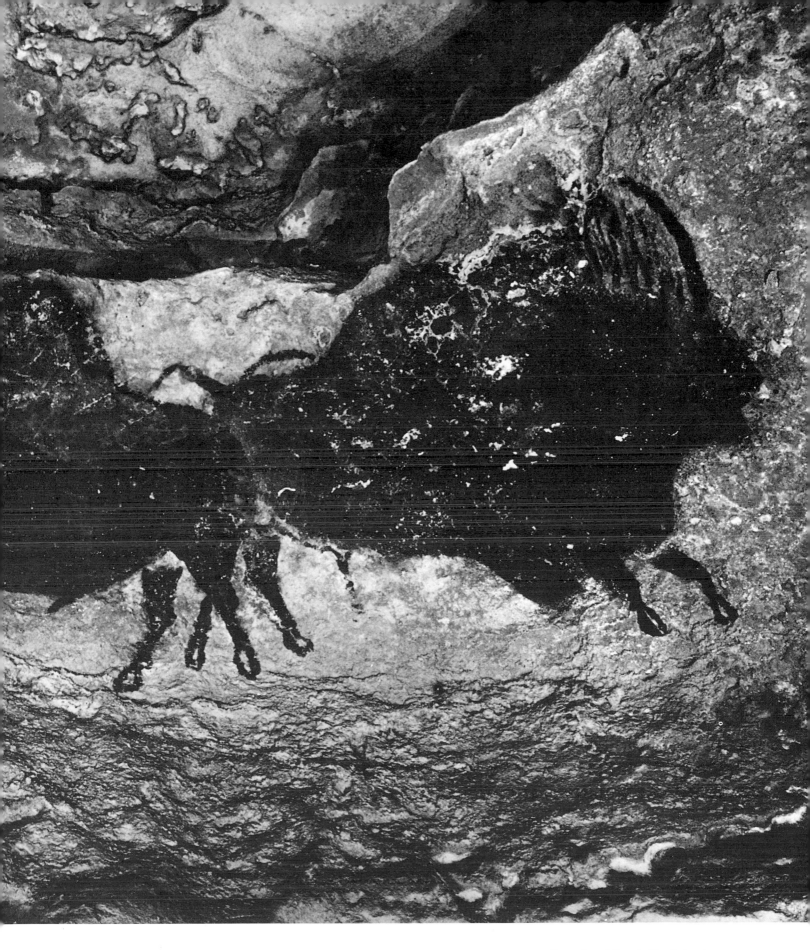

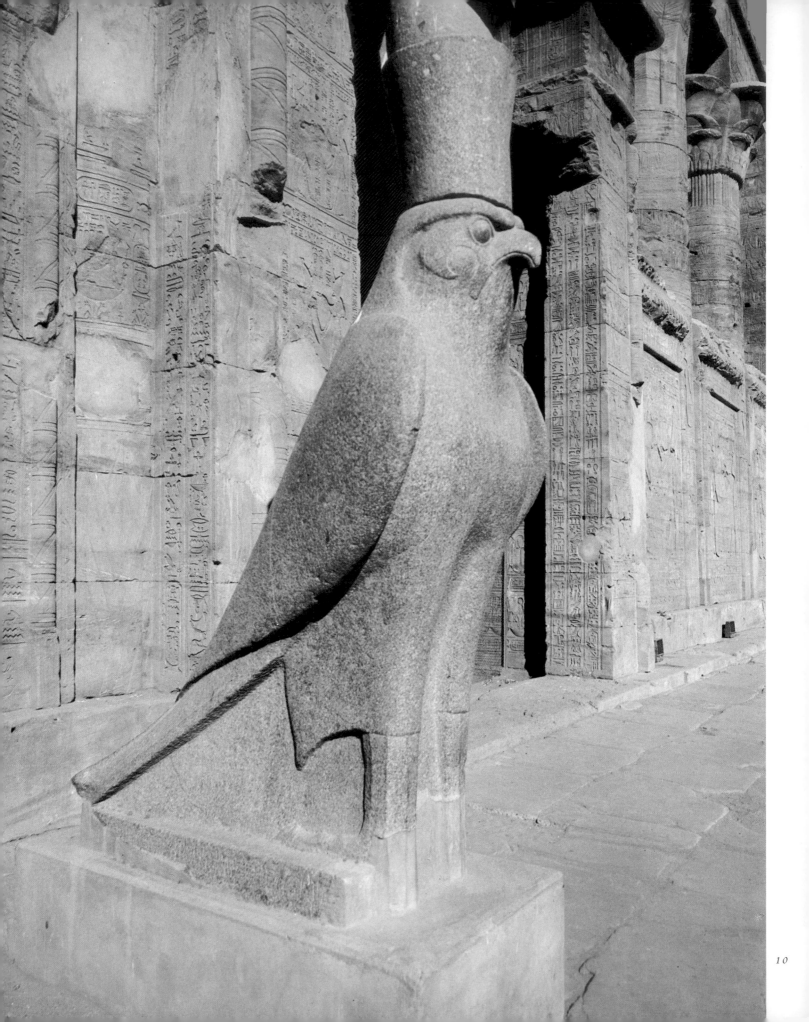

Totemism became religion

in ancient Egypt. Nearly all Egyptian deities have zoomorphic forms, sometimes a bewildering variety of them. The totem animal continues to be regarded as sacred, but now carries more sophisticated ideas concerned with supernatural, physical and moral forces. Sometimes the resulting image is wholly animal, sometimes wholly human, most often a mixture of the two. For some reason, the animal-headed gods of Egypt are harder for us to accept than the animal-bodied creatures (centaurs, harpies and mermaids) of Greek and later mythology.

On the left (10) is Horus, the falcon, a granite figure in the courtyard of his temple at Edfu. Horus was among the most ancient of the Egyptian gods; the ideogram of the falcon denotes 'god' in the earliest form of hieroglyphics. Attempts to construct a consistent 'theology' out of the Egyptian pantheon, however, are doomed to failure because each deity is an amalgam of disparate local beliefs, which were often combined in contradictory ways. But for the Egyptian artist, as for ourselves, it was enough that they embodied an aspect of the divine. Many of them have a majesty and a power unequalled in the art of other cultures.

Below (11): the ibis, one of the incarnations of Toth, who was also an ape (see next page) and a cat. He was often represented as an ibis-headed man surmounted by a crescent moon. This example, of silver and gilt wood, is of the first century BC.

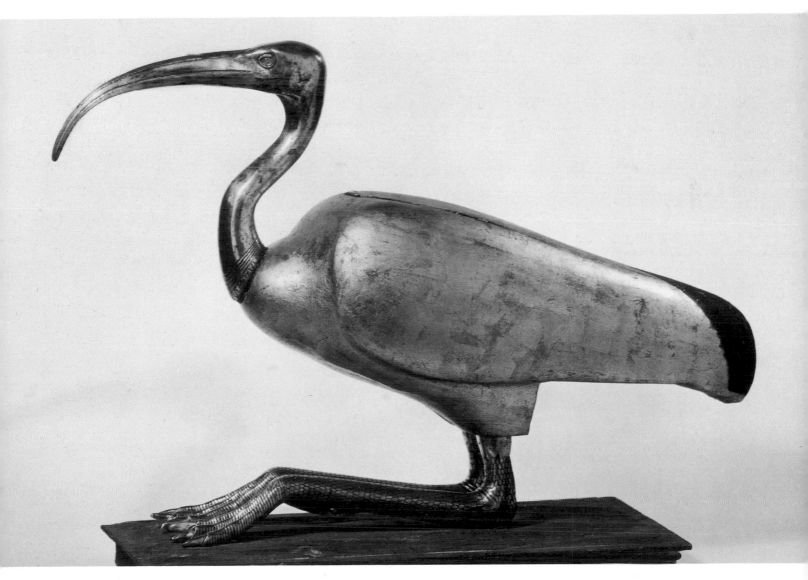

11

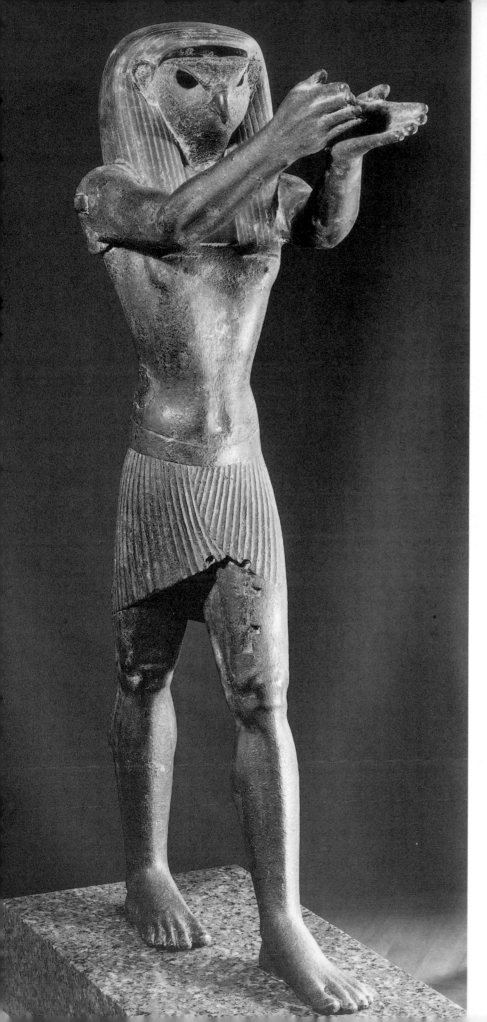

'Of wild animals

there are not a great many in Egypt', says
Herodotus, 'but such as there are, are without
exception held to be sacred. Anyone who
deliberately kills one of these animals is
punished with death. Should one be killed
accidentally, the penalty is whatever the
priests choose to impose. But for killing an
ibis or a falcon, whether deliberately or not,
the penalty is inevitably death.'

The animals shown here are the falcon, the
ape and the cow – Horus, Toth and Hathor.
Horus (left, *12*) is making a purificatory
gesture at the coronation of a pharaoh.
Above (*13*): an alabaster figure of Toth,
marked with the name of King Narmer
(*c*. 3000 BC) and hence known as 'King
Narmer's Ape'. It is the earliest known
large-scale Egyptian sculpture. Toth stood
for knowledge, science and magic, and his
chief centre was Hermopolis. The Greeks
identified him with Hermes, and he is
ultimately the 'Hermes Trismegistus' of the
Middle Ages. Opposite (*14*): Hathor,
watching over the Pharaoh Psammetichus I,
572–525 BC. Hathor was the protector of
women, the goddess of love and of
intoxication.

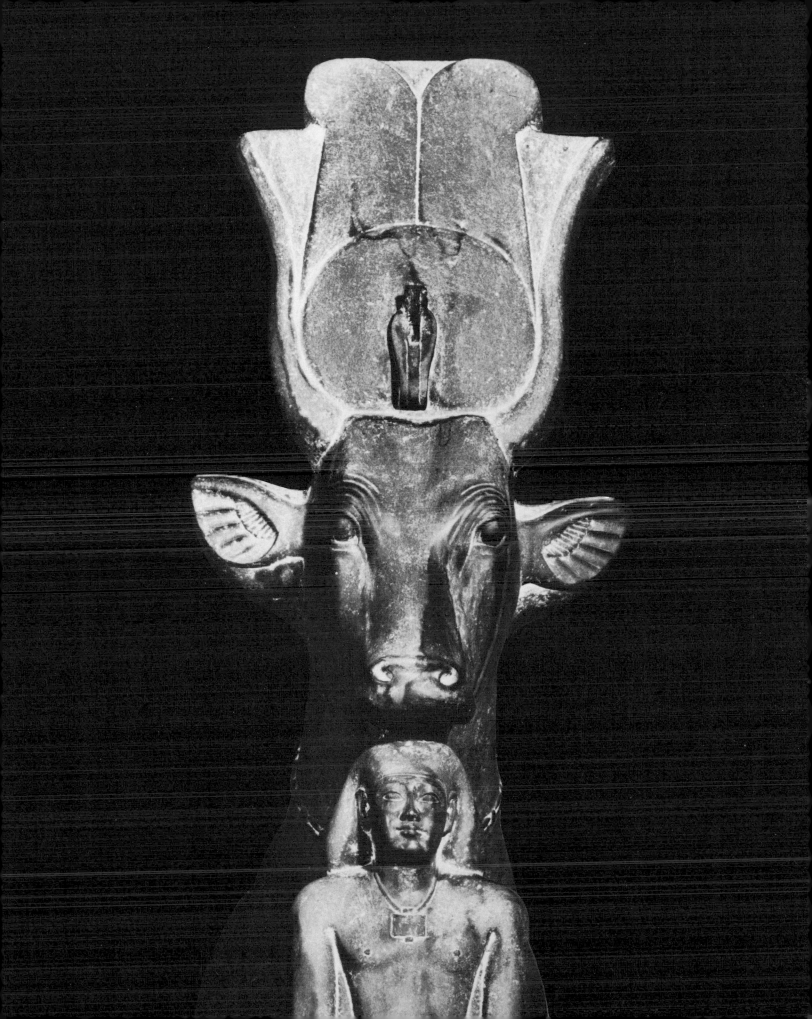

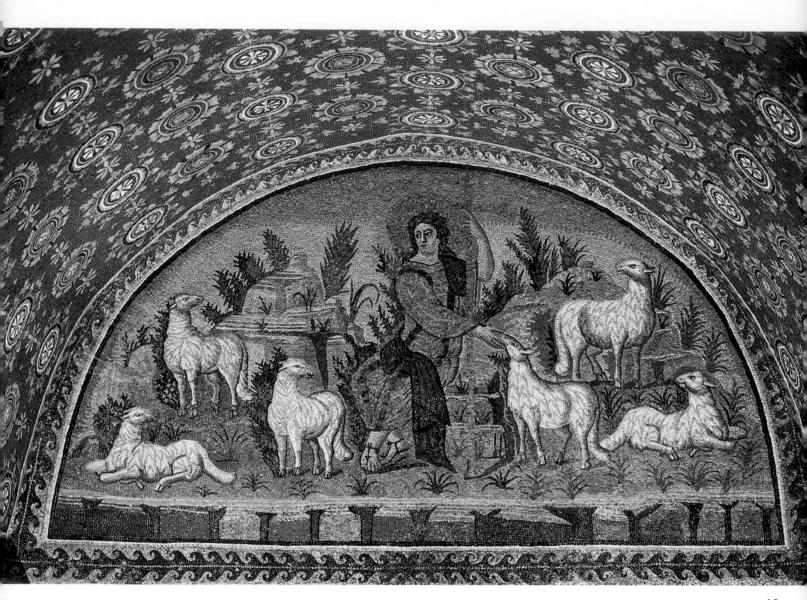

When totem animal becomes sacrificial victim

we have reached a stage of symbolism which is recognizably part of religion as we know it. The idea of the Lamb of God goes back to the story of the Plagues of Egypt in Exodus. To protect themselves from the Angel of the Lord, the Israelites were instructed to kill a lamb 'without blemish' and sprinkle their doorposts with its blood. In Christian belief, the lamb was seen as a natural 'type' of Christ, shedding His blood for the salvation of men. At the same time it also became a symbol for the soul of the innocent tended by Christ as the Good Shepherd. These mosaics at Ravenna illustrate both meanings. In the Mausoleum of Galla Placidia (above, *15*) the

faithful look up to their young Shepherd in an Arcadian landscape. 'In his ever verdant lovely Paradise,' says the ancient prayer 'Commendatio Animae', 'may Christ, the son of the living God, permit thee to live, and may that true shepherd count thee among His sheep.' In the choir vault of San Vitale (right, *16*), the Sacrificial Lamb is exalted by angels, echoing St John the Baptist's words, 'Behold the Lamb of God, which taketh away the sins of the world.' Note too the animals and birds in the four cells of the vault, resting on foliage or emerging from clouds, as if joining with the angels in praising their Creator.

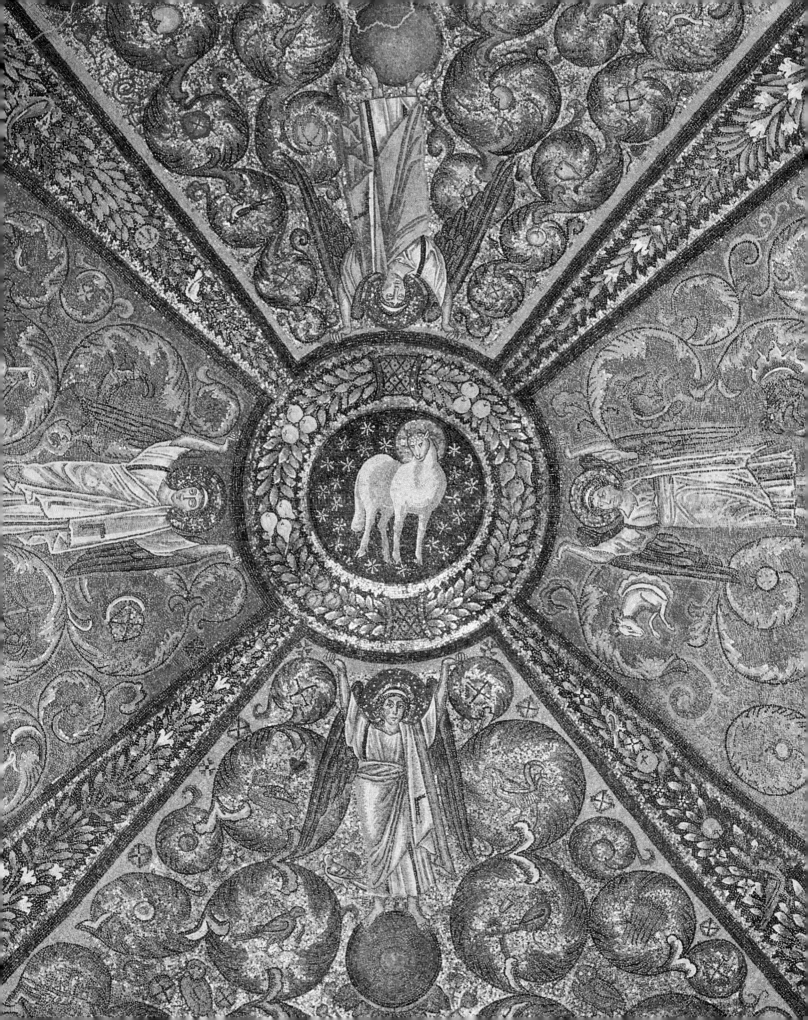

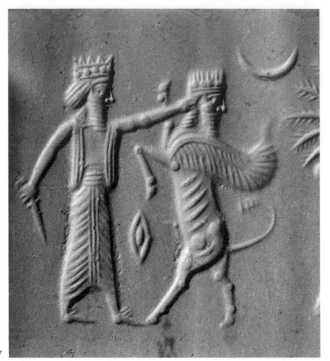

17

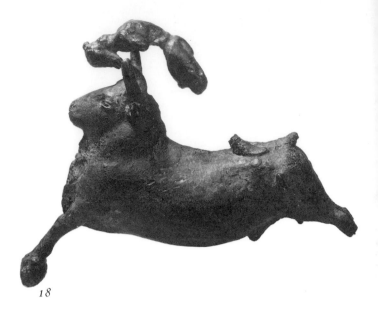

18

19

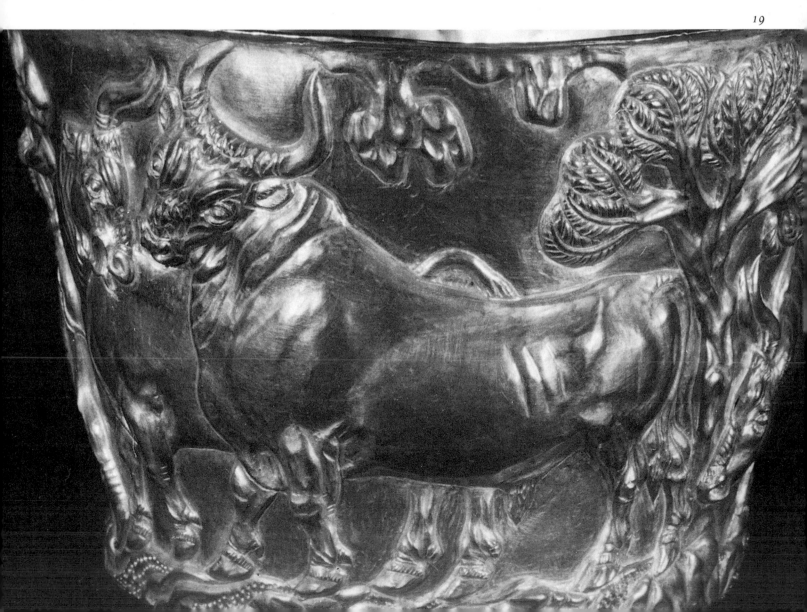

From the sacred to the symbolic

is a transition hard to plot in any detail. In the next few pages we look at two animals which, after figuring fairly constantly in the religions of the ancient Near East, became part of the vocabulary of visionary Christianity and ended their iconographical careers as symbols of two of the Evangelists – the bull and the lion. The bull as a symbol of potency and strength goes back beyond recorded history. In an early cylinder-seal from Akkad (enlarged, far left, *17*) a king is fighting or sacrificing a human-headed bull; probably by killing him he acquires the bull's strength. In the Old Testament (Numbers XXIII) Yahweh is compared to a bull. In Minoan Crete bulls seem to have been used in ritual games in which athletes leapt over their horns. A small damaged bronze (*18*) is one of the few remaining scraps of evidence, but that the bull was a sacred animal in Crete is not in doubt. The magnificent animals in the later Vaphio gold cup (below left, *19*) are surely connected with the bull-cult but it is not easy to say how. A bull is being captured with a decoy-cow, visible on the extreme left. In later Greek mythology the legend of Zeus assuming the form of a bull in order to carry off Europa (portrayed here, *21*, on a red-figure vase of about 490 BC) must go back to a connected myth or ritual. Finally, in the ancient cult which became the Roman mystery religion of Mithraism, the bull is again a sacrificial animal, killed (as in ancient Sumerian myth) by a solar hero. What is represented here is most probably the releasing of the earth's riches by penetration from the sun. (*20*)

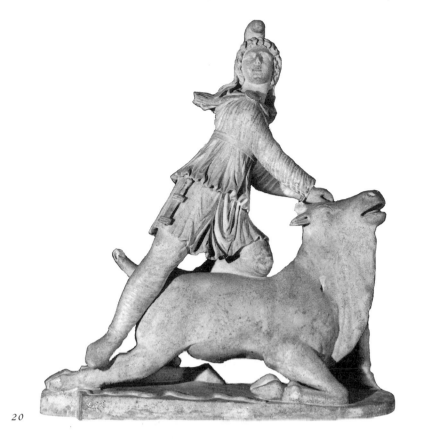

20

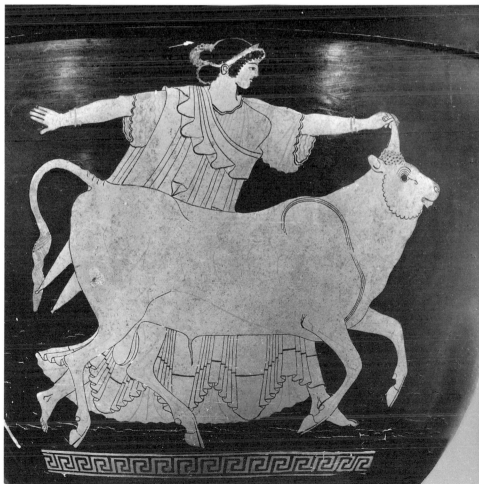

21

The bull of Ishtar.

One of the gates of Babylon, dedicated to the goddess Ishtar, incorporates rows of almost life-size bulls and dragons made of glazed tiles (*22*). From the *Epic of Gilgamesh* we learn that Gilgamesh insulted Ishtar and that Ishtar pleaded for revenge before her father Anu. 'When Anu heard what Ishtar had said he gave her the Bull of Heaven to lead by the halter down to Uruk. When they reached the gates of Uruk the Bull went to the river; with his first snort cracks opened in the earth and a hundred young men fell down to death. With his second snort cracks opened and two hundred fell down to death. With his third snort cracks opened, Enkidu doubled over but instantly recovered, he dodged aside and leapt on the Bull and seized it by the horns. The Bull of Heaven foamed on his face, it brushed him with the thick of its tail. Enkidu cried to Gilgamesh, "My friend, we boasted that we would leave enduring names behind us. Now thrust in your sword between the nape and the horns." So Gilgamesh followed the Bull, he seized the thick of its tail, he thrust the sword between the nape and the horns and slew the Bull. When they had killed the Bull of Heaven they cut out its heart and gave it to Shamash.'

22

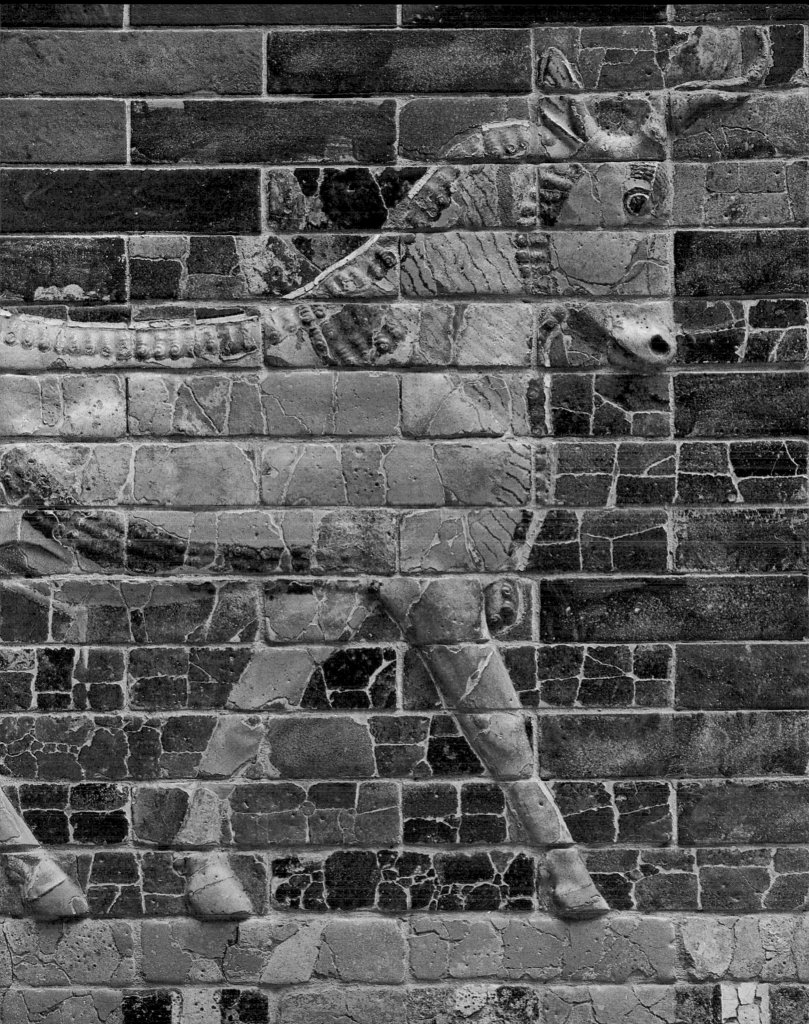

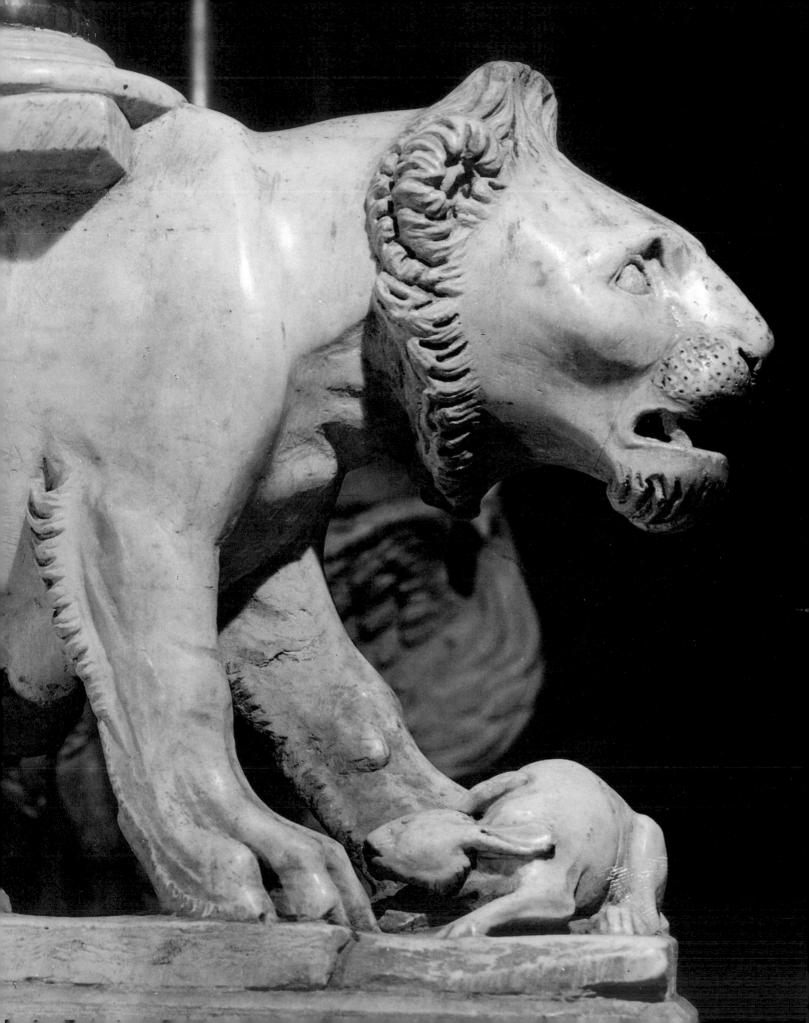

24

'The lion which is mightiest among beasts

and does not turn back before any.' The quotation is from Proverbs XXX. The tradition of the lion as the king of beasts and as the embodiment of courage goes back to prehistory. In ancient Egypt (above right, *24*), lions were placed at the doors of palaces to ward off evil spirits, beginning that long series of benevolent lions which leads to the Landseers in Trafalgar Square. In Christian art lions appear both as symbols of irresistible destruction, as in the Pistoia pulpit by Giovanni Pisano (left, *23*) and as symbols of protection. In the Early Christian choir screen at Torcello (lower right, *25*) there is also the suggestion of wildness tamed, the fiercest of animals happily sharing the paradise garden with the most peaceful.

25

23

HILACLEOHIS

26

As Evangelists' symbols,

the lion and the ox, together with the eagle, became by far the most frequently portrayed animals in medieval art. The iconographical story begins with the Book of Ezekiel. Ezekiel in his vision sees 'four living creatures', each of them with four faces. The image is taken up in Revelation, where the lion, ox, eagle and man appear as the guardians of God's throne. It was an imaginative and poetic step to identify them with the four Evangelists. The first recorded instance seems to be in St Irenaeus in the second century, though the exact correlation of saint and symbol was not standardized until later, and a certain element of arbitrariness remained. The lion seems to have been adopted for St Mark because his Gospel stresses Christ's majesty and dwells most fully on His resurrection: the lion was thought to give birth to dead offspring and to bring them to life by breathing on them. The ox, a sacrificial animal, was appropriate to St Luke, according to St Jerome, because his Gospel emphasizes the sacrifice of Christ. Here are shown two of the most spirited of early renderings, probably painted either in Ireland or Northumbria in the eighth or ninth centuries: the lion of the Echternach Gospels (26) and the ox from the Book of Kells (27).

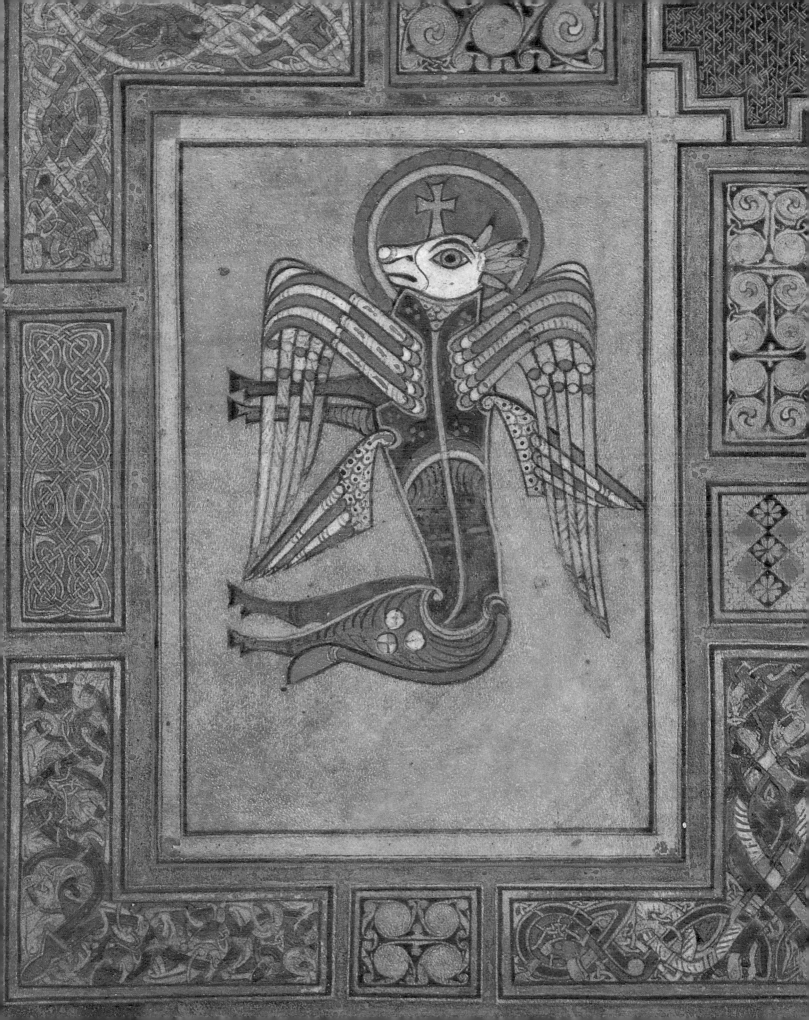

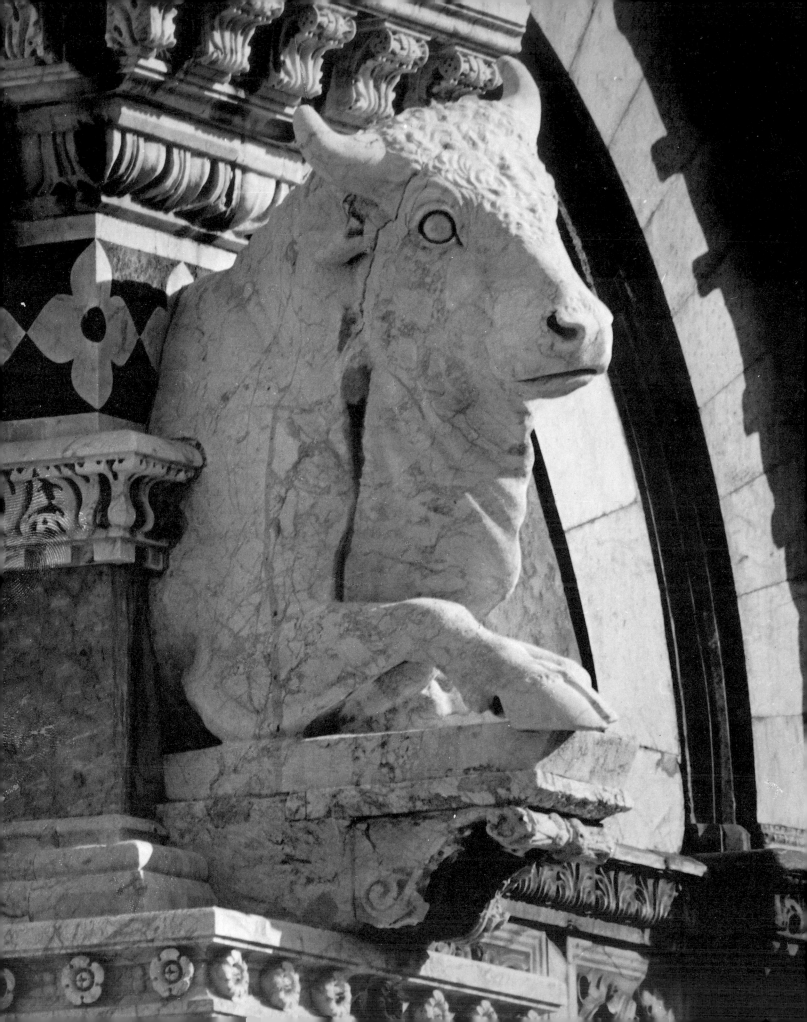

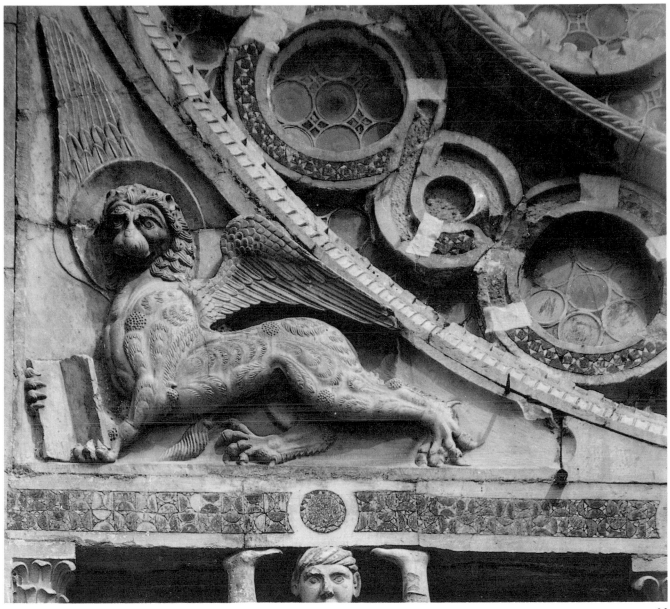

Animal incarnations.

There would seem to be an obvious conflict in the task which the medieval artist set himself: to portray life-like animals with something of their true energy and nature and yet to express through them a spiritual and theological message. In the event, he succeeded to an amazing degree in doing both. The lion of St Mark on the façade of Spoleto Cathedral (*29*) is a heraldic image of unmistakable power and splendour, but still essentially leonine. And Giovanni Pisano, in his ox at Siena Cathedral (*28*), can adopt almost pure naturalism, and still leave the spectator in no doubt that he is looking at a religious symbol.

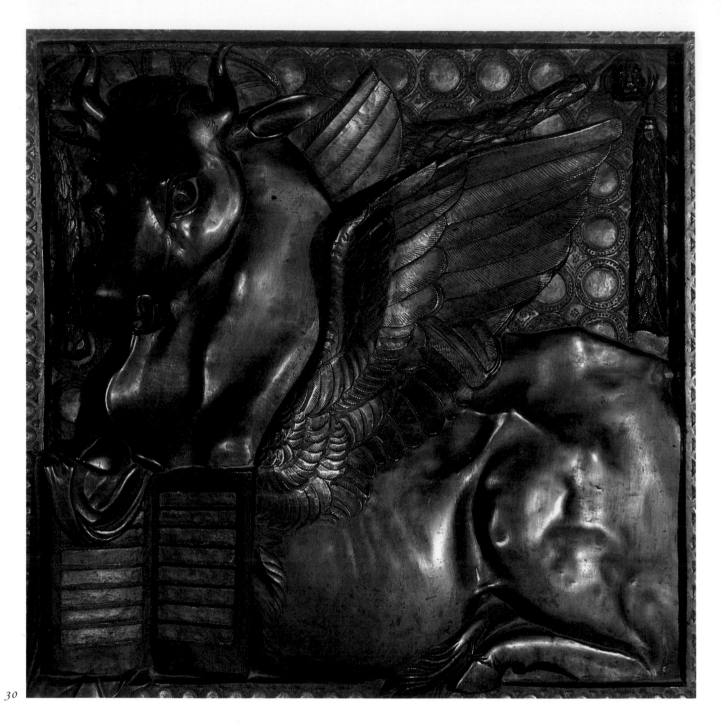

30

Symbolism sacred and profane.

Donatello's ox of St Luke from his bronze altar of the Santo at Padua (*30*) is an animal whose tenseness and urgency makes manifest its spiritual role. The lion of St Mark (*31*), on the other hand, soon ceased in Venetian eyes to be a religious symbol and became a political one.

The Venetians stole the body of St Mark from Alexandria in 828, installing him as their own patron saint. The winged lion, its paw on the book inscribed 'Pax tibi Marce, Evangelista mea', proclaimed Venice's pride and the servitude of her empire.

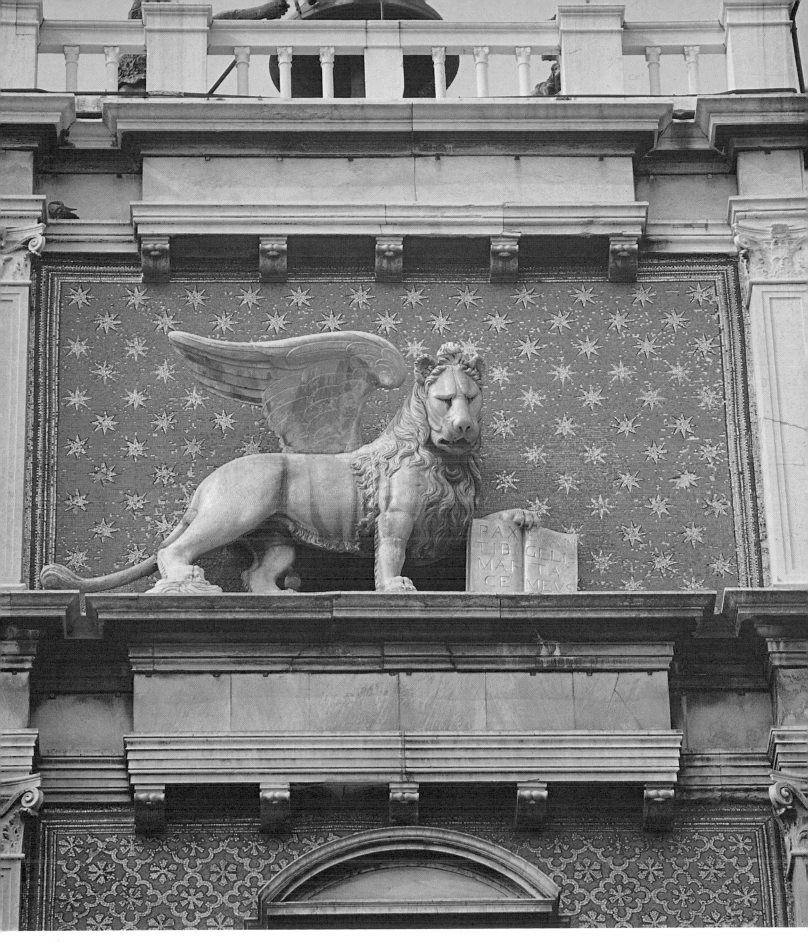

Fear of animals

is something which everybody has experienced, and which seems to live on even more powerfully in the unconscious. When medieval artists wanted to portray the forces of evil or the punishments awaiting the damned they often turned to images of bestial ferocity. Scenes like these, from Chauvigny in France (*32*), and Isola di San Giulio, Italy (*33*), surely go back to a period of human history that is pre-Christian and even prehistoric. The immediate sources are in classical, Byzantine and Coptic art. The French example derives from the sphinx of Antiquity, which in the Middle Ages was given a reptile's tail; the Italian probably from an eastern textile. Sculptors seem to have copied these images without knowing what they originally signified.

32

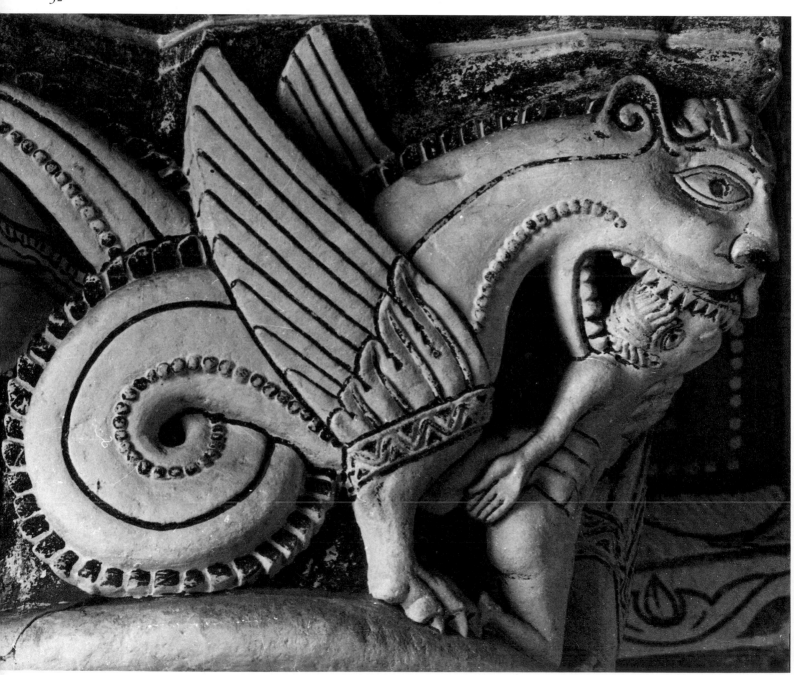

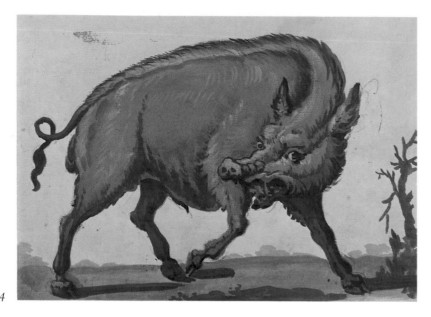

34

Shorn of their magic

but still keeping something of their old
numinous power, sacred animals lived on in
the stylized ranks of heraldry. Shown
opposite is one of the most appealing animals
in all art, the White Hart, Richard II's
emblem, from the Wilton Diptych (*37*). On
this page: three eighteenth-century designs for
inn signs from an album by a pupil of Wootton.
Addison, in 1711, complained that the
streets were 'filled with blue boars, black
swans and red lions; not to mention flying
pigs and hogs in armour.' Such creatures
could have a long ancestry. The Blue Boar (*34*)
can be traced back to a description by Pliny.
The Black Bull (*35*) was the sign of the Duke
of Clarence, Edward III's second son. The
Fighting Cock (*36*) had been a shop sign since
Roman times, and to a medieval Christian
would at once have suggested St Peter and
Christ's Passion. Behind nearly all of them
lurk the dim shadows of once terrible animal
gods.

35

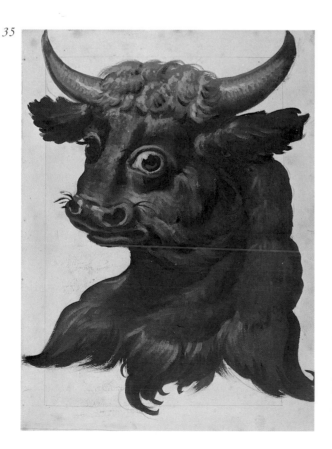

36

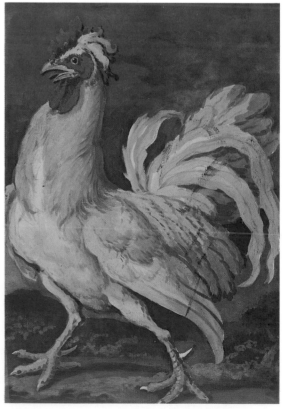

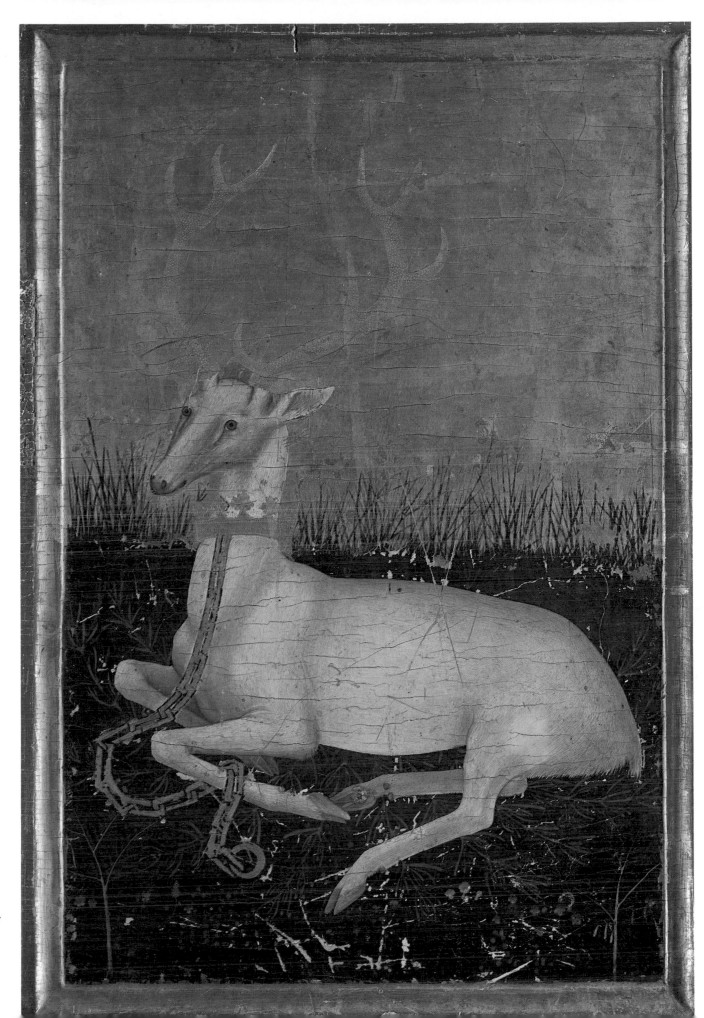

37

Sepe etiam necis illate euidentia canes ad redarguen
dos reos indicia prebuerunt. ut multo eorum testimonio
plerumq3 sit creditum. Antiochie fertur in remotiore parte
urb' quidam crepusculo necatum uirum. q3 canem & ad uinctu
haberet. Miles q3dam predandi studio: ministr' extitit cedis.

The world of the Bestiaries

is a strange mixture of observation and
dogma. To the moralist of the Middle Ages,
everything in nature had been put there to
reveal the will of God. The dog (38) which
sees the reflection of a cake and lets go the real
one in order to secure the illusion 'symbolizes
those silly people who leave the Law for some
unknown thing'. The two dogs at the bottom
are licking their wounds in order to cure
them. Even so 'the wounds of sinners are
cleansed when they are laid bare in
confession'. The eagle (above right, 40) flies
up to the sun to burn away the film over its
eyes and then plunges into the sea to renew
the splendour of its plumage. The meaning:
'Lift up your eyes to God, who is the fount
of justice, and then your youth will be
renewed.' A favourite scene was that of
St Brendan and his companions who
anchored on the back of a whale, mistaking it
for an island (39). 'Now, this is just the way in
which unbelievers get paid out, I mean people
who are ignorant of the wiles of the devil and
place their hopes in him and in his works.
They anchor themselves to him and go down
into the fires of Hell.' Finally, an illustration
from Beatus' *Commentary of the Apocalypse*, in
the eleventh-century St Sever manuscript (41):
a fabulous bird of the East, disguising its
beauty with dirt and making itself
insignificant, surprises and kills a serpent.
The bird is Christ, disguising His divine
nature in order to conquer the Devil.

38

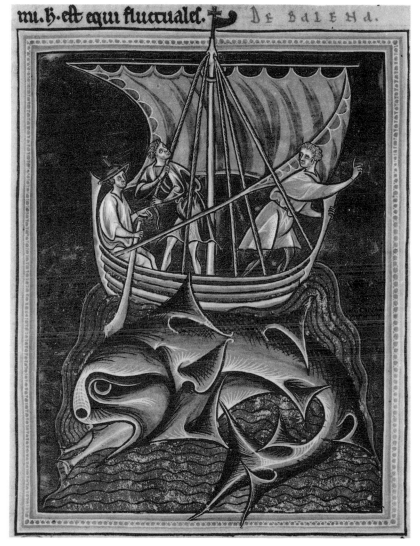

mu. ħ. eſt equi fluctualeſ. ✝ De balena.

39

40

41

The enraged swan

of the Netherlands defends her nest against
'the enemy of the state'. The painting, by a
rather obscure Dutch artist, Jan Asselijn,
dates from the middle of the seventeenth
century, and has for long been interpreted as a
symbol of national resistance to outside
aggression. But did he intend it? No one can
be sure. The lettering which spells out the
message was definitely added after his death.
Yet the fact that it was so quickly and
universally adopted as a symbol is perhaps
even more significant than if it were created
as one. Its power is undeniable. The swan is
over life-size, the whole picture nearly five
feet tall (42).

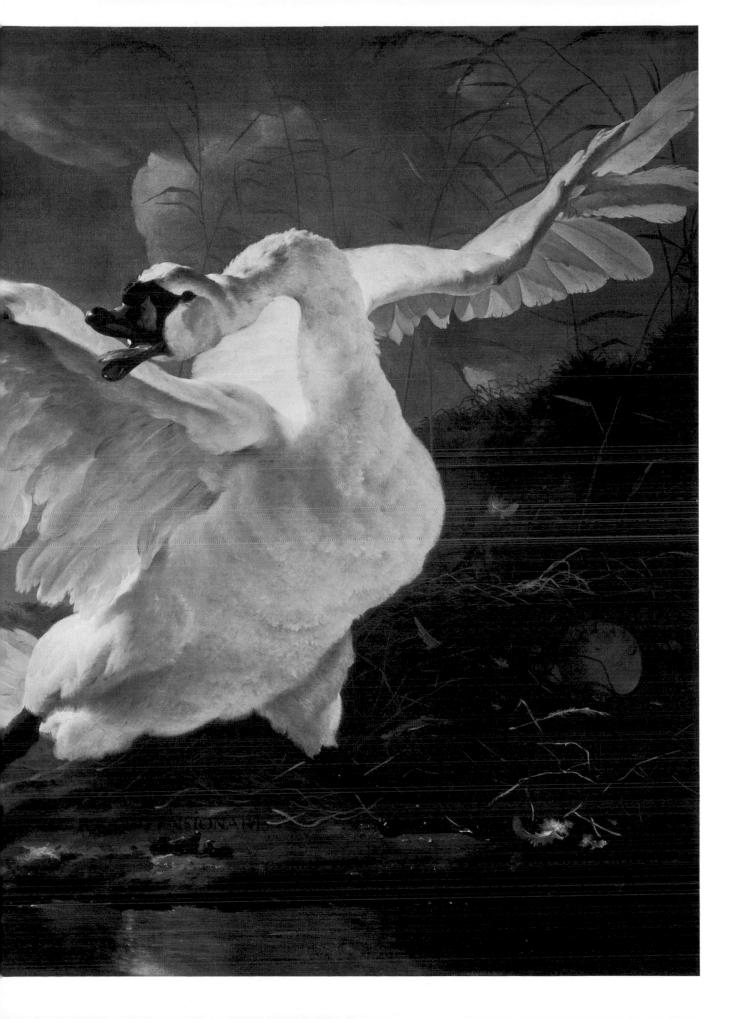

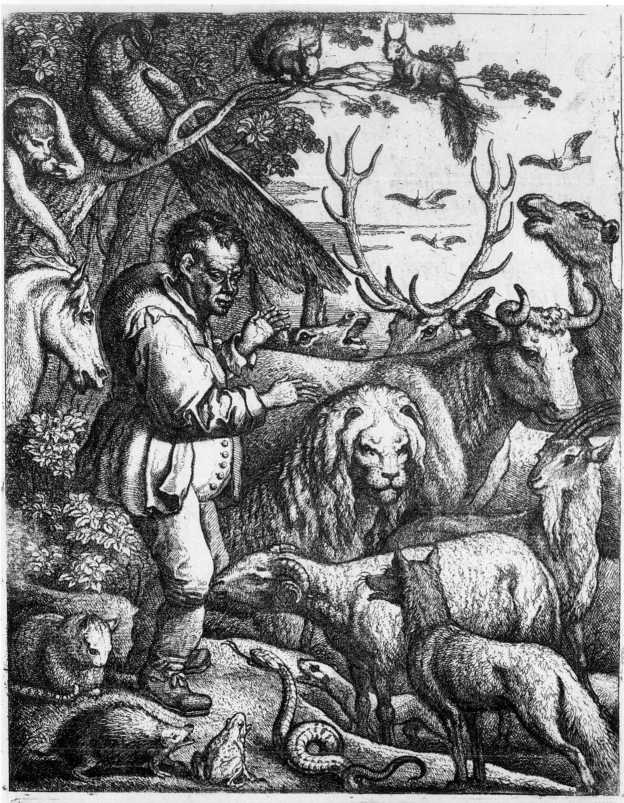

See here how Natures Book vnclasped lies,
Whose Pages Æsop reads with pearcing eyes

Who wth wise Apologues from Beasts, deriu'd,
Tells man they for his conduct were contriu'd.

43

Animal fables

are close to the Bestiary stories. The points they make are moral rather than religious, but as records of animal behaviour they are equally fantastic. The man credited by the Greeks with inventing practically all of them was Aesop. According to Herodotus he lived in the sixth century BC and was a slave on the island of Samos. Later legends supplied more picturesque details, in particular that he was ugly and misshapen. In Francis Barlow's frontispiece to his edition of the *Fables*, published in 1665 (*43*), Aesop becomes a sort of poor man's Orpheus, a man gifted with an understanding of animals and insight into their characters. The lion (above right, *44*), unable with all his strength to escape from the net, is saved by the humble mouse which can gnaw through it. Below (*45*): some adders have tricked a porcupine into giving up its nest and then refused to move: what is gained by subtlety must be kept by force. Barlow himself marks the beginning of a new attitude in the systematic portrayal of animals. Although he still leant heavily on such compilations as Gessner's sixteenth-century *Historia Animalium*, he was also a scientific observer in the spirit of Newton and the Royal Society. His animals, even when participating in fables, are accurately represented and given neither human nor symbolic attributes. Like Bewick, he was a naturalist and a lover of the English countryside.

44

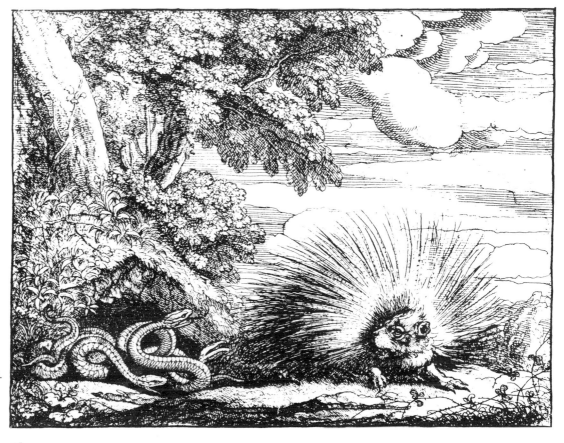

45

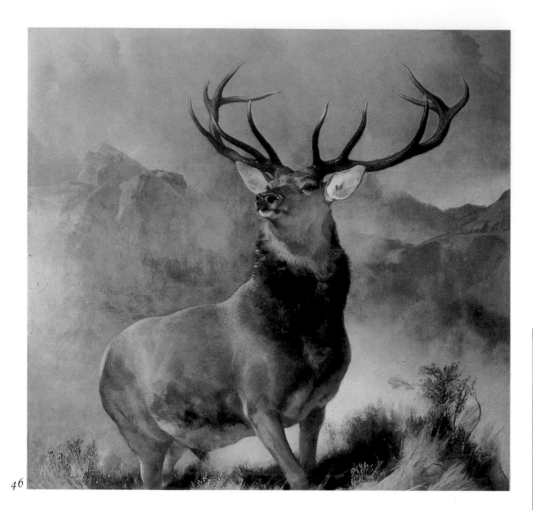

46

The Monarch of the Glen

epitomizes the self-satisfaction of the
Victorian ruling class – masterful, courageous,
aggressively masculine, dominating the whole
environment. By deliberately endowing the
animal with these human qualities, Landseer
makes him an unconsciously revealing symbol
of his own and his patrons' values. Landseer
certainly loved animals for their own sake;
Ruskin called him 'much more a natural
historian than a painter'; and even when his
social rise was introducing him to the heady
pleasures of deer-stalking in the company of
princes and dukes he was still troubled by the
thought that 'in truth he ought to be ashamed
of the assassination'. The *Monarch* was painted
in 1851, appropriately the year of the Great
Exhibition. It was commissioned for the
Peers' Refreshment Room in the House of
Lords, but the Commons refused to vote the
money and it was sold successively to a peer,
a soap manufacturer and a whisky distiller (46).

The Scapegoat

by William Holman Hunt is a more potent
and more conscious symbol: 'And the goat
shall bear upon him all their iniquities unto a
land not inhabited', a verse from Leviticus long
interpreted as an allusion to Christ. From his
study of the Talmud Hunt knew exactly
when, where and how the goat was driven
out to die, a fillet of scarlet wool bound to its
horns, to turn white if the propitiation were
accepted. Faithful to his doctrine to truth to
nature, he journeyed to the Dead Sea in 1854,
bought a goat, tethered it in the sun and day
after day painted it. For him, the painting was
a religious experience. Ford Madox Brown

said, 'Hunt's *Scapegoat* requires to be seen to
be believed in', but the public was unable to
understand it. Ruskin condemned its technical
execution, but was thoroughly in sympathy
with the idea behind it. Almost echoing the
medieval bestiarist, he wrote: 'The beauty
of the animal form is in exact proportion to
the amount of moral or intellectual virtue
expressed by it . . . There is not any organic
creature, but in its history and habits will
exemplify or illustrate to us some moral
excellence or deficiency, or some point of
God's providential government, which it is
necessary for us to know.' (47)

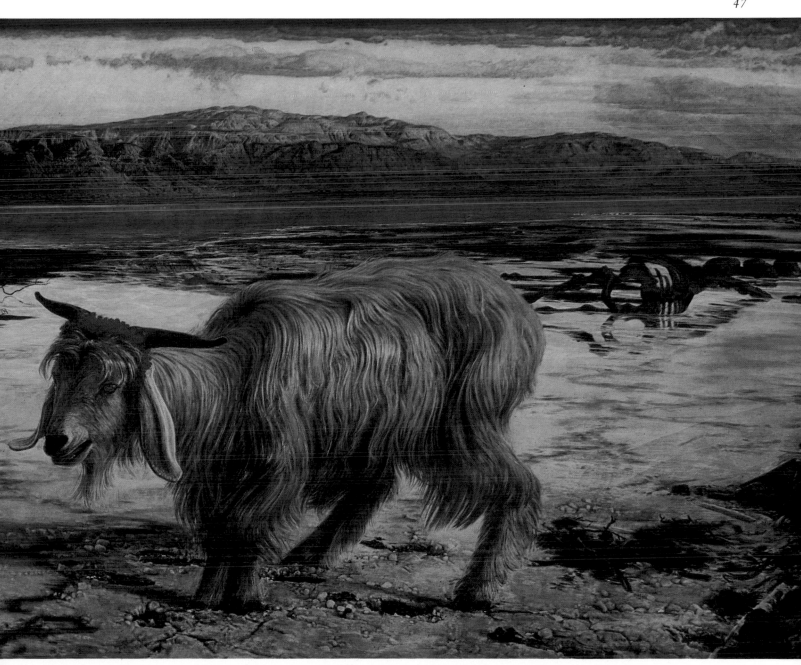

Animals Observed

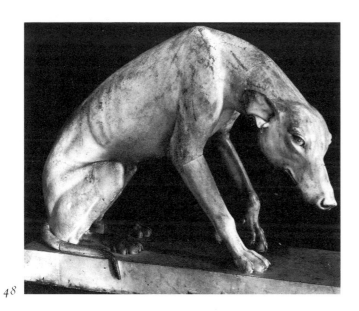

48

Close and accurate observation

of animals is most likely to be found in
cultures where they have no religious or
symbolic function, though this is by no means
a rule (in Egypt both existed happily side by
side). In Greece there is an interesting
development from the Classical period, when
both humans and animals were idealized to
conform to an image of perfect beauty, to the
Hellenistic, when artists tried to show life as
it really was, and in fact sought out subjects
that were emphatically *un*beautiful, including
deformity and sickness. The marble sculpture
of a sick greyhound (left, *48*) is entirely typical.
It was carved somewhere in Magna Graecia
about 200 BC. The observation is almost
clinical, yet pathos and sympathy are not
excluded.

During the early Middle Ages artists were
for the most part unconcerned with
appearances, concentrating upon the meaning
of an image and therefore using a stylized
vocabulary that conveyed the meaning most
directly. The return to naturalism was slow.
Matthew Paris's mid-thirteenth-century draw-
ing of an elephant (right, *49*) is exceptional.
It comes in his *Lives of the Abbots of St Albans.*
Paris had seen the elephant, presented by St
Louis to Henry III, which arrived in London
in 1255. He was obviously fascinated by the
strange beast, and the absence of an accepted
model to copy helped to produce the first
realistic elephant, and almost the first realistic
animal, in post-Classical Western art.

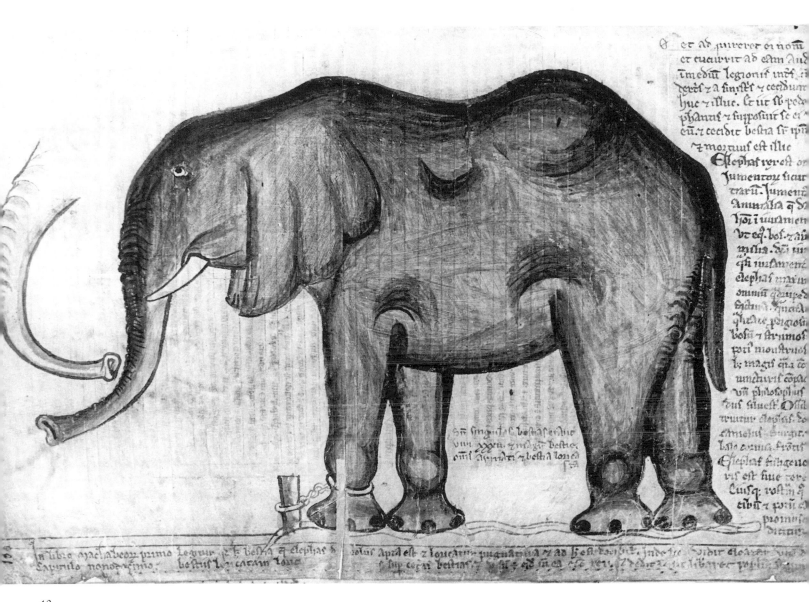

49

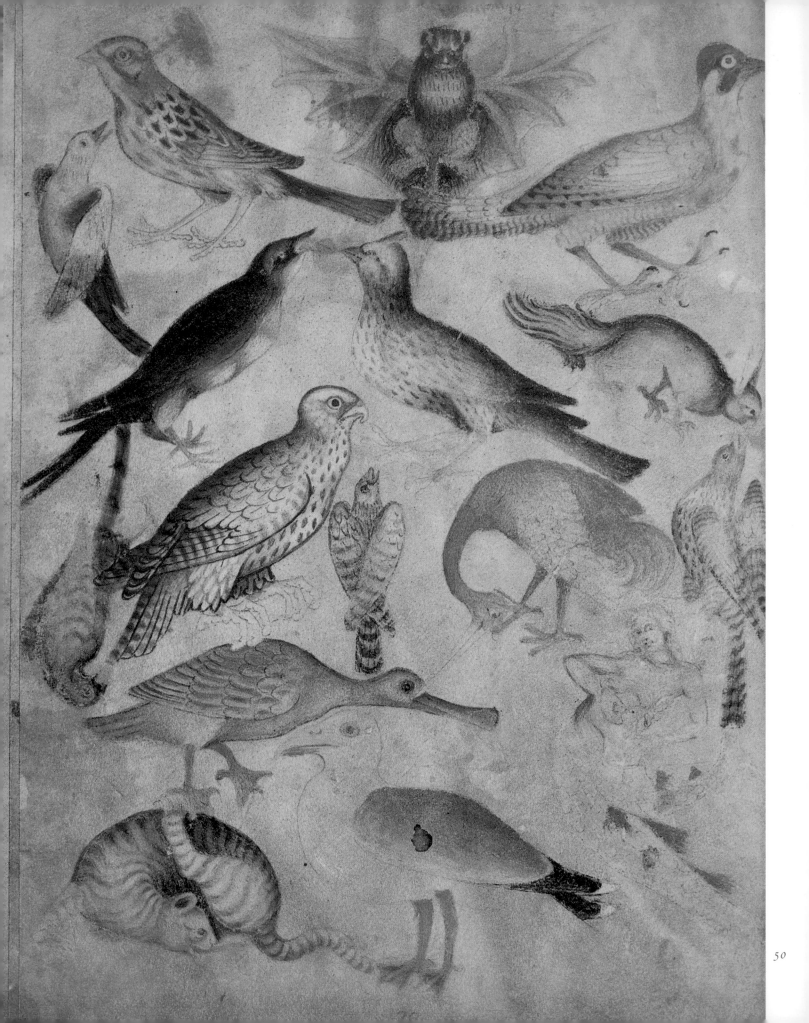

51

52

How the Middle Ages looked at Nature is one of the minor riddles of cultural history. Numberless miniatures and drawings seem to breathe a fresh enjoyment in and love of the natural world. Yet when their sources are traced they turn out to be exact copies of previously existing models. Obviously *somebody* must have made the observations in the first place, but they were not part of an artist's required training. (In a similar way much medieval poetry is apparently spontaneous but on closer study found to be derivative and conventional.) On the left (*50*) is a page from a sketch book of about 1400, now in the Pepys Library, Cambridge. Prominent among the birds are bunting, woodpecker, whitethroat, lark, eagle, shoveller, crane and herring gull. Above (*51, 52*): two details from the Sherborne Missal, 1396–1407, showing two marginal decorations, a mallard duck and a chaffinch.

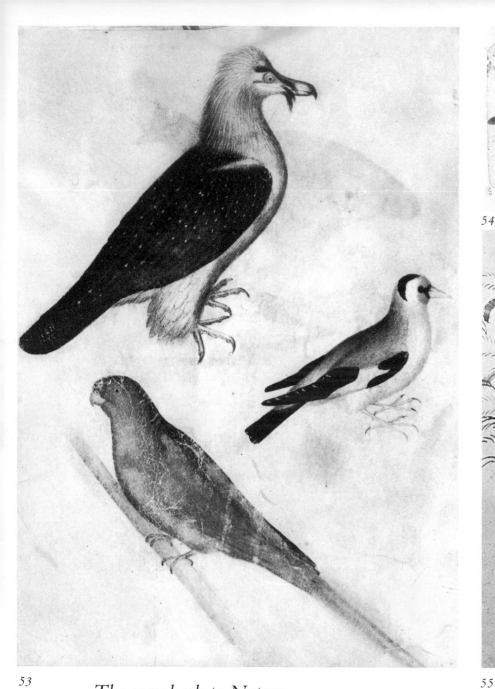

The way back to Nature

was only fully opened by the Italian Renaissance, when the physical world became an object of passionate study for its own sake. On this page are four examples of North Italian bird sketches of about 1450. Above (53) from the Grassi Sketchbook: kite, goldfinch and parrot. Right (54–56) from the circle of Pisanello: eagle, stork and two hoopoes. Opposite (57): 'Chuck Will's Widow' (a species of nightjar, here feeding a voracious infant), by the nineteenth-century American artist John James Audubon, showing how the same spirit of inquiry produces closely similar results four hundred years apart.

Chuck Wills widow

Caprimulgus Carolinensis

Spanish Whip-poor-Will common name

Drawn from Nature by John J. Audubon
Natchez May 7th 1822

Weight of Male. 3 3/4 Female. 3 1/4lb.
Length of — 12 3/4 in. — Egg
Breadth — 26.

Animals observed—mathematically

In Paolo Uccello a keen eye for appearances was combined with a preoccupation with abstract form. *The Rout of San Romano* (*58*) was painted to celebrate a victory by Florence over the Sienese in June 1432. It cannot be said that Uccello's treatment conveys much idea of the blood and sweat of battle. Rather, his warriors seem to be taking part in an elaborate masquerade – the men, horses, lances, headdresses and banners forming a highly self-conscious exercise in foreshortening. His horses are living geometry, held frozen in mid-step while the artist invites admiration for the curve of a haunch or the graceful line of a head and neck.

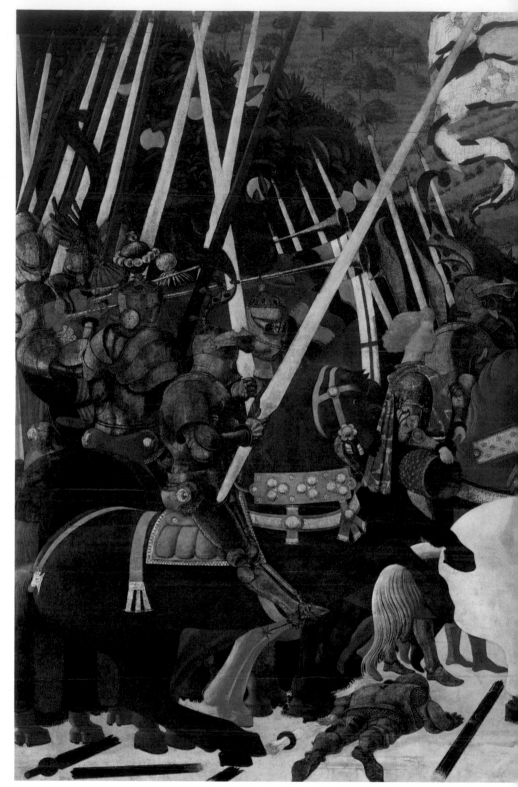

58

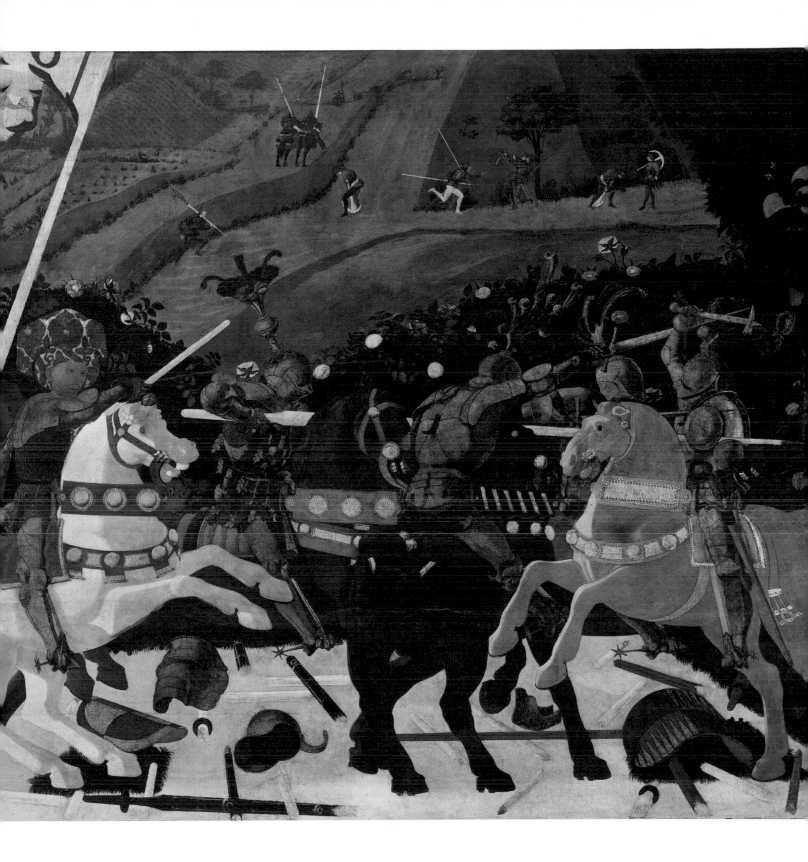

59

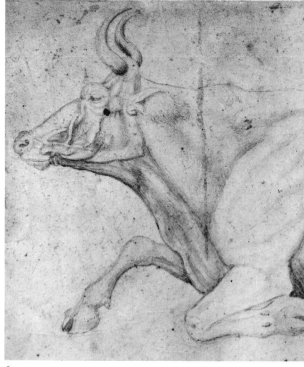

60

61

Sketching from life

was part of the artist's normal routine by the middle of the fifteenth century. But the drawings were still not valued for their own sake. They were either studies for a particular commission, or a useful stock of ideas to be used when necessary. Two very notable albums of such sketches survive, one compiled in the studio of the Bergamese Giovannino de' Grassi (he died in 1398, but the album went on being added to), the other by a

greater artist of the next generation, Pisanello (died 1455). Here the stags and the mouse (*59, 61*) are from the Bergamo album, the bull and the horses (*60, 62*) from that of Pisanello. The horses – which are in fact the same horse seen from opposite directions – are a study in foreshortening as well as in animal anatomy, used by Pisanello in his large fresco of St George in St Anastasia, Verona.

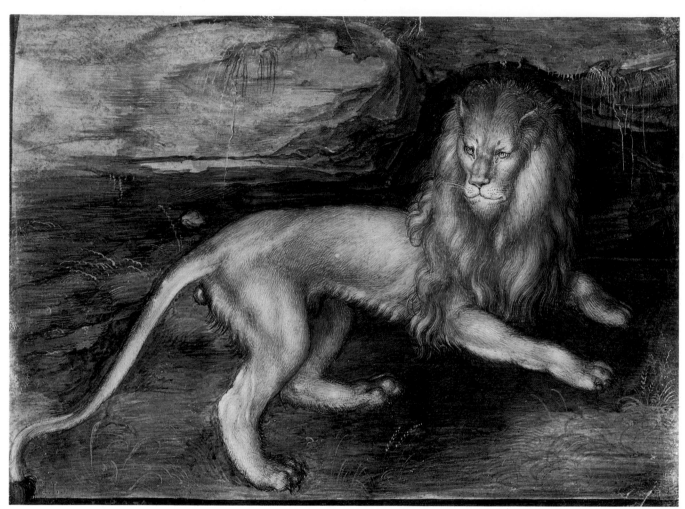

63

'When I was young,'

wrote Albrecht Dürer, 'I craved variety and novelty; now in my old age I have come to understand that simplicity is the ultimate goal of art.' Among the 'novelties' which fascinated him were exotic animals. He kept numerous pets, went to see as many unusual creatures as he could, and introduced them into almost all his major paintings. It is especially interesting to note in Dürer a phenomenon that occurs in all art – the way in which first-hand observation is conditioned by, and even subordinated to, a preconceived artistic convention, or *schema*. His lion (above, *63*), for instance, is partly based on the Venetian lion of St Mark (see p. 91), with the book taken away and the front legs rearranged. The ostrich (opposite, *64*) was a rare sight in Europe in 1508, though its feathers and eggs had long been sought as curiosities.

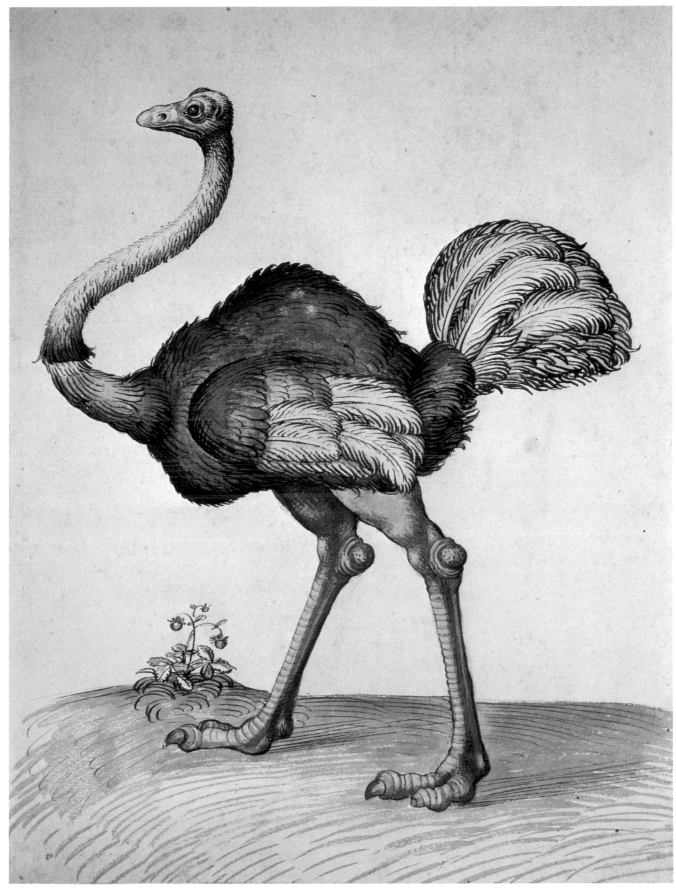

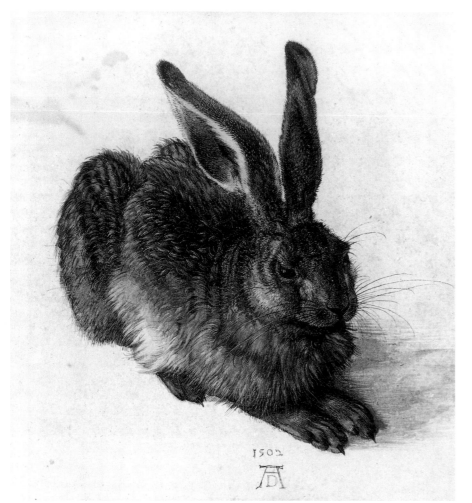

Dürer's curiosity

was universal and insatiable, embracing both the familiar and the exotic. His drawings of animals have an analytical quality, as if he were using the medium of art as a scientific technique to probe the structure of natural things. His hare (*65*) of 1502 combines photographic realism with an intense nervous vitality, making it one of the most popular animal pictures in all art. Dürer drew the walrus (*66*) in 1521. It had been washed ashore by a freak storm on Zeeland; later he transformed it into a dragon for an altarpiece. Even more menacing is his crab (*67*), done when he was on his first visit to Venice.

Dürer's rhinoceros (opposite, *68*) was not actually observed, but re-created in imagination from a sketch and a description. His notion that it was encased in a sort of armour-plating was wrong, yet he produced an image so convincing that even Stubbs, in his far more accurate painting from life (below, *69*), could not banish it from his mind. It was commissioned by the anatomist John Hunter, as part of an encyclopaedia 'museum' of the animal kingdom. The rhinoceros belonged to a menagerie in the Strand, London, and it was here that Stubbs studied it in the 1770s. This was an age of great interest in exotic animals, not merely as curiosities but as the means of extending knowledge of the natural world.

65

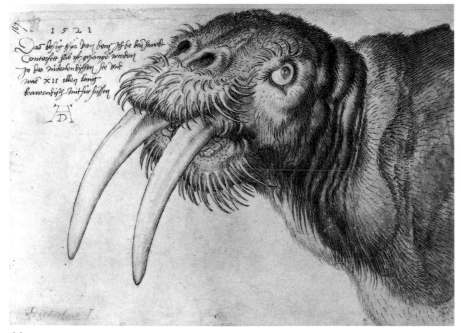

66

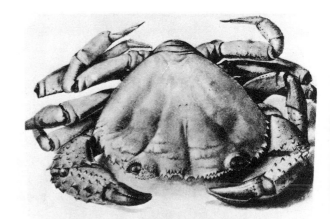

67

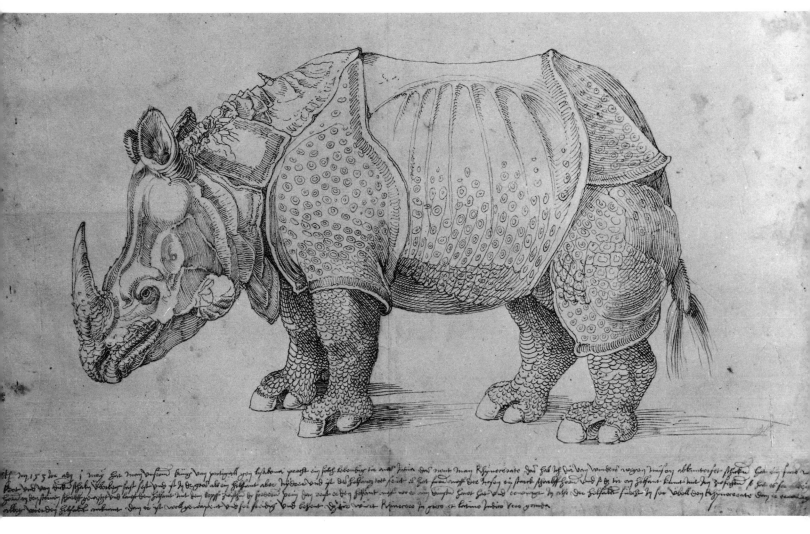

ekh dem 1513 Jar adj 1 may. Hat man dem großmechtigen künig von portugall geprackt ein solch lebentig tier aus India das nenet man Rhynocerus das hab ich dir dey wunder werppen laßen zey abkunterfert schicken. Hat ein fard...

...

68

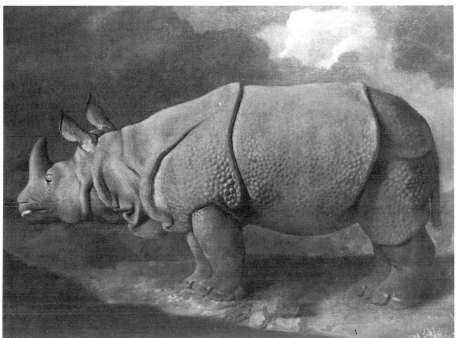

69

The flocks and herds

of the countryside have no doubt always
had an appeal for the town-dweller, and it
seems natural enough that this should have
been given its first unequivocal expression
in Venice, a city more decisively cut off from
its surroundings than any other. Dürer's
studies of animals had been made for his own
pleasure: in his finished works they had to be
subsidiary to a historical or religious theme.
Jacopo Bassano and his son Francesco, some
sixty or seventy years later, are still obliged to

pay lip-service to the same convention;
but by now it is no more than that. *The
Departure of Abraham for the Promised Land*
(above, *70*) by Francesco is clearly any group
of peasants herding livestock to market.
Right: a detail from *The Earthly Paradise* (*71*)
by Jacopo, with Francesco's assistance. This is
essentially a pure landscape painting, interest
in the scenery and animals outweighing any
religious connotation. Nor is it at all idealized.
Bassano's Paradise is the Italian countryside.

71

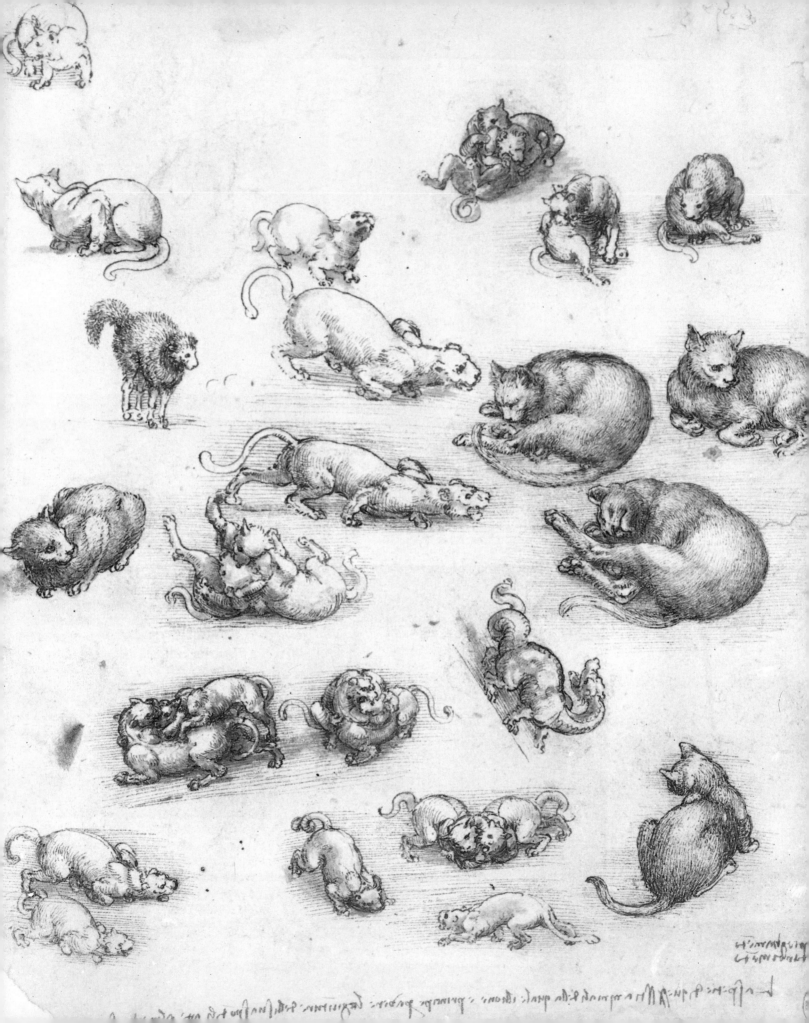

73

How animals move and stand

has fascinated artists, who perhaps relish the absence of self-consciousness which a human subject can never overcome. Leonardo was clearly intrigued by the suppleness of cats (left, *72*), the way they can twist their bodies into such an extraordinary variety of graceful contortions: alert, relaxed, washing, fighting, defiant. But he does not seem to have succumbed to feline charm; some of them hardly look like cats at all, and one in the centre is definitely a dragon (though behaving in a very cat-like way). On the right are two drawings of a greyhound and a whippet, the first by Dürer (*73*), the second by Augustus John (*74*). Both catch the tense, nervous energy of the animal, but there is an interesting difference of viewpoint. With Dürer we are at human height and the dog looks up at us; with John we are at its own level and somehow sense its anxiety more directly.

74

72

75

The painters of Holland

took up the portrayal of rural life where the Bassani left it. By the seventeenth century no religious excuses were needed to show farm animals, and they were painted with a fidelity and – surely – a love that have never been surpassed. Adriaen van de Velde was a specialist in animals and often added them to other people's pictures. The *Goat and Kid* (left, 75) was probably done as a study; it reappears in several of his other paintings. Aelbert Cuyp was especially drawn to the rotund forms and placid contentment of cows (below, 76). Paulus Potter, who died at the age of twenty-nine in 1654, was taking that art to a yet higher point. His *Young Bull* (detail opposite, 77) has a sort of youthful joy in life that contrasts tellingly with the tired face of the old man.

76

77

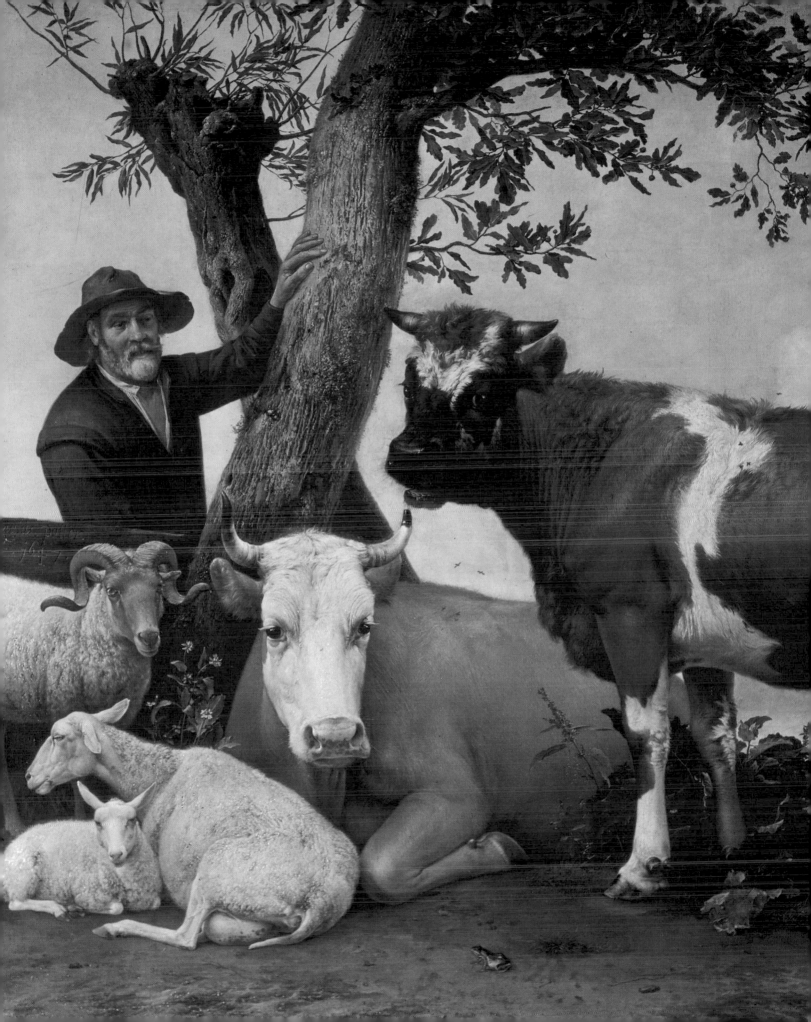

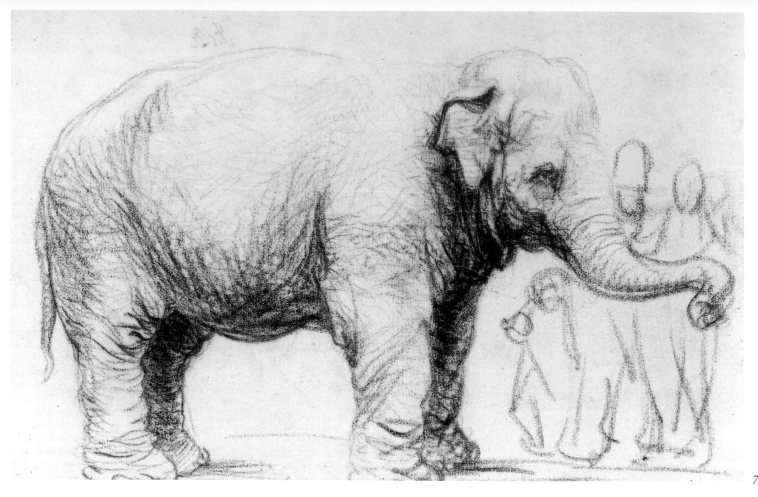

78

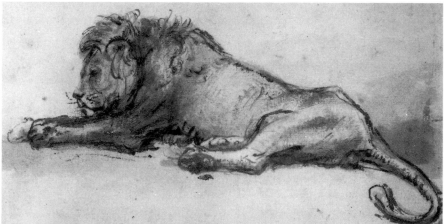

79

How men see animals

can indeed be as revealing about men as about animals. In these drawings Rembrandt, Munch and Landseer have each managed to evoke an animal's personality very strongly in a few strokes. Rembrandt's elephant, lion and hog (*78–80*) have a dignified self-sufficiency, inhabitants of a world that is solid and permanent. Munch's tiger and mandrill (opposite above, *81, 82*), by contrast, are mirrors of his own inner torment. He drew them in Copenhagen Zoo in 1909, when under psychiatric care and when human subjects were thought to be too upsetting. Landseer's young hippopotamus (*83*) of 1850 shows him at his happiest, technically assured, affectionate but not sentimental. In her diary for 18 July 1850, Queen Victoria wrote: 'We went straight to the house where the hippopotamus is kept . . . It is only 10 months old and its new teeth are only just coming through. Its eyes are very intelligent. It was in the water, rolling about like a porpoise.'

80

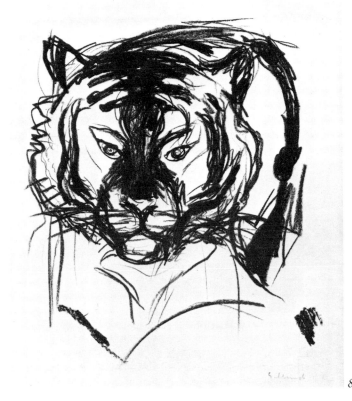

81

82

83

Horse portraits

were as much part of the eighteenth-century social scene as human ones. They were records of their owners' possessions and triumphs; masterpieces were not required. Perhaps for this reason, George Stubbs never achieved fashionable success and ended his life in poverty. *Hambletonian, Rubbing Down* was painted for Sir Henry Vane Tempest (and Stubbs had to go to court to collect his fee). The horse had won the St Leger in 1795, and in 1799 beat Mr Joseph Cookson's Diamond at Newmarket in a spectacular finish. 'The St Leger winner held the lead until Diamond challenged in the last half-mile, and from then on both horses seem to have been cruelly punished, Hambletonian being only just lifted in ahead by Buckle's splendid riding in the last few strides . . . Sir Harry determined never to race him again.' It is the scene immediately after the race that is represented here. Hambletonian is exhausted, an animal which has endured the very uttermost of physical stress. Stubbs implies no moral judgment, as a Victorian painter might, but he gives the horse a heroic quality and a nobility that is lacking in the stable-boy and the trainer. (*84*)

84

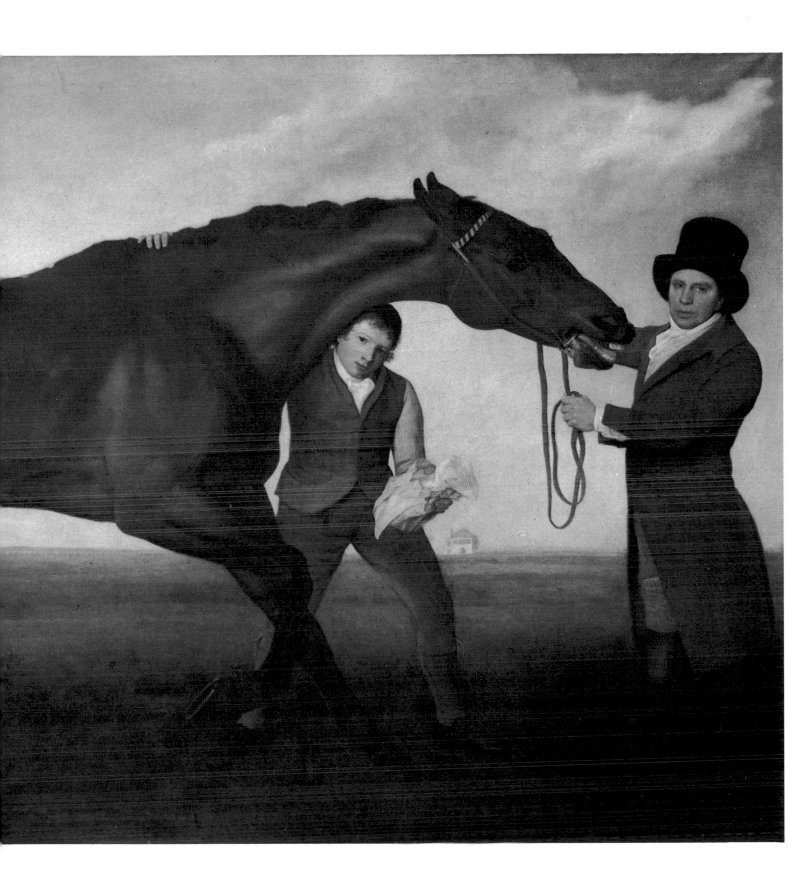

Horses inhabit two worlds of man's imagination. One is the ordered world of everyday life, illustrated on this page, where they are the servants of man, respected and admired but still submissive. The other is the world of beauty and energy, to be examined in the next chapter, where the horse is a force of nature, rebellious, untamed and elemental. Below (*85*): one of the Duke of Mantua's horses, a fresco in the Palazzo del Tè by the workshop of Giulio Romano. Duke Federigo II was particularly proud of his stable of stallions, which still symbolized knightly valour. Opposite above (*86*): *Mambrino*, painted as part of a series of sixteen famous racehorses to illustrate a History of the Turf. Stubbs's knowledge was immense, his ability to convey movement and life complete; but his composition is often curiously Classical,

looking back to Renaissance models (such as the Mantuan horses) in a way that by 1790 was definitely old-fashioned. Below (*87*): *Grey Horse: At the Blacksmith*, by Géricault. It is interesting to see Géricault, the arch-Romantic, tackling a genre scene in such an emotionally low key. He had come to England in the spring of 1820 and been impressed both by English sporting pictures and by the huge English dray-horses. His drawing here is coolly objective, but he clearly felt sympathy with the patient, overworked animal – as he did with the human poor, oppressed and mad in his other more personal paintings. Such a spirit was foreign to English animal painters up to that date, who rarely depicted work-horses. Stubbs's horses had been thoroughbreds, the aristocrats of equine society.

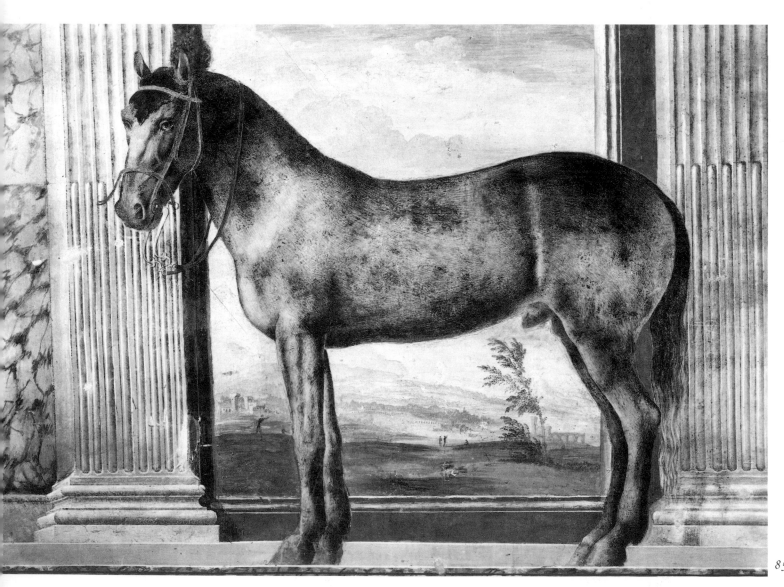

85

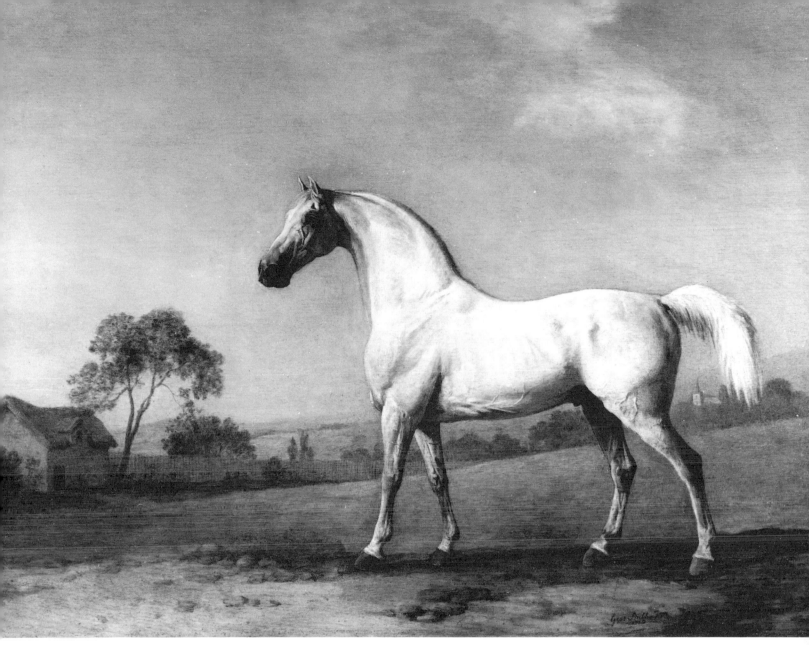

86

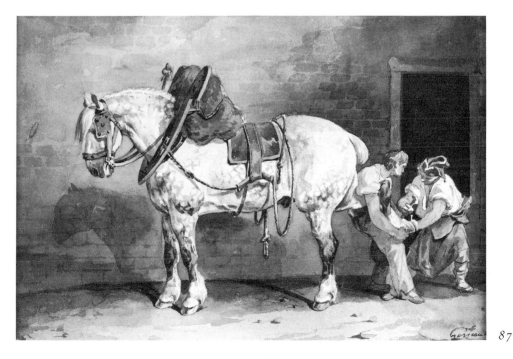

87

129

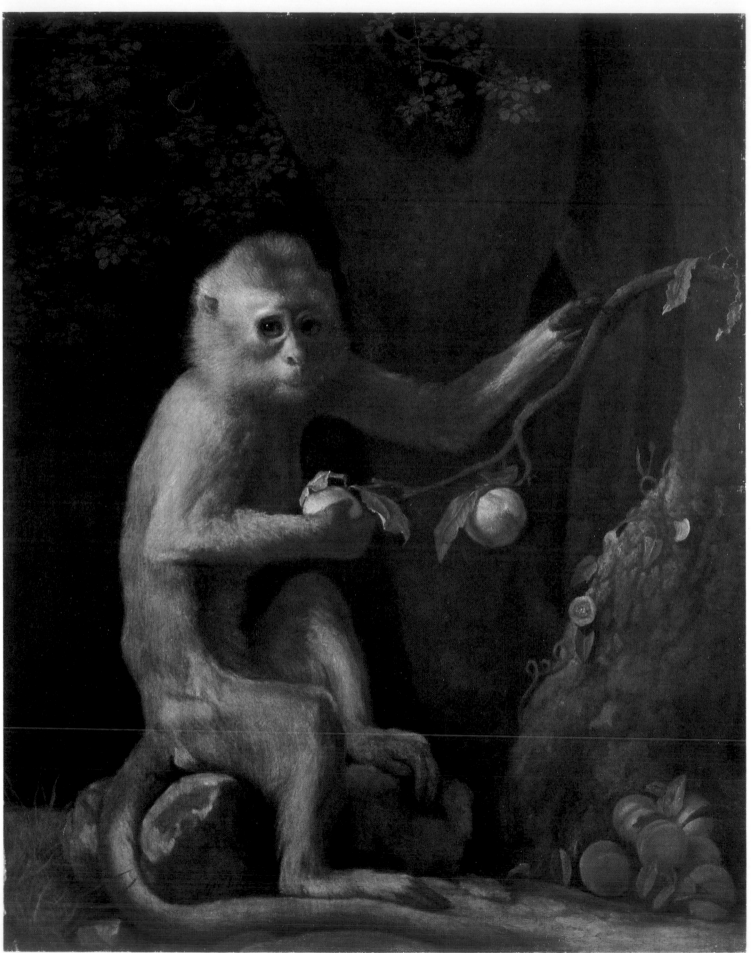

The exotic, the lovable, the hostile:

the category of 'animals observed' must not exclude any particular attitude. Stubbs's *Green Monkey* (left, *88*) of 1798, is another of the 'museum' paintings for John Hunter. It is probably a crab-eating macaque from South-East Asia, and would not normally eat the rich fruit shown. Nor is 'green monkey' an accurate description, though there is a greenish tinge to the fur. Stubbs warmly evokes the animal's character while intellectually keeping his distance: he is still a scientific observer. Can one say the same of Rosa Bonheur's sheepdog *Brizo* (below, *89*), painted sixty years later? It is easy to accuse her of sentimentality, but the charge depends on the choice of an appealing subject rather than on the way it is treated. Kokoschka's *Mandrill* (right, *90*) runs no such risk. Kokoschka painted it while staying in London in 1926 'The director of the London Zoo was the eminent scientist Julian Huxley . . . He granted me permission to paint in the Zoo outside normal visiting hours. At night in the Monkey House, I painted a big, solitary mandrill, who profoundly detested me, although I always brought him a banana in order to make myself agreeable.'

90

89

The Beauty and Energy of Animals

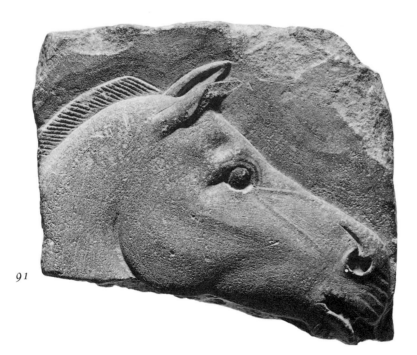

91

Man has found in animals

embodiments of many qualities which exist
primarily in his own mind or imagination.
A gazelle has 'beauty' because its shape and
movements make us aware of grace, harmony
and proportion. A lion leaping on its prey
has 'energy' because it makes manifest
forces that are greater than our own and
which excite our awe and fear. Both words
tell us less about animals than about human
attitudes to the natural world. One attitude is
characteristically Classical, the other
characteristically Romantic.

As we saw in the last chapter, the horse is
an animal which has preoccupied artists
throughout history, and which has played its
part in both these contrasting world views.
As an embodiment of beauty it can be traced
back to the second millennium BC. The relief
on the left (*91*) is not Greek, as one assumes
at first sight, but Egyptian. It was carved
during the Eighteenth Dynasty, about
1350 BC. As an embodiment of energy the
horse finds splendid expression in the work
of Géricault. His *Chasseur* (*92*) was painted in
1812. The man, a cuirassier in the army of
Napoleon, does not so much dominate and
control his horse as unite himself with its
elementary energy; he is immersed in it
and part of it. Through this union he becomes
heroic. In later paintings (see p. 157) Géricault
was to show man as inferior to and defeated
by such elemental forces – the heroic vision
turning into the tragic.

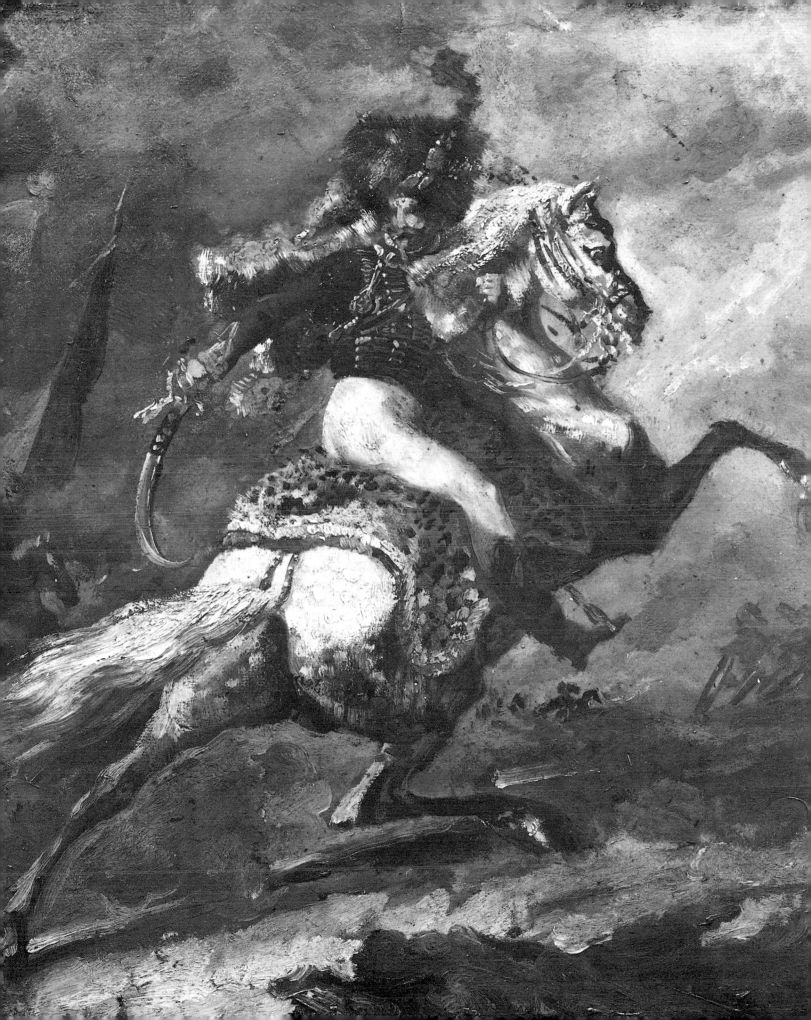

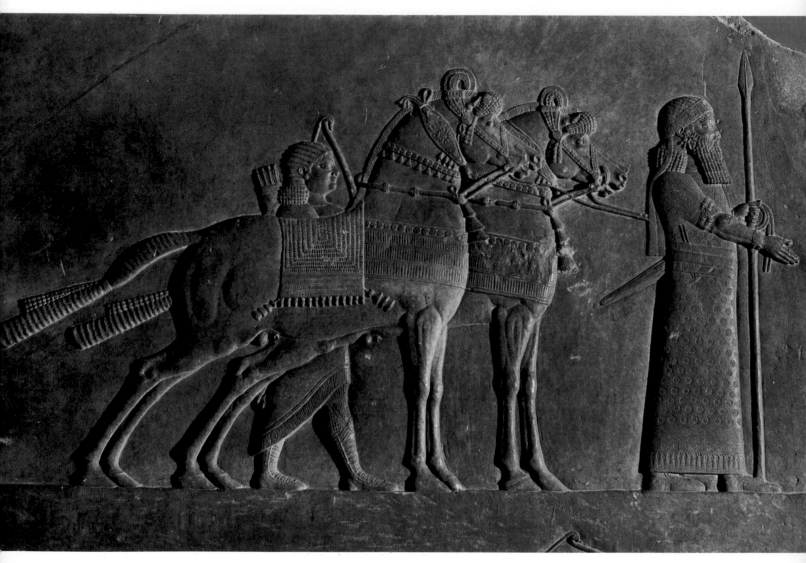

93

The Assyrian artist who carved, or supervised, the series of hunting reliefs on the walls of Assurbanipal's palace at Kyunjik had a sympathy for animals and an ability to create living images that has hardly been rivalled since. His work was no doubt meant to glorify the King and his lords. But for us the heroes of the hunt are the horses and the lions (who appear later, p. 200–201). The animals speak to us; the men are silent. (*93, 94*)

94

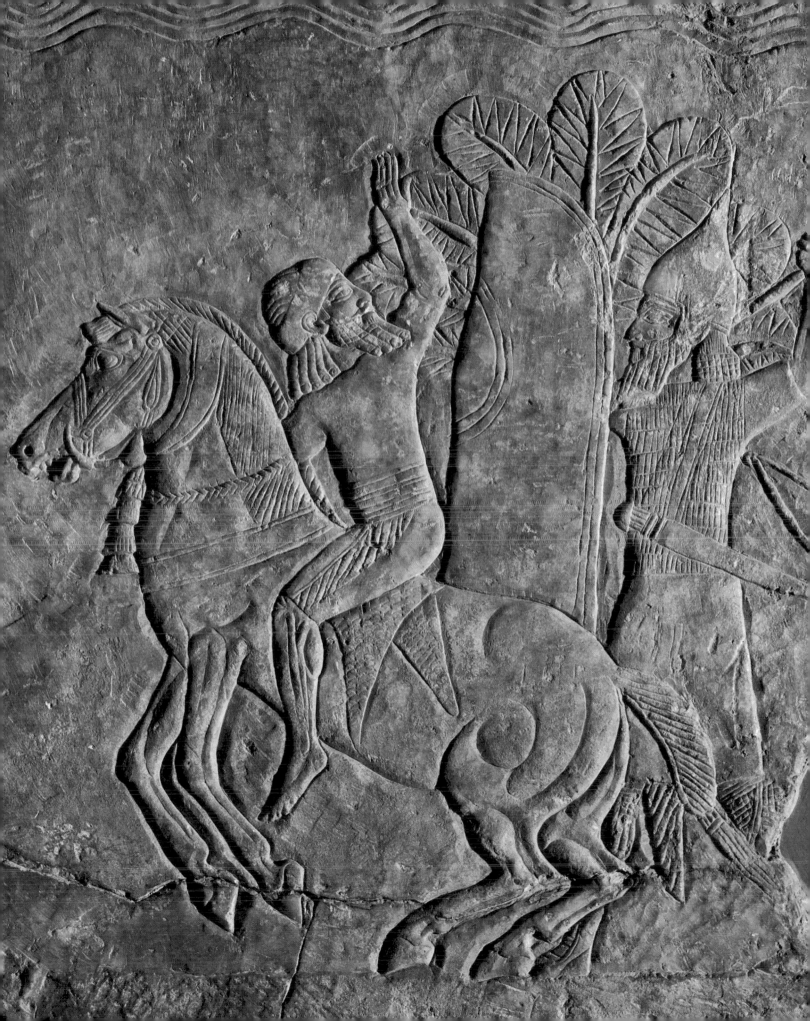

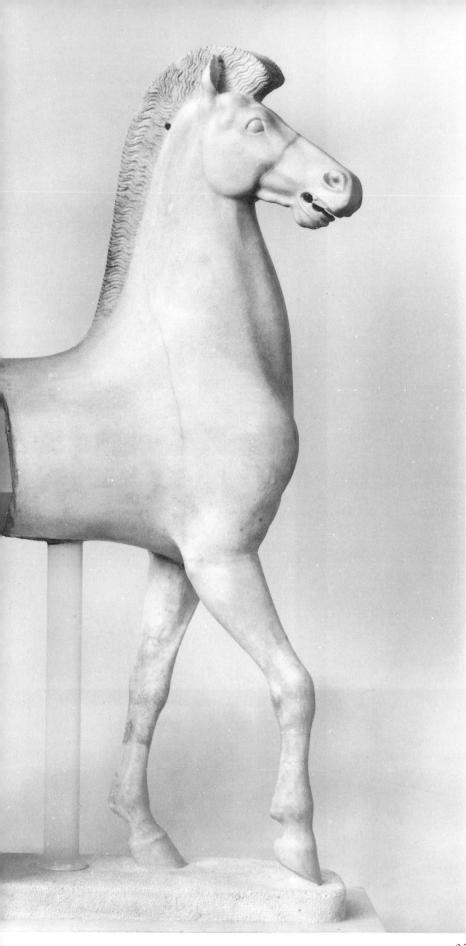

Pride in horses

is a constant theme of the Homeric poems ('Hector, tamer of horses') and remained associated with heroic excellence throughout Greek art. Left (95): fragment of a marble horse from the Acropolis, Athens. Right (97): horses from the frieze of the Siphnian Treasury at Delphi, c. 525 BC. The formal beauty of the horse's body is already clearly conceived and economically rendered. To this the horses of the Parthenon (above, 96) add liveliness and movement – 'energy', it may be called, but energy still firmly restrained and held in check.

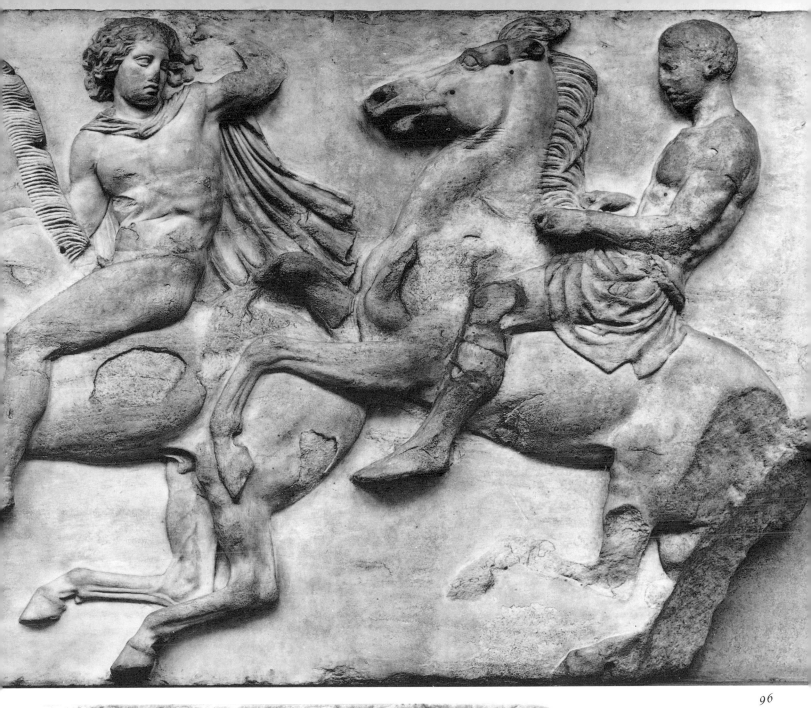

96

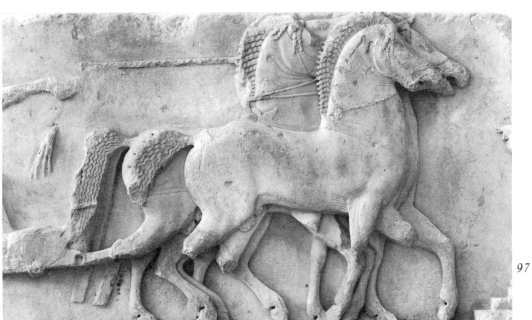

97

137

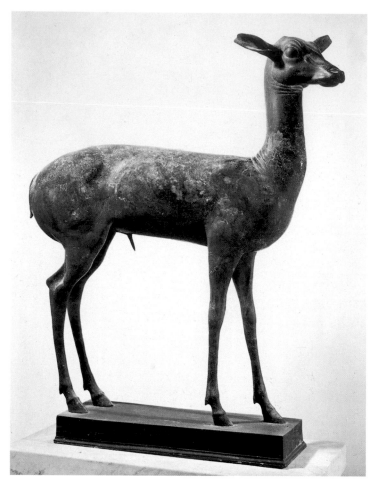

98

The animals in Roman art

look back to Greek or Hellenistic models,
and it is difficult to know how far they reflect
a genuine Roman sensibility. The little
bronze hind (*98*) found at Herculaneum
was probably a fountain ornament. Its shy
glance and nervous tenseness of the legs are
beautifully observed. The most famous
horses of Antiquity, the horses of St Mark's
(right, *99*), present a more formal composition,
though endowed with equal vitality. Whether
they are fifth-century Greek works or copies
made for the Emperor Nero is uncertain; but
they adorned Nero's Golden House in Rome,
and after the division of the Empire were
transferred to the Hippodrome at
Constantinople. In 1204 the Venetians carried
them off as war booty and placed them first
outside the Arsenal and then on the façade
of their cathedral.

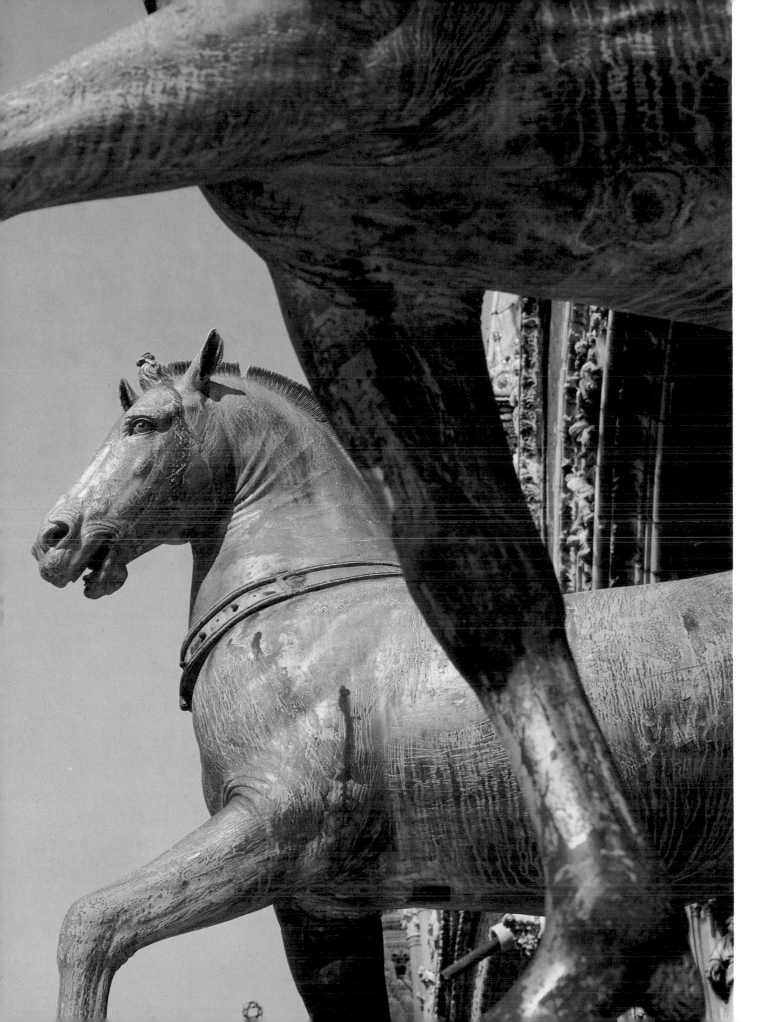

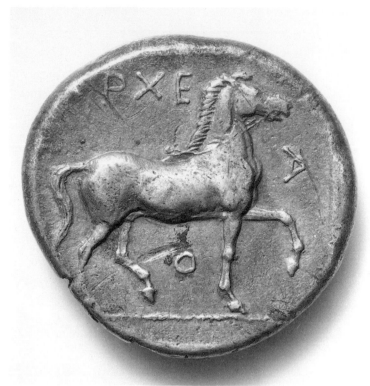

101

100

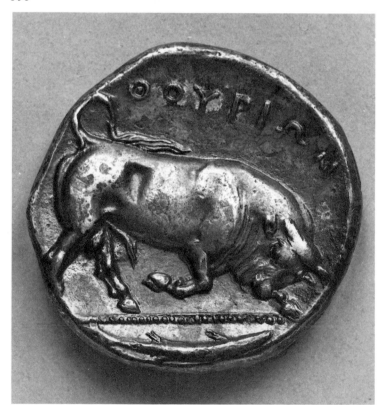

102

Some of the most perfect

representations of animals are found on Greek coins, where the tiny scale forced the artist to simplify his forms but allowed him enough detail to bring them to life. Far left (*100*): a coin from Agrigentum, Sicily, 413–406 BC. The crab was an emblem of Agrigentum, which also identified itself as the spot from which Scylla, the sea-monster, fell upon those hard-pressed seamen who had escaped the whirlpool of Charybdis. Left above (*101*): from Syracuse, fifth century BC. The horse seems to have been a symbol of independence.

Left below (*102*): from Thurium, in southern Italy, first half of the fourth century BC. The emblem of the bull was either taken over from the neighbouring city of Sybaris, or represents the bull of the fountain of Thourios, after which Thurium was named. Below (*103*): another Syracusan coin, 425–406 BC. Above a four-horse chariot, *quadriga*, hovers the winged figure of Victory, crowning the charioteer. The armour at the bottom represents spoils captured by Syracuse from the Athenians.

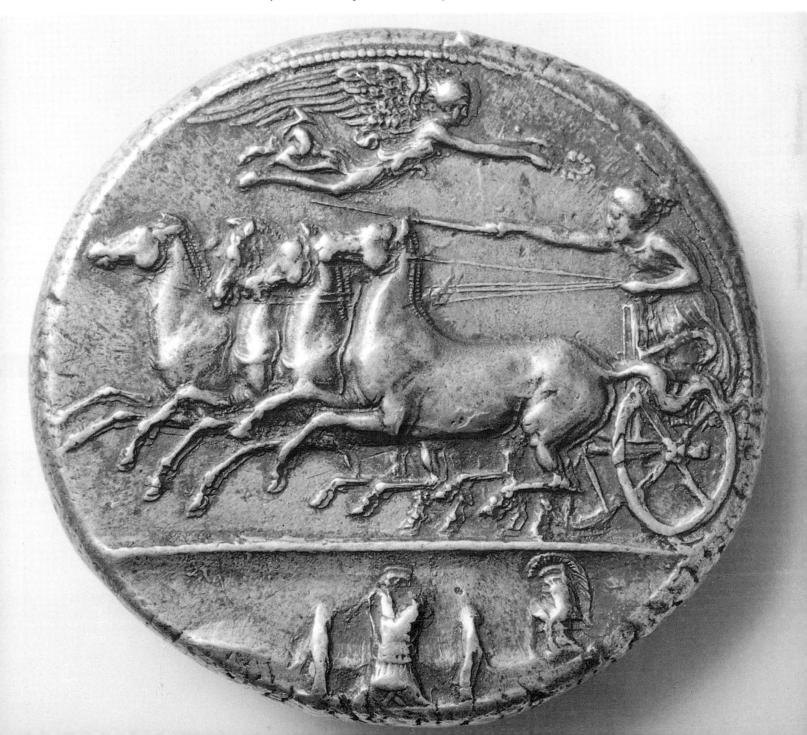

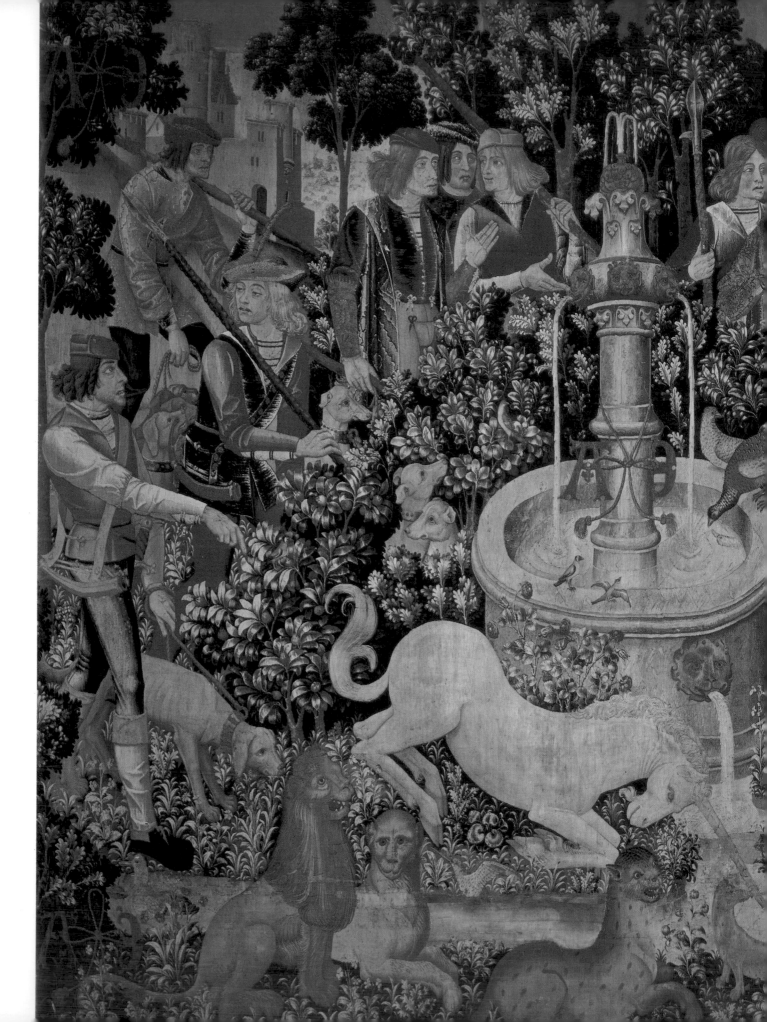

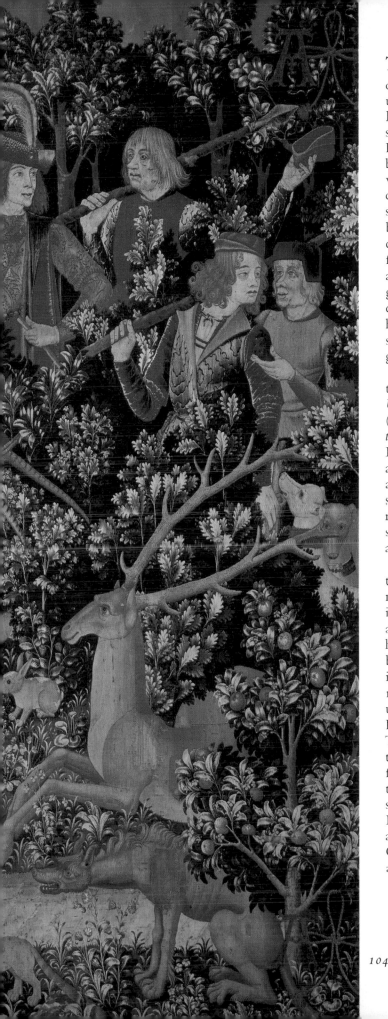

The most beautiful animal

of the Middle Ages never existed. It was the unicorn. Greek writers reported that there lived in India a dangerous animal with a single horn which was an antidote to poison. Physiologus transmits the story that it could be captured only by a virgin, in whose lap it would submissively lay its head. This connection with virginity gave the unicorn a symbolic value to the medieval Christian, but it seems never to have been clearly decided exactly what it symbolized. By the fifteenth century it was represented as an animal of radiant beauty, a white pony with a goat's beard. Although its existence was certainly believed in (were not the narwhals' horns that appeared regularly in Europe sufficient proof?), it kept much of the glamour of myth.

Two series of tapestries have immortalized the unicorn in art. One is the *Hunt of the Unicorn* in the Metropolitan Museum (Cloisters), New York; the other the *Lady and the Unicorn* in the Cluny Museum, Paris. Both were made in the late fifteenth century, and are full of that delight in plants, animals and the natural world that characterizes the style known as International Gothic. On the next six pages five tapestries from the two series are illustrated; a detail from a sixth appears on p. 207.

The Unicorn at the Fountain comes from the New York series. In some ways it is the most puzzling. Hunters surround the unicorn in what seems like a paradise garden. There is a lion, a lioness, a panther, a civet and a hyena, as well as a stag, dogs, rabbits and brightly coloured birds. From the fountain in the centre, through a lion's mouth, water runs into a small pond or stream. In this the unicorn dips its horn. What does it mean? Probably the water is the Water of Life. The unicorn is purifying it from the poison of the serpent so that all the animals may drink from it ('The hart' once again 'panteth after the water brooks'). Like Christ, the unicorn, serving others, endangers and sacrifices itself. But as well as Heavenly Love the unicorn also seems to have acquired the meaning of Courtly Love and the two themes, religious and secular, became inextricably blended. (*104*)

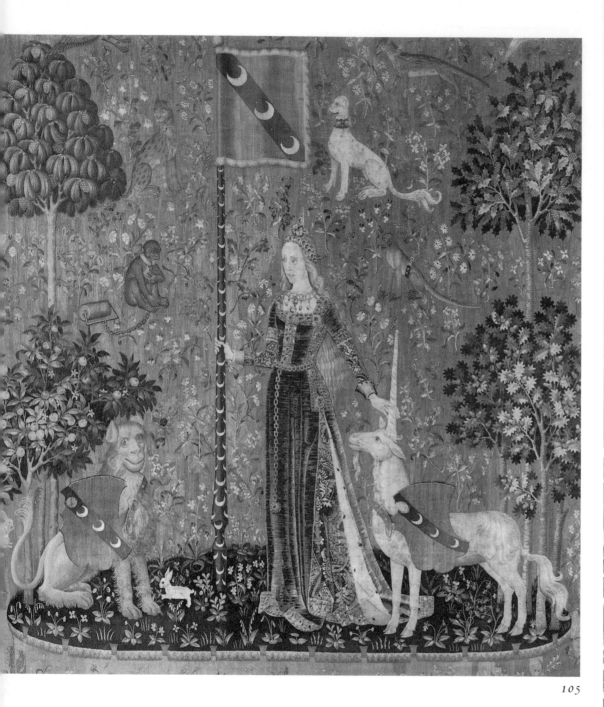

105

The Lady and the Unicorn

at the Cluny Museum is a series of allegories of the senses, each of them featuring the Lady, the lion, the unicorn and various other dramatis personae. These two stand for *Touch* (*105*) and *Sight* (*106*). In the first the Lady is touching the unicorn's horn. In the second she holds a mirror in which the unicorn can see himself. This tapestry contains the usual rich assembly of animals including a monkey chained to a roller to stop it climbing trees.

106

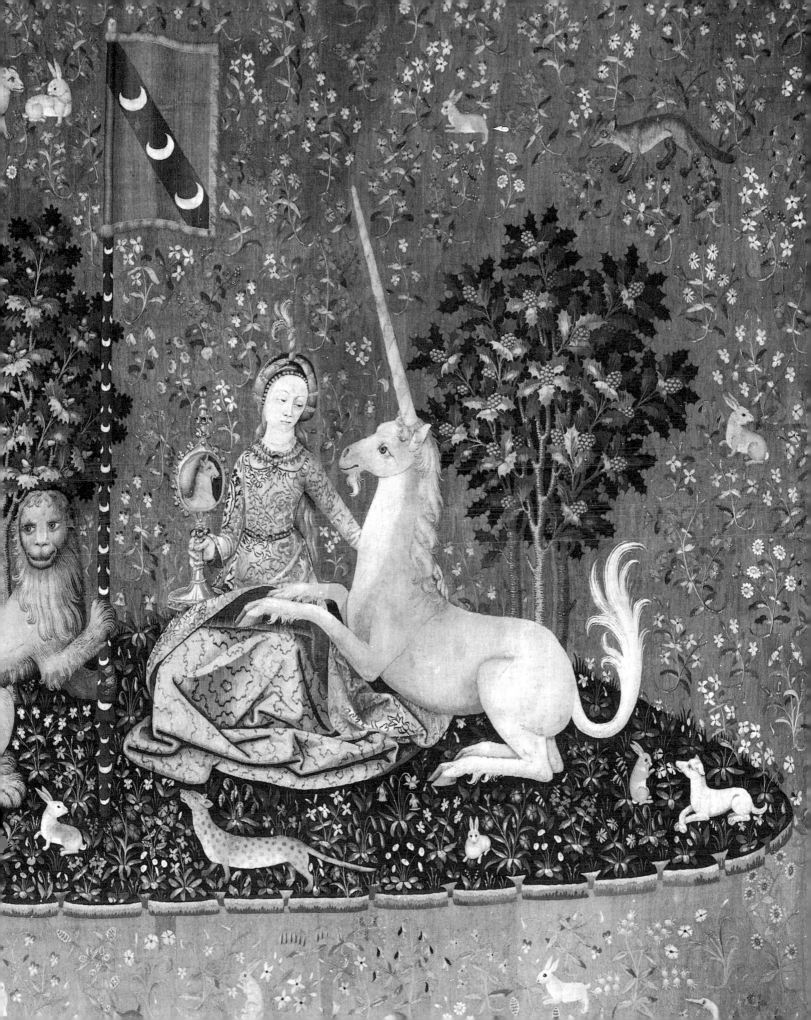

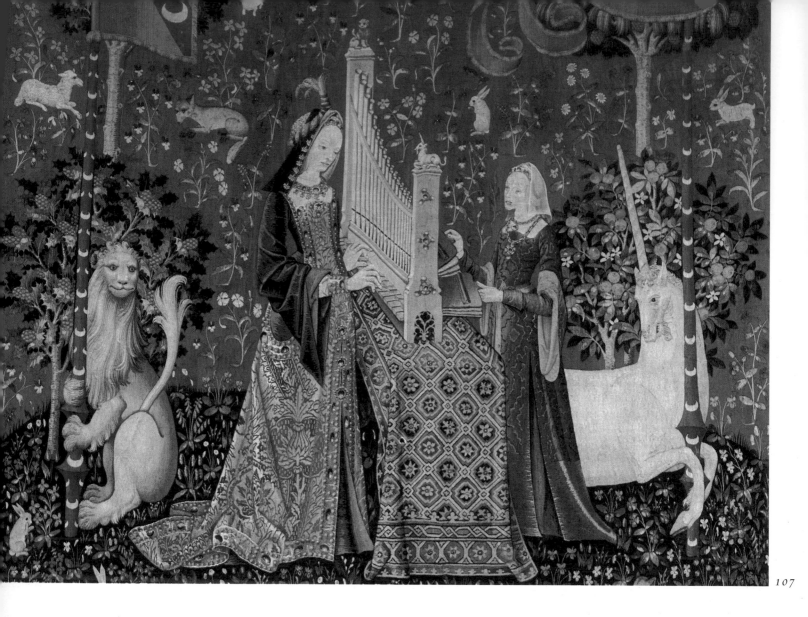

107

The unicorn's magic

did not outlive the Middle Ages, though it survives as a heraldic companion to the English lion. In the sense of *Hearing* (above, *107*) from the Cluny series the Lady plays a small organ while her attendant works the bellows. Opposite (*109*): *The Captive Unicorn*, the last of the New York series. Enclosed by a fence, chained with a golden chain to a pomegranate tree, the unicorn seems reconciled to its fate – the Risen Christ (according to some), symbol of eternal rebirth. Domenichino's seventeenth-century painting in the Farnese Palace (right, *108*) is among the latest treatments of the theme to retain some genuine poetry. Trustingly the unicorn, which was also the emblem of the Farnese family, lays its head on the virgin's lap, amid the lush landscape of the Roman Campagna.

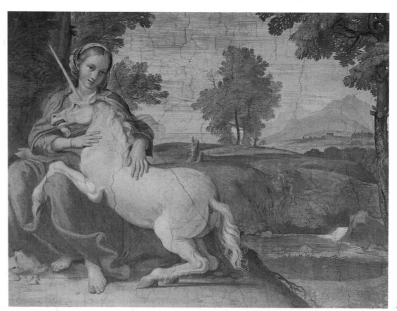

108

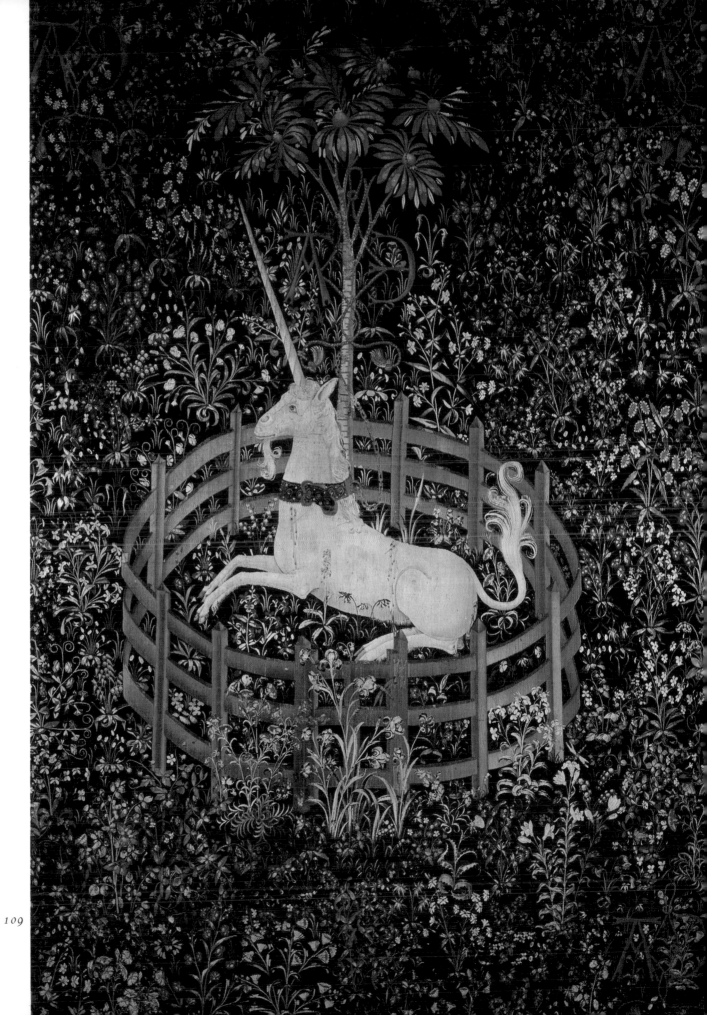

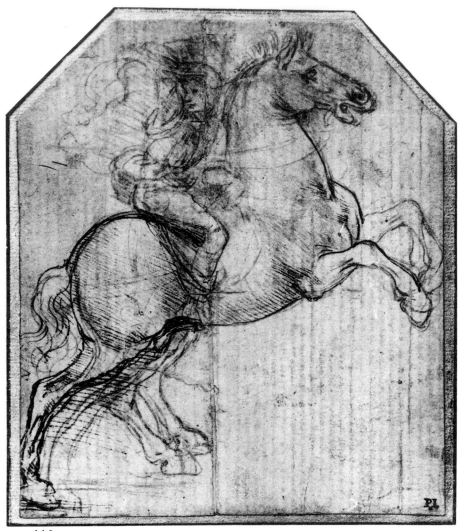

110

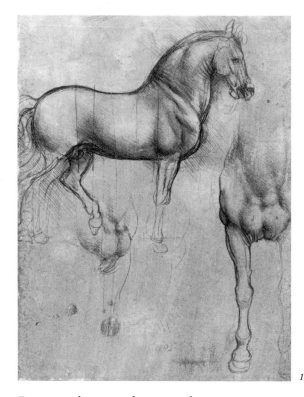

112

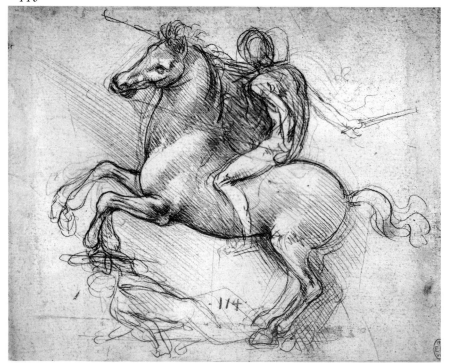

114

111

Leonardo was haunted

by the image of horses. Like Stubbs, he made
a scientific study of the anatomy of the horse,
fascinated both by the formal beauty of its
body in repose (above, *112*: a drawing of
about 1490) and by its wild, superhuman
energy in motion. The upper drawing on the
left (*110*) is probably connected with the
Adoration of the Magi in the Uffizi; the
lower (*111*) is a preliminary idea for the
Sforza monument, on which he worked
during his first stay in Milan. Typically,
the expressive pose of the rearing horse goes
far beyond any practical realization in bronze.
His preoccupation reached its climax in *The
Battle of Anghiari* painted in fresco in the
Palazzo Vecchio, Florence, in 1503–6. Here
the ferocity of the human protagonists, their
faces distorted with rage, is equalled or
surpassed by the ferocity of the horses. A
preliminary drawing (lower right, *114*) shows
that this parallel was explicit and deliberate.

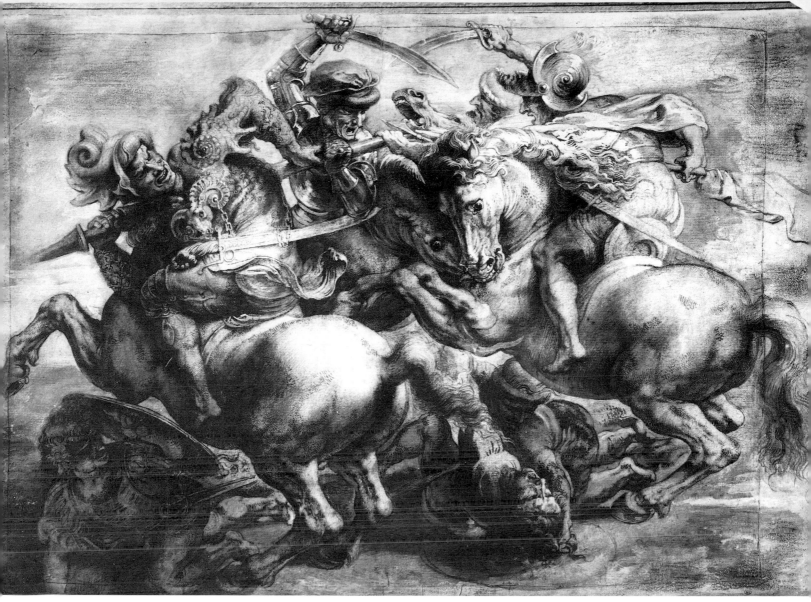

113

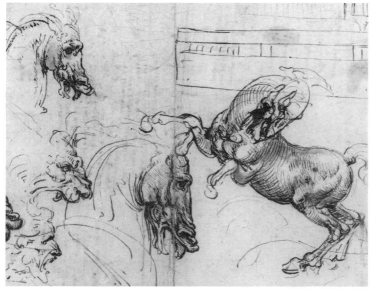

114

The Battle of Anghiari hardly outlasted its creator. Leonardo's experimental fresco technique was a failure, and the decomposing fragments were probably destroyed by Vasari when he repainted the room later in the sixteenth century. Only copies of it survived, but from one of these Rubens was able to re-create something of its original overwhelming power (above, *113*). Rubens was greatly influenced by it in his own work. He had little interest in domestic animals or pets, but he rejoiced in painting the gory struggles of mighty beasts, symbols of passions unleashed. His vast *Lion Hunts* ▷ (overleaf, *115*) created a new genre, displaying a delight in unrestrained violence for which there is hardly any precedent. Such a picture is already a complete expression of certain Romantic values. Delacroix himself could go no further.

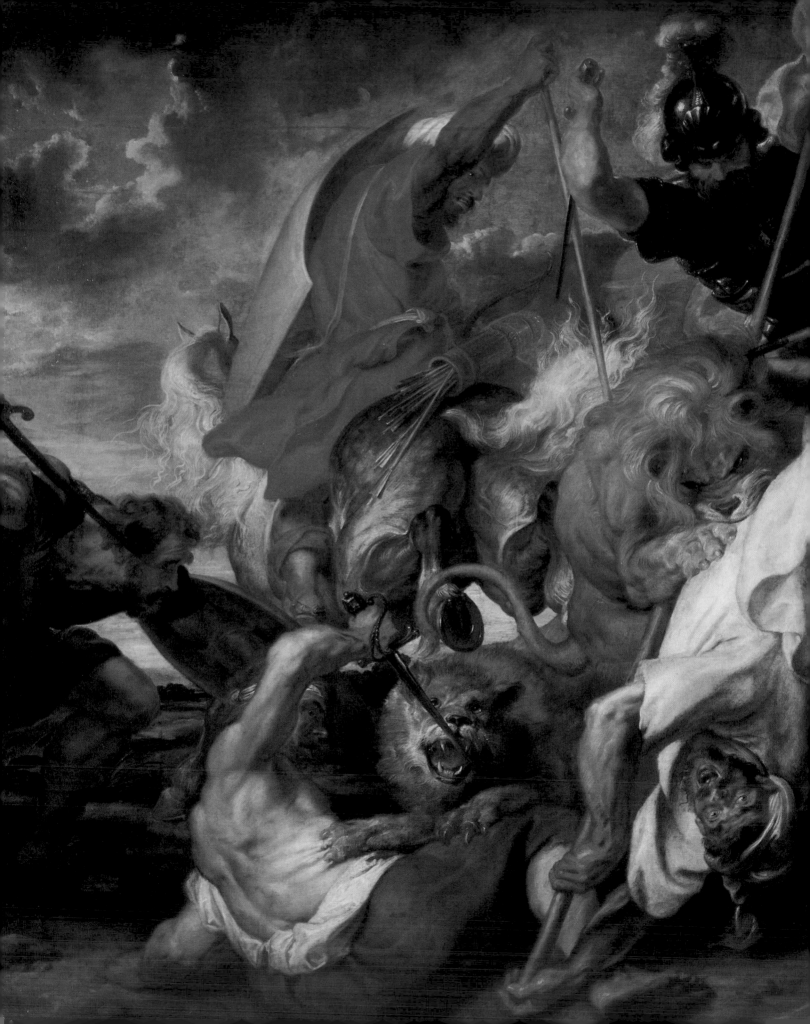

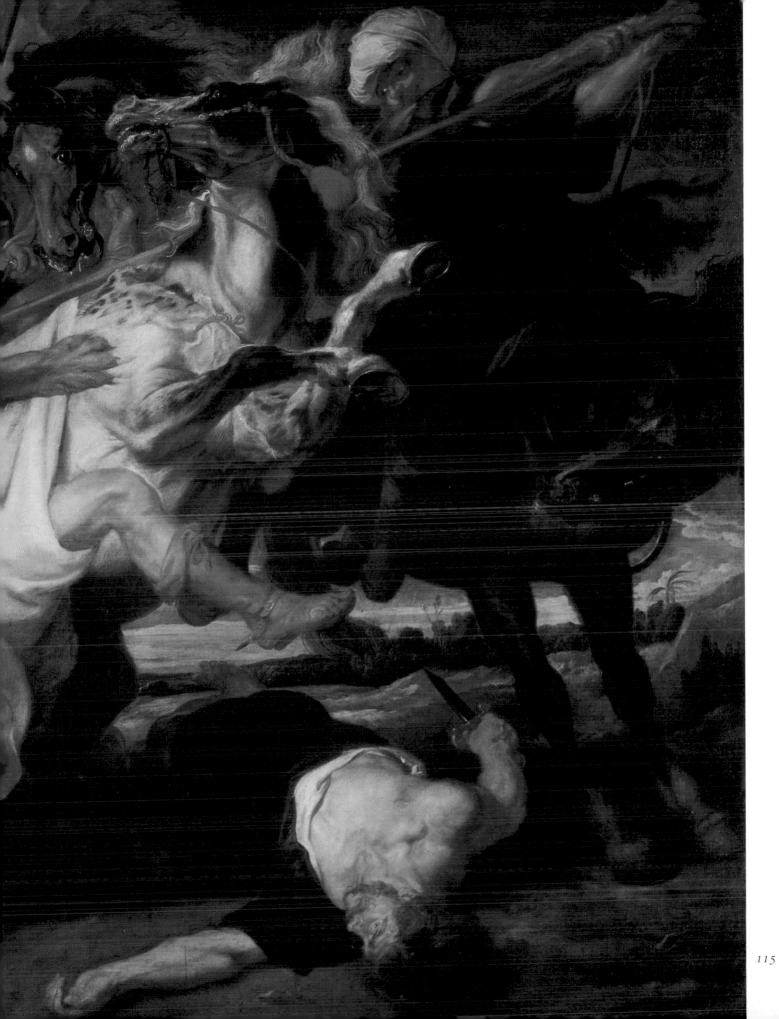

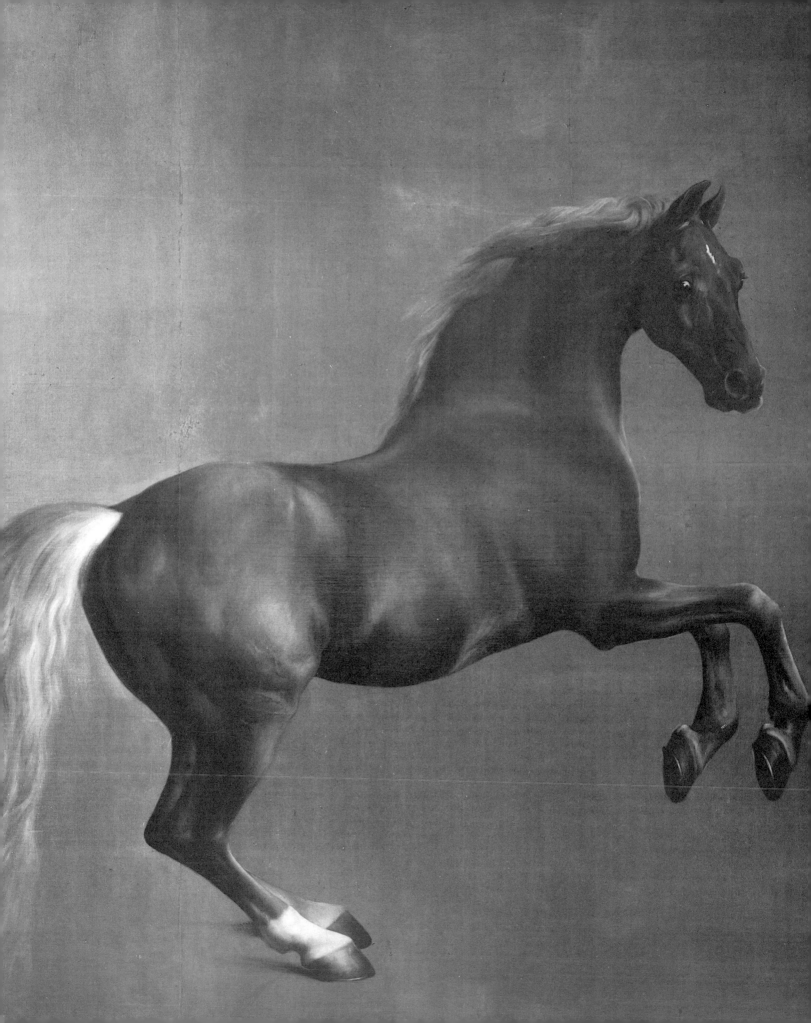

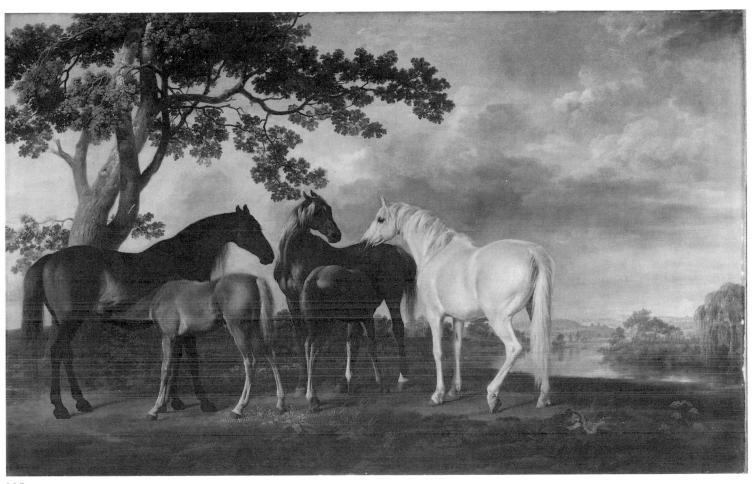

117

Stubbs's genius

is in many ways comparable to Leonardo's.
For both, the line between reality and the
transformation of reality into images of
beauty and energy was an artificial one.
Whistlejacket (left, *116*) is the closest he comes
to creating the ideal horse. It was painted for
Lord Rockingham and has a curious history.
The original idea was for a life-size equestrian
portrait of George III to be painted by three
artists: the best portraitist was to do the
portrait, the best landscapist the landscape,

and the best horse-painter (Stubbs), the horse.
But when Stubbs had finished his contribu-
tion, Rockingham, to his credit, recognized
that he had a masterpiece, and decided to
leave the picture as it was. *Mares and Foals in a
Landscape* (above, *117*) has something of the
same perfection, though the mood is relaxed.
Arranged in a fairly narrow band across the
picture, the horses form a frieze in which
shape echoes shape and line follows line with
a lucid mastery of composition.

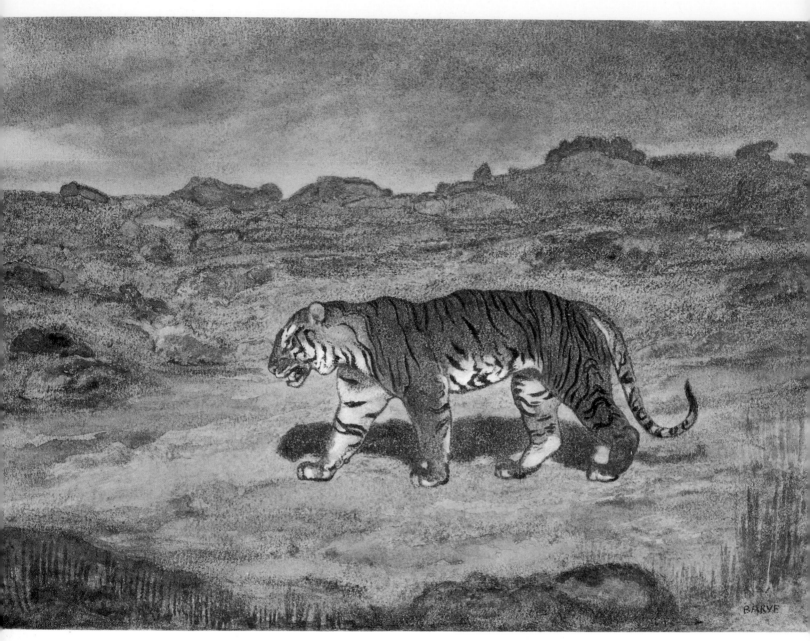

'*The tigers of wrath,*' said Blake, 'are wiser than the horses of instruction.' Spontaneous emotion and natural instinct, in other words, are more genuine guides than the intellect and man-made rules. The Romantics turned their backs on the cultivated garden of civilization and strode into the jungle. Antoine-Louis Barye is chiefly famous for his animal sculptures where fierce beasts sink their teeth into each other. His watercolours (above, *118*) have the same truth to nature but are less melodramatic. Delacroix, like Barye, regarded animals as noble in themselves, and had particular sympathy with the great cats. His *Young Tiger with its Mother* (lower right, *120*) is probably the same animal drawn by Barye at St Cloud. The drawing of the head of a cat (upper right, *119*) may be a domestic pet, of which he had a large number, or a wild cat which he had seen in Africa. Delacroix himself, says Gautier, 'had tawny, feline eyes, with thick, arched brows, and a face of wild and disconcerting beauty; yet he could be as soft as velvet, and could be stroked and caressed like one of those tigers whose lithe and awesome grace he excelled in portraying.'

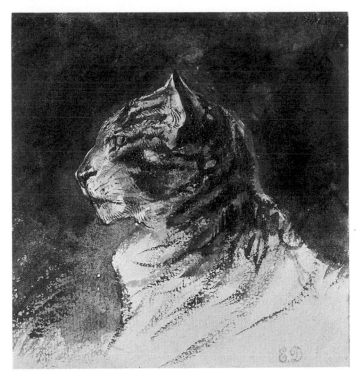

119

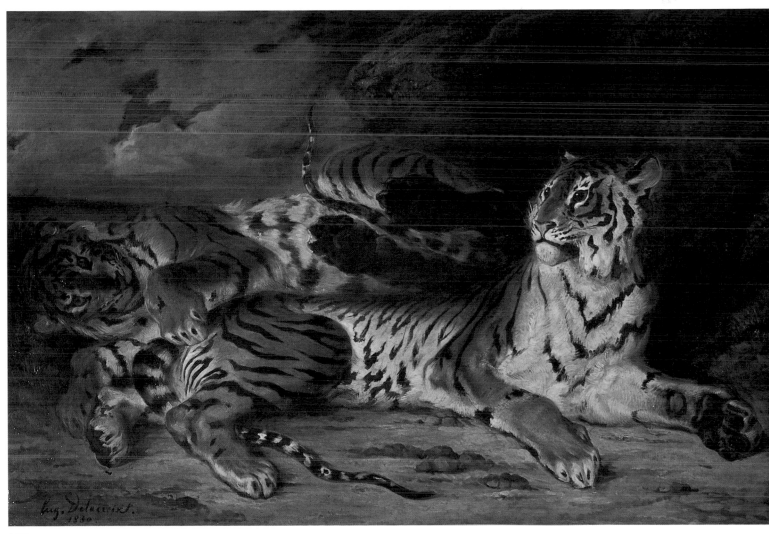

120

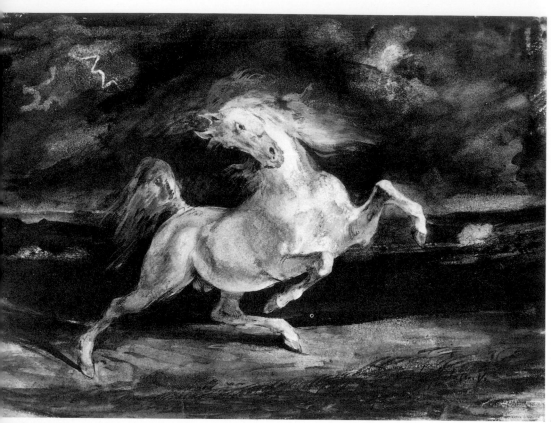

121

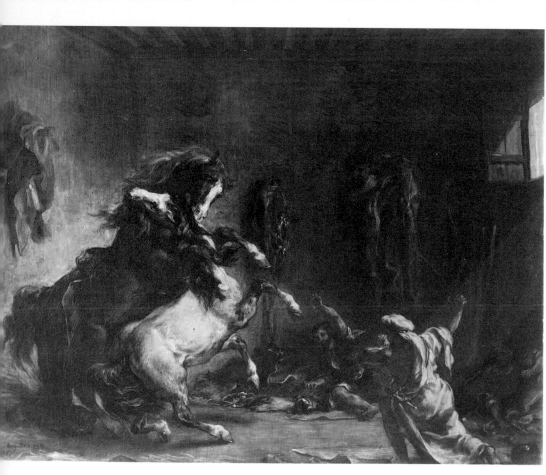

122

156 Beauty and Energy

all the most extreme emotions find expression in the animal paintings of Géricault and Delacroix. 'One must', wrote Delacroix, 'be very bold. One must be out of one's mind, if one is to be all that one might be.' In all these paintings the horses are literally out of their minds (*amens*), completely possessed by passion. Left: two works of Delacroix, *White Horse frightened by a Storm* (*121*) and *Horses Fighting in a Stable* (*122*); of the second, a scene

he had himself witnessed, he wrote: 'They reared up and fought with a fury that made me tremble.' Below: Géricault's *Race of the Riderless Horses* (*123*). Dumas describes this famous race, which took place in Rome. 'A detachment of carabinieri, fifteen abreast, galloped up the Corso in order to clear it for the wild horses . . . Almost instantly, amid a tremendous outcry, seven or eight of them passed by like lightning.'

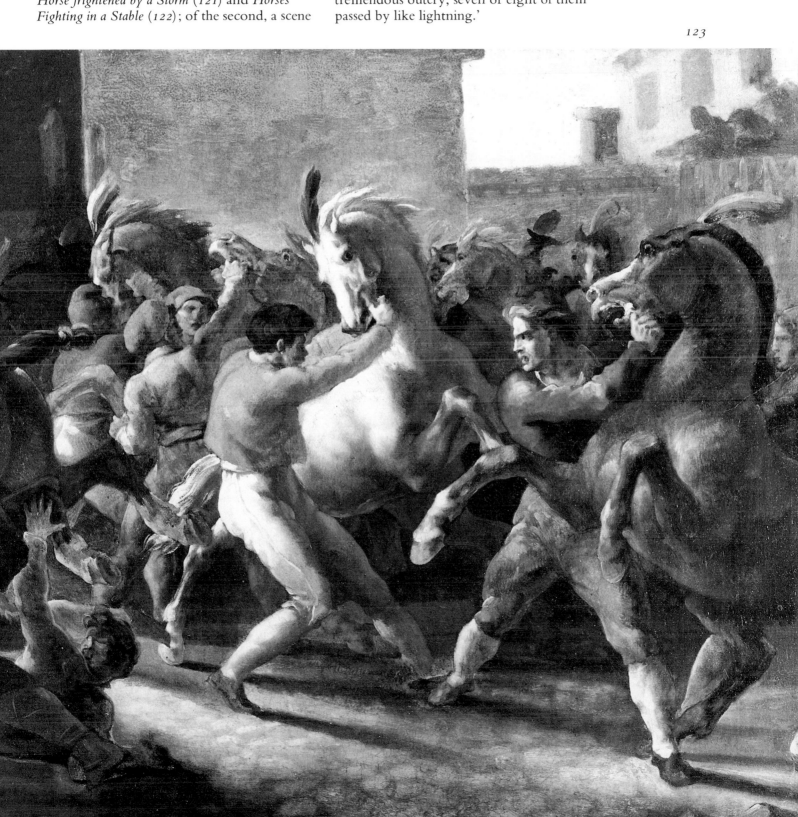

'*A terrifying confusion* of lions, men and horses . . . a chaos of claws, swords, fangs, lances, torsos and backs.' – Théophile Gautier of Delacroix's *Lion Hunts*, details of two of which are shown here. They are not, in fact, hunting pictures. They are episodes in an eternal battle between men and animals, reason and passion, civilization and nature. (*124, 125*)

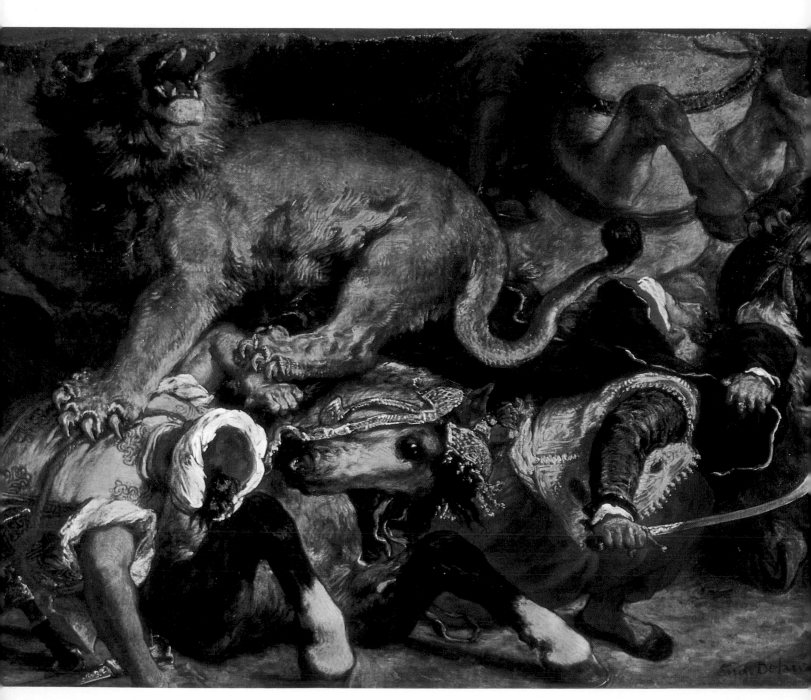

124

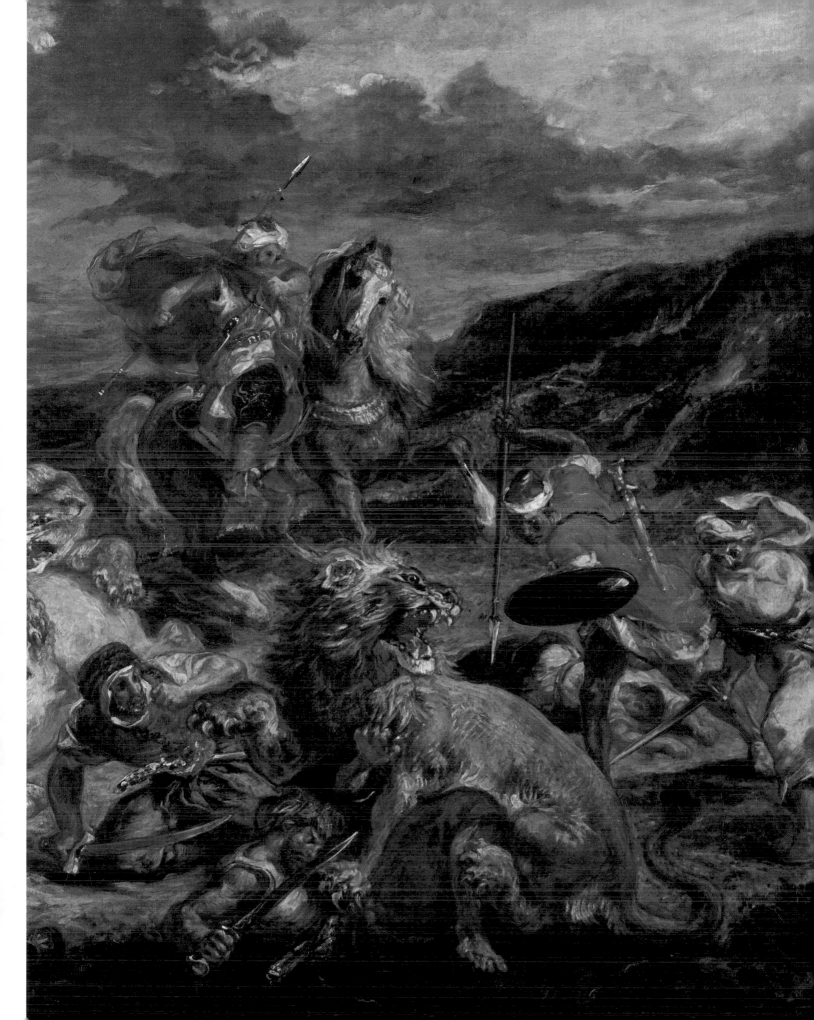

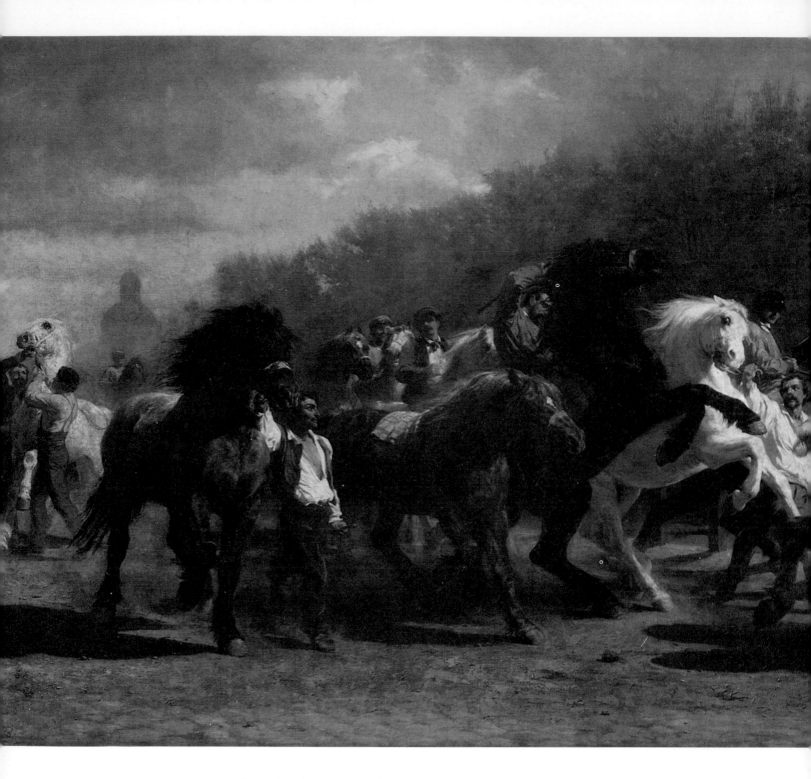

After the frenzies of Romanticism the public turned with relief to the gentler art of the mid-century. Rosa Bonheur's *Horse Fair* (1853–55) was one of the most popular paintings of its time. In it one can hear the muffled thunder of Delacroix and Géricault, like the distant echo of a receding storm. It has energy, but its energy is cheerful, not savage. Bonheur had studied

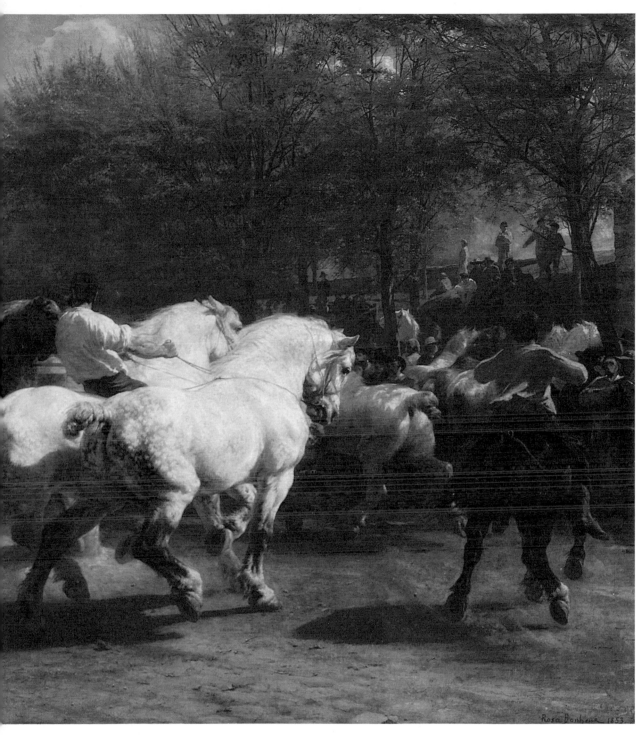

Rosa Bonheur 1853 126

animals with as much dedication as the rest;
it is said that she visited abattoirs and markets
dressed as a man in order to gain knowledge.
Stylistically she took something from both
Landseer and Barye. If there is little intellectual
or emotional force behind her pictures, they
have an authentic honesty which has
preserved them from changes in fashion. (126)

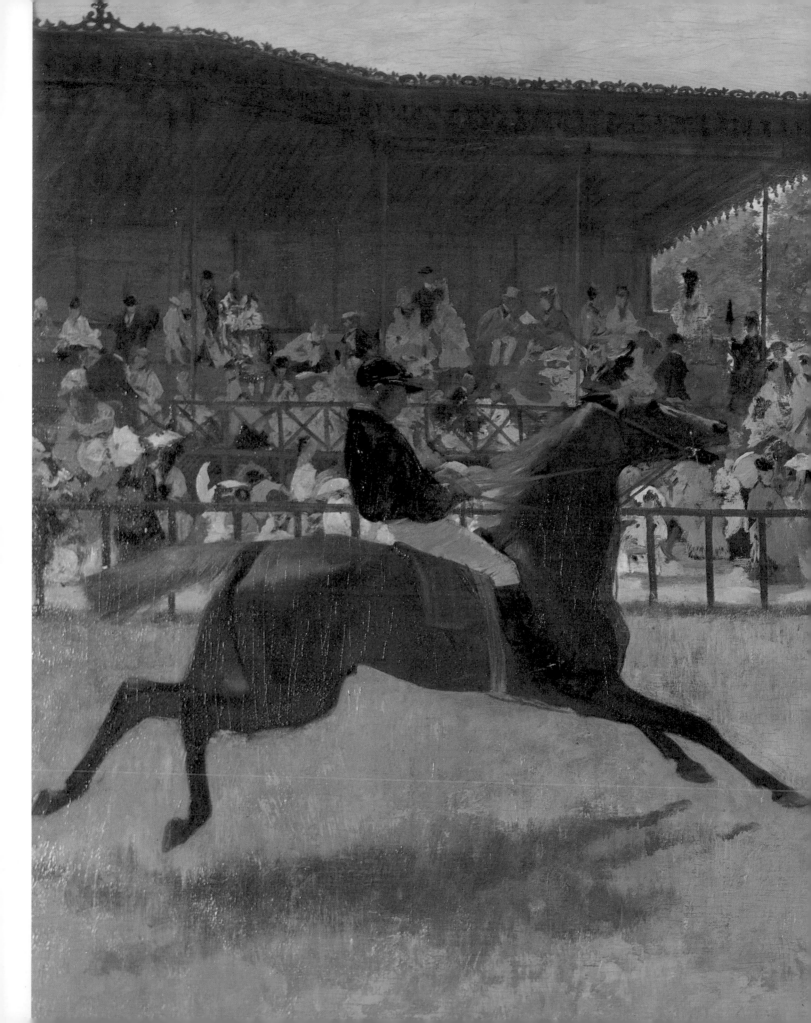

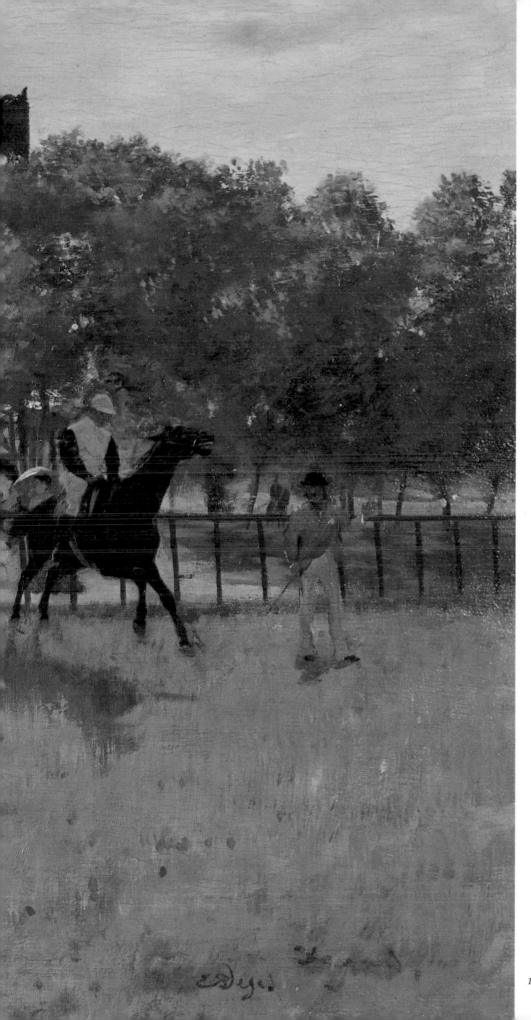

What Degas brought

to animal painting was an intensified sense of movement – movement in time as well as space. He loved the colour and excitement of the race-course, and part of that excitement lay in the awareness of where the horses had been the moment before and where they would be the moment after. In *The False Start*, painted about 1870, the horse is caught in a pose that obviously could not be held for more than an instant. The eye recognizes it as part of a sequence of movements, just as it does with Degas' other favourite subjects, the ballet dancers. By pushing the horse and grandstand to one side of the composition he suggests the space into which the horse is about to move. This technique is sometimes called 'photographic', so it is interesting to note that Degas retains the traditional pose of the galloping horse with outstretched legs, which Muybridge's photographs were soon to prove was a mistake: another case of observation being conditioned by the accepted *schema*. Degas did not in fact paint on the spot; he worked laboriously in the studio from drawings and models. 'One sees as one wishes to see,' he said, 'and it is that falsity that constitutes art.' (*127*)

Beauty and Energy 163

127

Animals Beloved

128

Love of animals

is nothing new, and at least from Greece onwards it is not difficult to find literary evidence for it. The visual record takes us even further into the past. From ancient Egypt, if not before, art is full of studies of animals that leave us in very little doubt about the artist's feelings. These can range from besotted affection to an almost complete objectivity. Paolo Veronese, a dog-lover himself, seemed to take special pleasure in showing children and dogs playing together; the detail on the left is from his *Supper at Emmaus* in the Louvre (*128*). At the other end of the emotional scale are Henry Moore's drawings of sheep (*129*). Like Cuyp's cows, one could easily put Moore's sheep into the category of 'Animals Observed', but he goes back to them so often and seems to feel such sympathy for their naïve dignity, that one is surely right to call them 'beloved'.

129

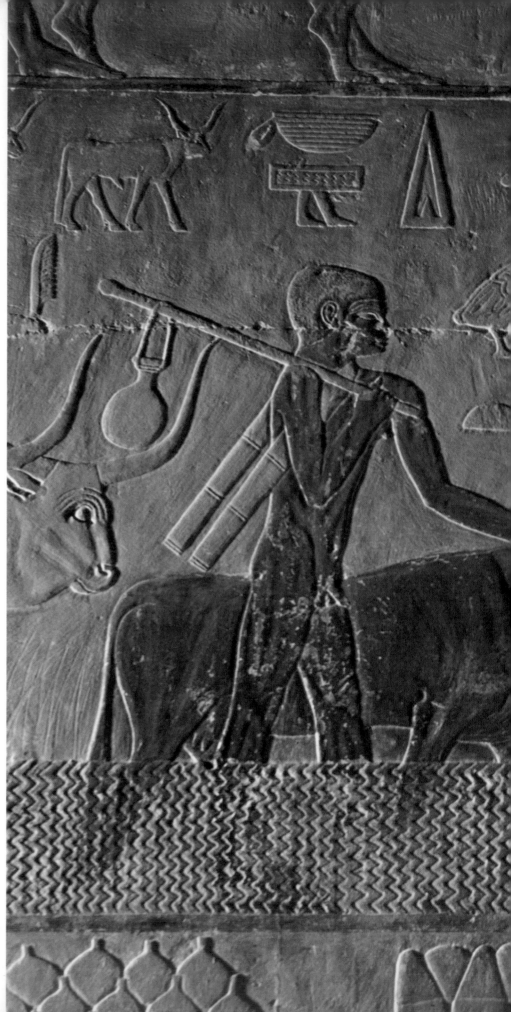

Herdsmen wade through a river

with their cattle. One man carries a calf on his back across the water. It turns back to look at its mother, and she raises her head to try and lick it. The painting comes from the Tomb of Ti, at Sakkara, a rich and varied source for scenes of daily life in the Nile valley about 2300 BC. Other details show wheat being harvested, donkeys laden, a cow giving birth, calves feeding and even cranes being herded together. The ancient Egyptians' love of animals is attested by the slightly cynical Herodotus, and a painting like this leaves us in no doubt about it. (*130*)

130

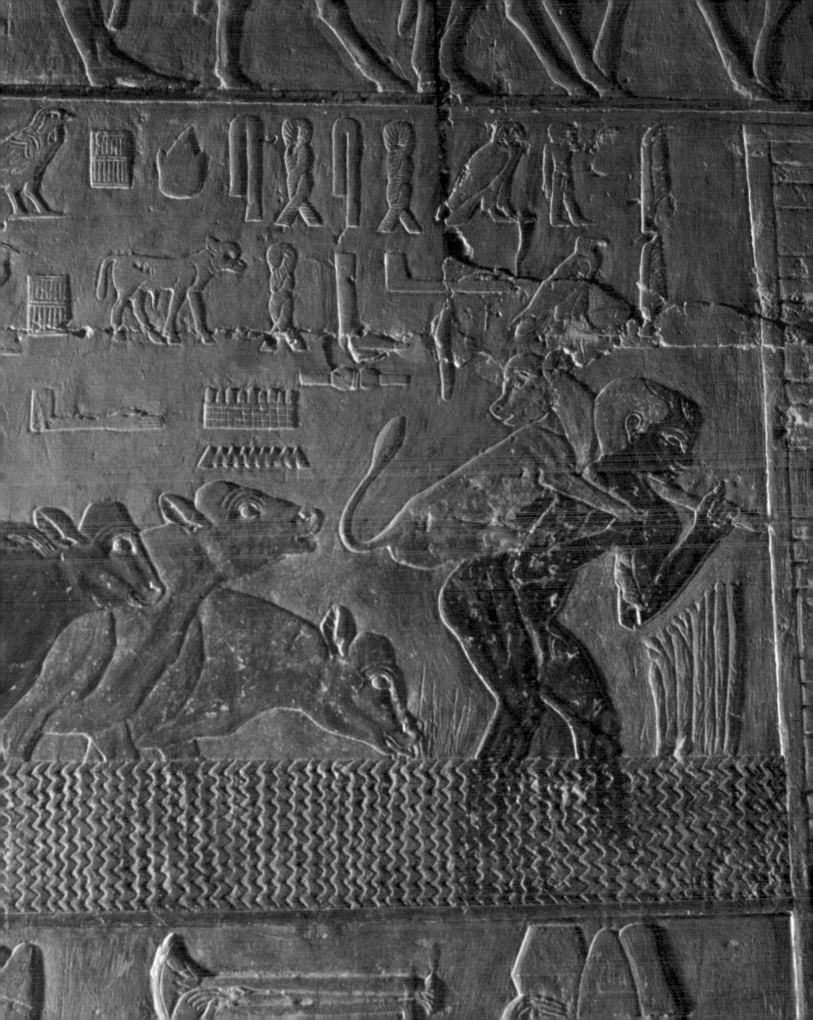

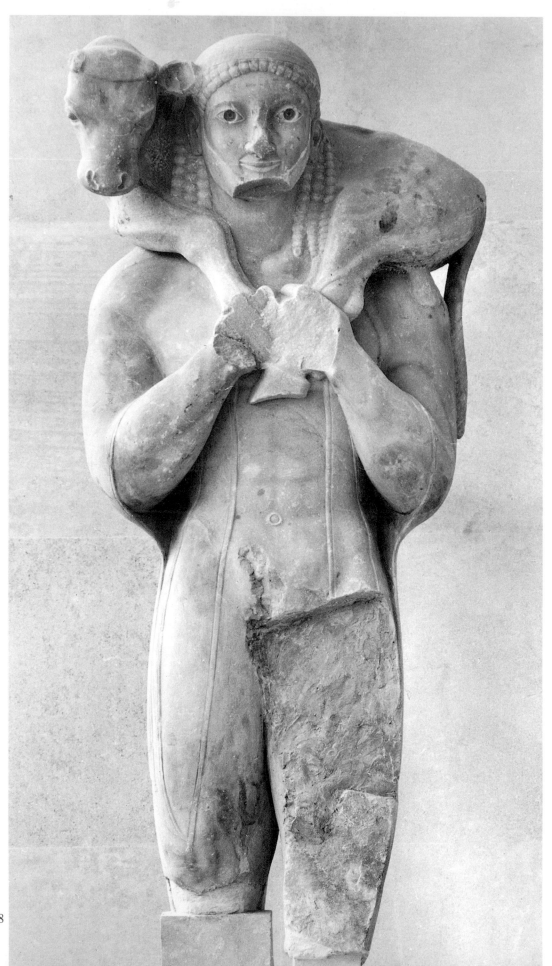

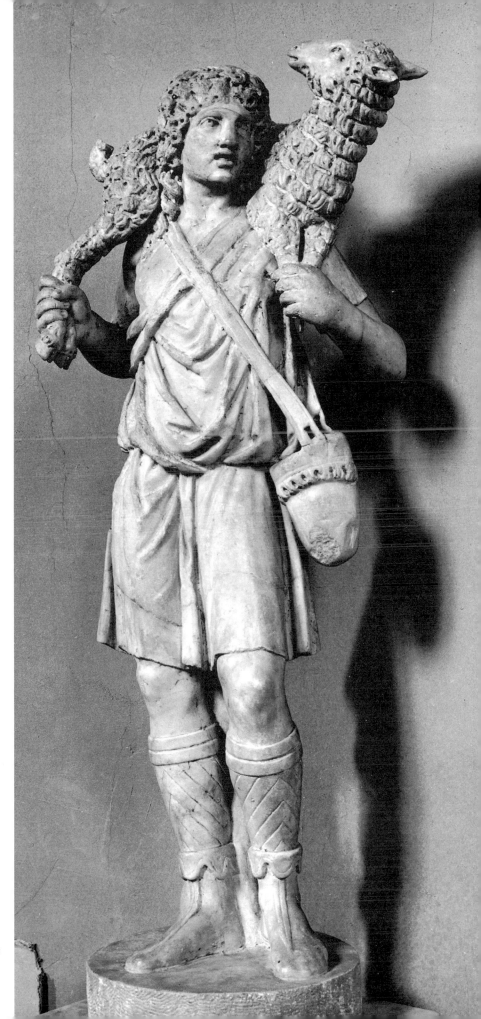

The image of the calf-bearer

passed from Egyptian into Greek art. The
marble group to the left (*131*) comes from the
Athenian Acropolis: carved about 570 BC,
it seems to make visible the unity of man and
animal. Yet an inscription on the base tells us
that it is dedicated by a citizen of the city to
the goddess Athena. The calf, in other words,
is a sacrificial offering. Is it absurd to think of a
man loving the animal he is about to sacrifice?
One remembers the story of Abraham and
Isaac, and how the sacrificial lamb of the Jews
eventually achieves its consummation in the
person of Christ, the Beloved Son. When the
figure of the calf-bearer emerges into
Christian art (right, *132*), the calf has become
a lamb. It is usually taken to illustrate the
parable of the sheep 'that was lost and is
found', i.e. the sinner saved by Christ, the
Good Shepherd. But at a deeper level may
not the memory of the sacrificial victim still
linger?

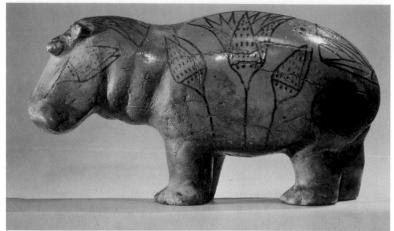

133

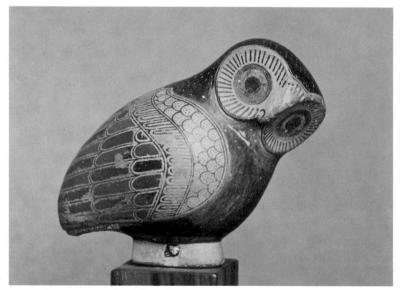

134

Playthings

or friendly supernatural powers? Perhaps all
toy animals, even today, are something of
both to the child who knows and loves them.
The Egyptian faience hippopotamus (*133*)
partook of the hippo's divinity, to be
described more fully later (p. *198*).
The owl (*134*) belonged to the wise and
mighty Athena; while the lively little bronze
piglet from Herculaneum (*135*) was
traditionally a symbol of good luck.

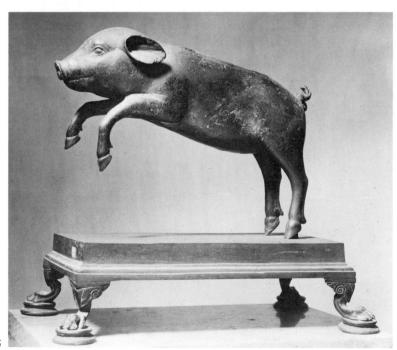

135

The cat was a goddess

in ancient Egypt – Bast, goddess of pleasure
and music, guardian against contagious
diseases and evil spirits. Herodotus says that if
an Egyptian's house caught fire he would
save the cats before any other of his
possessions. It was also a pious custom to
mummify the bodies of cats, and at Beni
Hasan a whole cat-cemetery has been
discovered. (*136*)

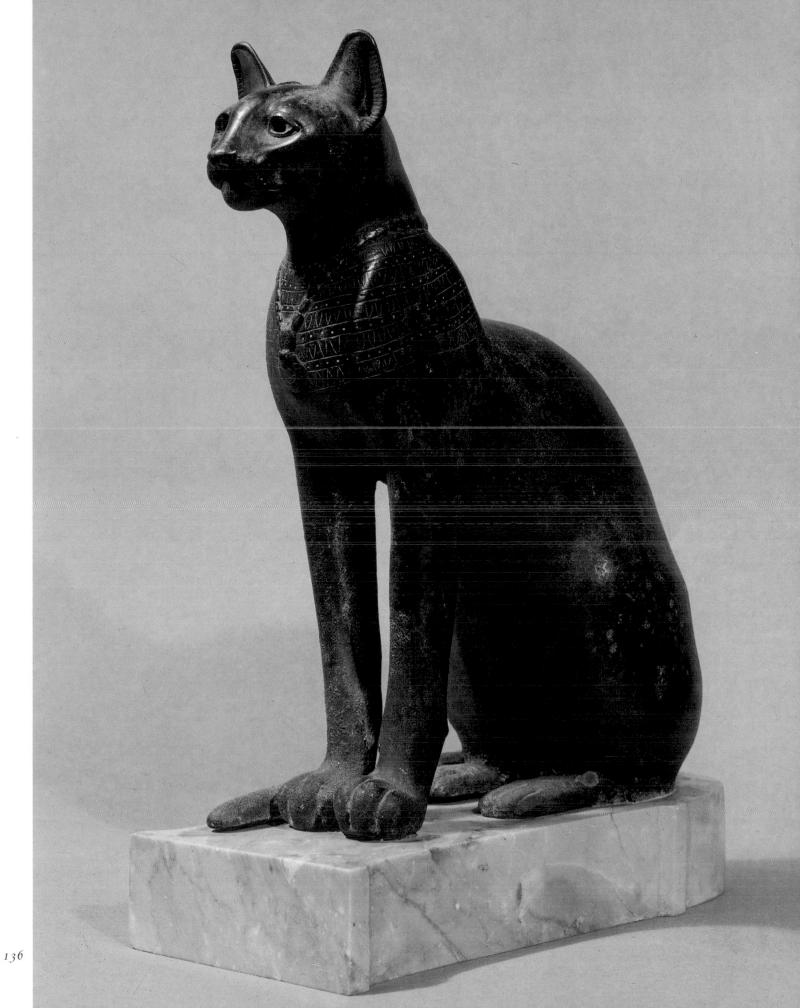

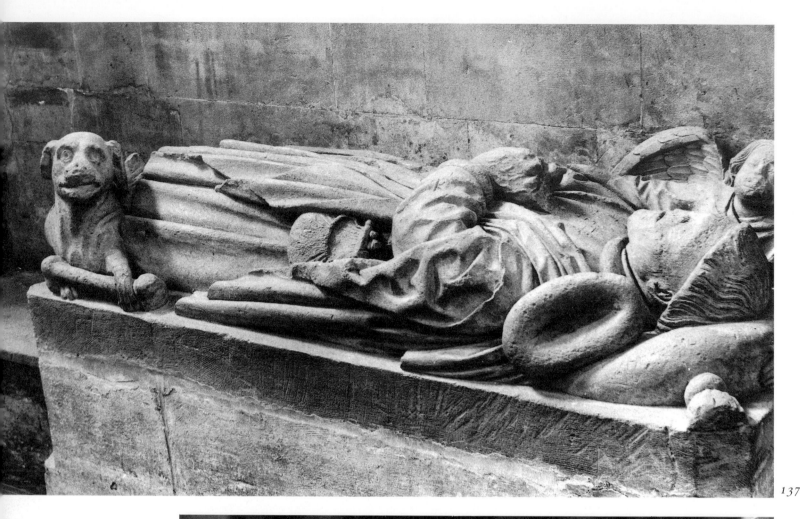

137

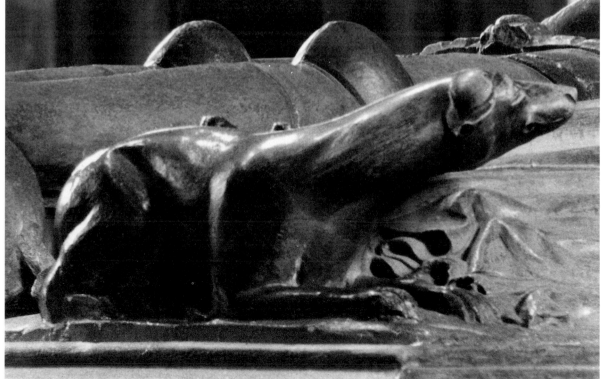

138

172 *Animals Beloved*

The faithful dogs

who lie at their master's feet on medieval tombs are, at one level, expressive witnesses of man's love for animals – and vice versa. At another level they possibly descend from the guardian animals or fetishes that adorn tombs in every civilization, accompanying the soul on its crossing of the river of death. Upper left (*137*): tomb of William Canynge in the south transept of St Mary Redcliffe, Bristol. Lower left (*138*): detail from the tomb of Sir John Beauchamp in Worcester Cathedral. Below (*139*): detail from the tomb of Lord Hungerford in his chantry chapel in Salisbury Cathedral.

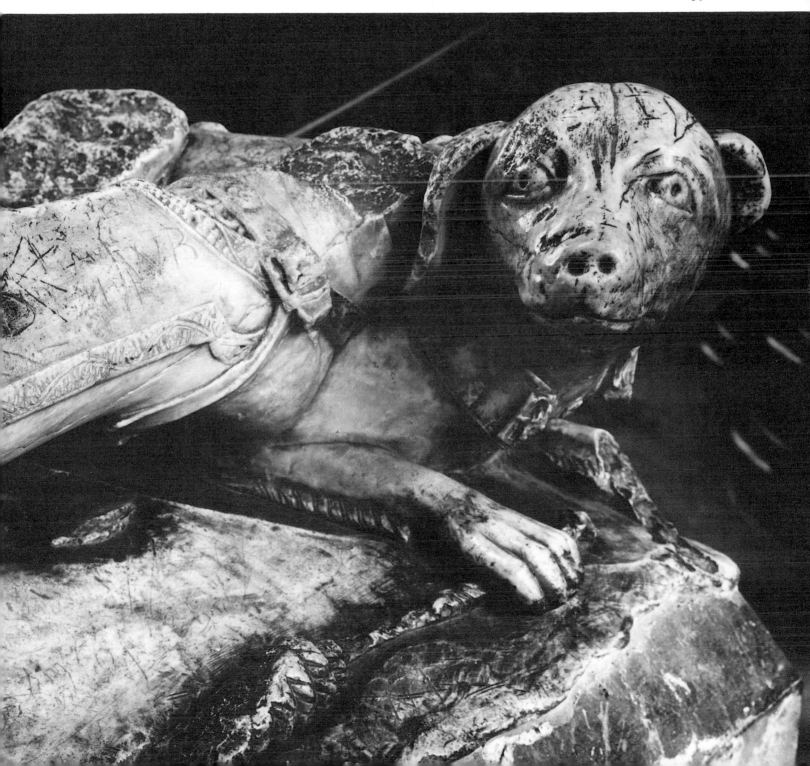

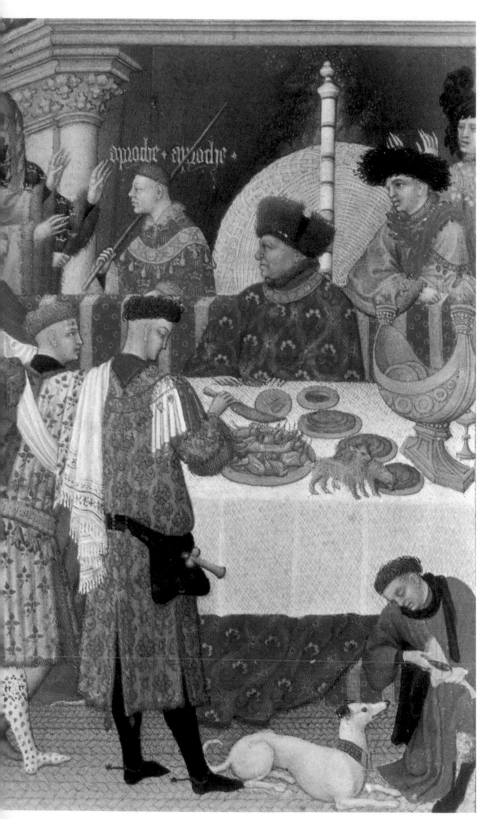

Dogs' lives

in the later Middle Ages could be very comfortable, to judge by the frequency with which they feature in paintings and by their generally pampered appearance. In the famous January scene of the *Très Riches Heures* (left, *140*) the lap-dogs actually run about on the table helping themselves to the food, while the hound at the bottom is being fed by a servant cutting off a slice of the joint. In Venice, Carpaccio's *Two Courtesans* (*141*) play with their pets to relieve the boredom of waiting for customers. In the *Lady and the Unicorn* (upper right, *143*) the little dog sitting on a brocade cushion in the very centre of the composition probably stands for fidelity. So may the well-known griffin terrier in Van Eyck's *Arnolfini Marriage* (lower right, *144*), where its position is that of a tomb dog, immediately beneath the couple's feet. Even more spiritual is the fluffy dog in Carpaccio's *Vision of St Augustine* (lower left, *142*), who seems to be receiving the vision of St Jerome's death before it has been vouchsafed to St Augustine.

140

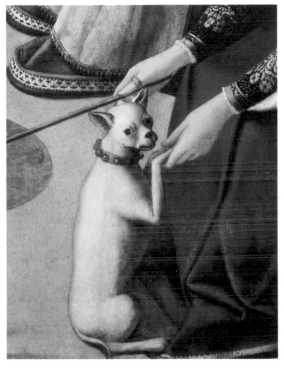

141

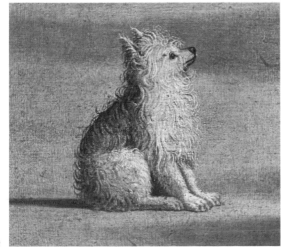

142

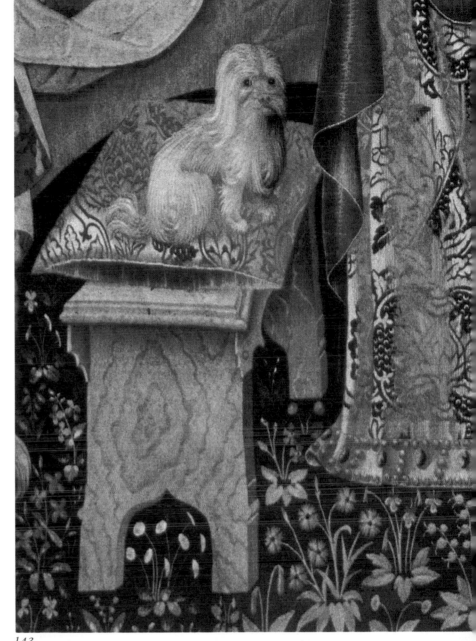

143

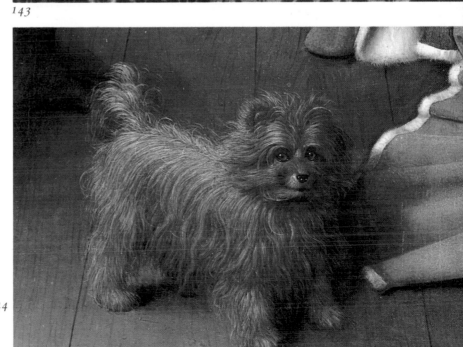

144

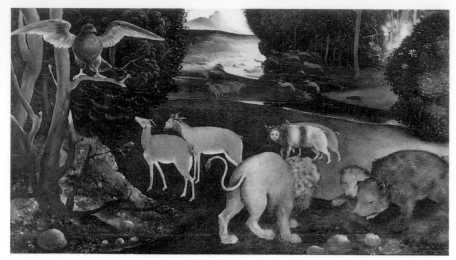

145

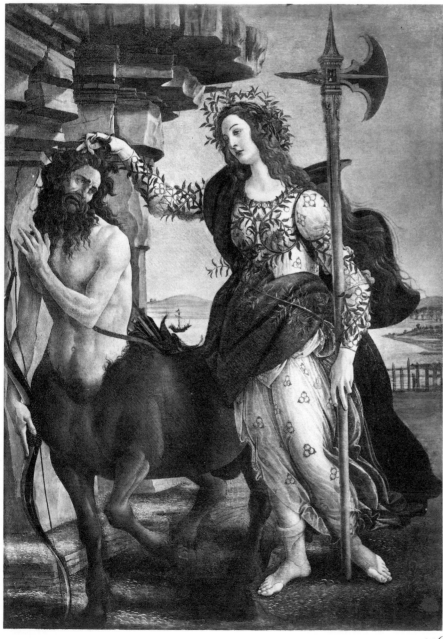

146

Can human beings

ever see into an animal's mind, or an animal into a human's? The question seems to have haunted certain painters of the Renaissance, notably the eccentric Piero di Cosimo. Vasari says he led the life 'of one who was less a man than a beast', taking especial pleasure in 'such animals, plants or things as nature at times creates out of caprice'. In his *Forest Fire* (detail upper left, *145*) he imagines a prehistoric world when men and animals were not yet distinct species and strange hybrids could still exist. The dog in his *Death of Procris* (*147*) is completely true to life, but seems to mourn with a human understanding. In Botticelli's *Minerva and the Centaur* (lower left, *146*) a being that is half human and half animal symbolizes the dawn of reason, a dawn that brings more sorrow than happiness.

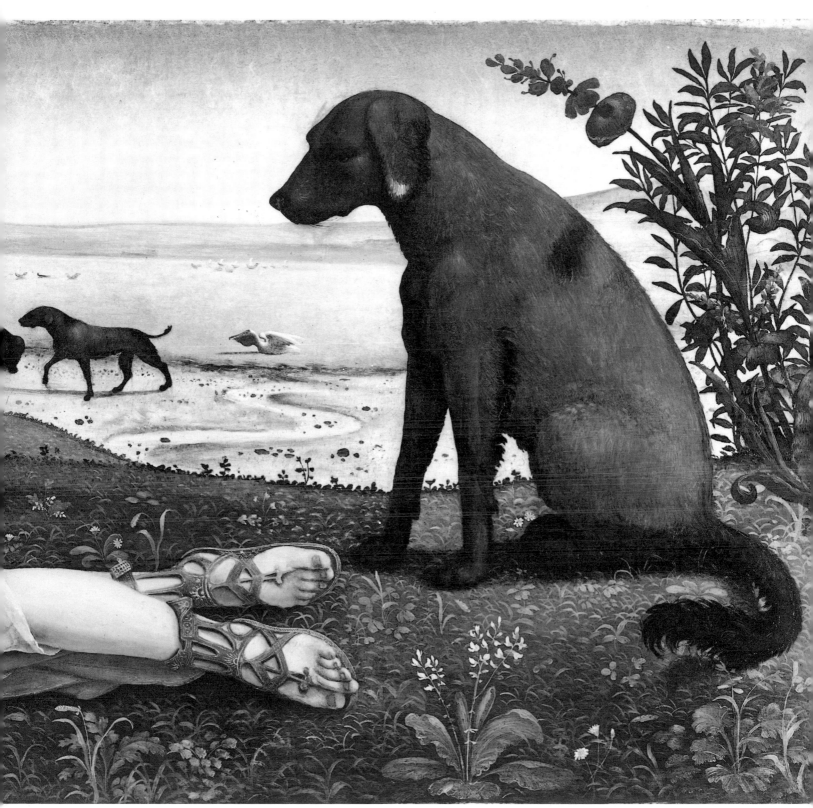

147

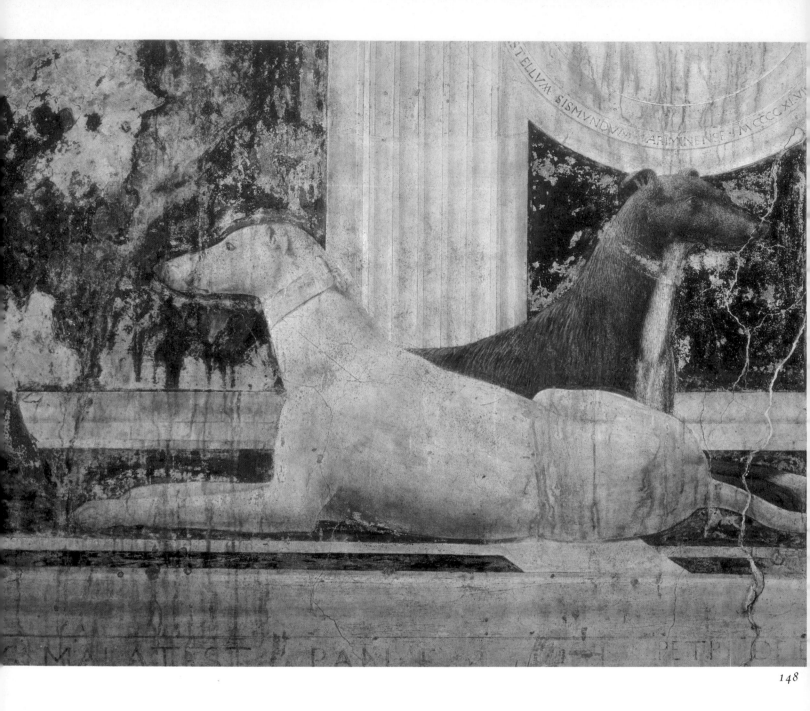

148

In the ordered world

of early Renaissance frescoes animals must take their appointed places, elements in compositions where the laws of geometry hold sway over both observation and love. If Degas' horses (p. 162) could keep their pose only for a split second, the animals – and humans – of Piero della Francesca and Mantegna seem able to keep theirs for an eternity. The two dogs who accompany Sigismondo Malatesta in Piero's picture of him kneeling before his patron saint (above,

148) are almost heraldic in their stillness and symmetry. One even suspects at first that Piero might have used the same cartoon reversed, but this seems not to have been the case. The two mastiffs in the *Camera degli Sposi* by Mantegna (right, *149*), however, are surely drawn from sketches of the same animal seen from different angles (compare Pisanello, p. 113). The horse has all the sculptural repose of a Roman equestrian statue.

149

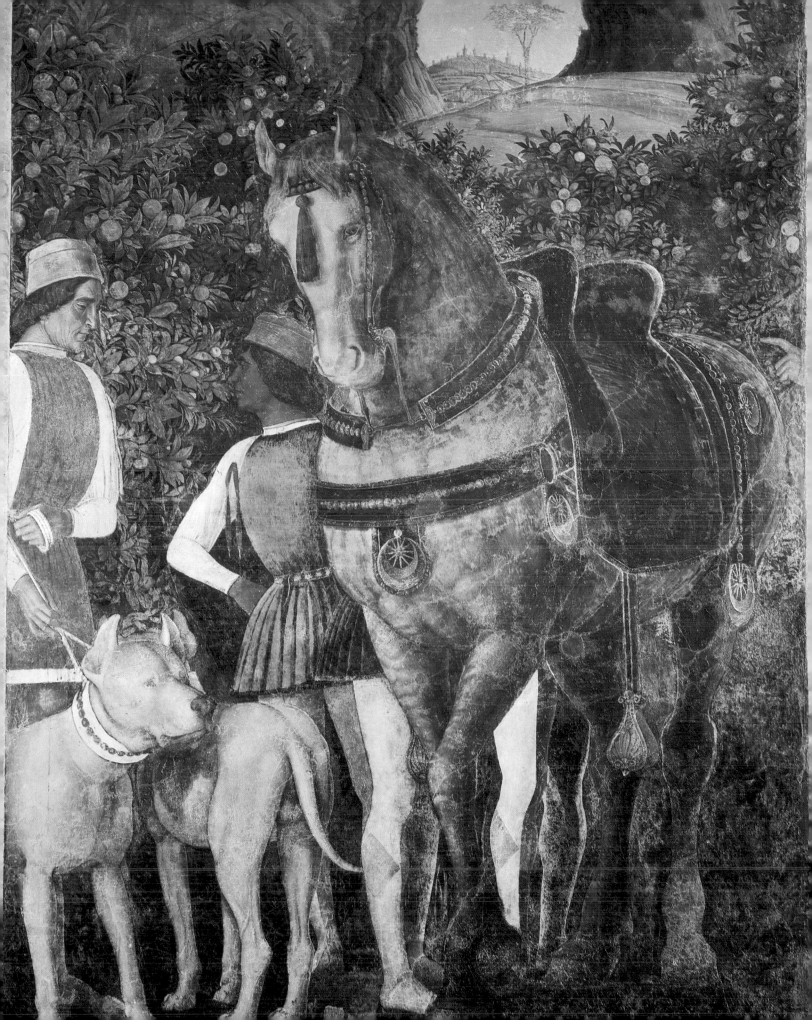

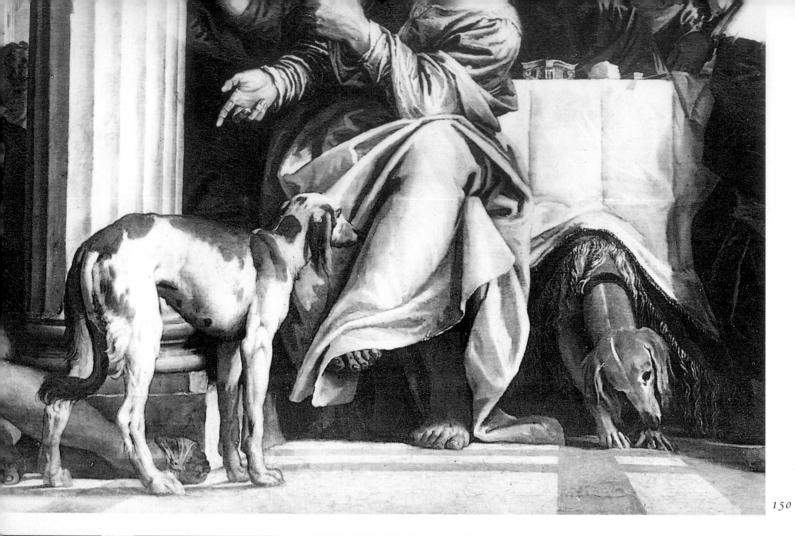

150

151

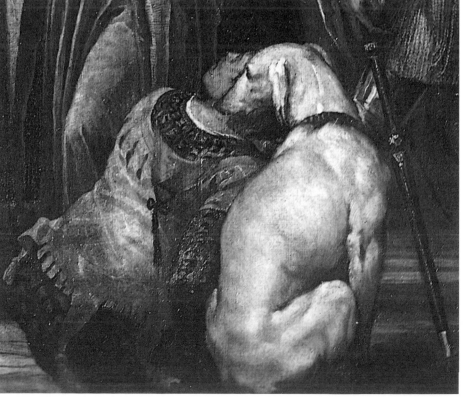

152

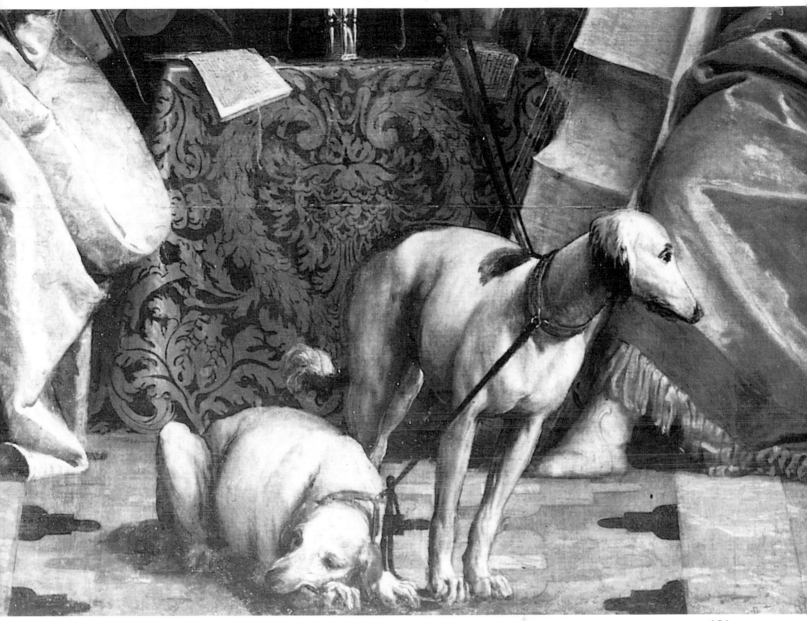

153

'The essence of dog

is there,' said Ruskin about Paolo Veronese, 'the entire, magnificent, generic animal type, muscular and living.' Veronese indeed seems to have been the greatest dog-lover in Italian art. The way he places them prominently in the foreground of even the most solemn scenes has been defended as having symbolic significance, but is surely more easily explained as simple favouritism. Opposite top (*150*): detail from *The Feast in the House of Simon the Pharisee*, now in Turin. Opposite left (*151*): detail from the *Madonna of the Cuccina Family*. Ruskin again: 'The dog . . . cannot understand, first, how the Madonna got into the house; nor, secondly, why she is allowed to stay, disturbing the family and taking all their attention from his dogship. And he is walking away, much offended.' Opposite right (*152*): a dog from the foreground of *Esther before Ahasnerus*. Above (*153*): two dogs in the centre foreground of his vast *Marriage at Cana*, now in the Louvre.

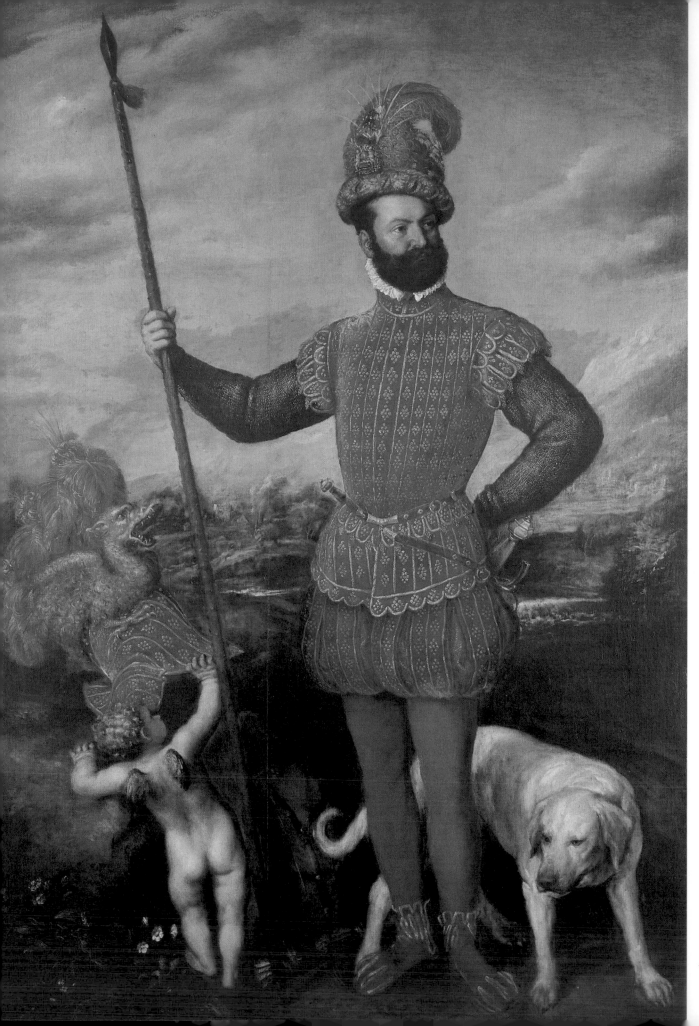

154

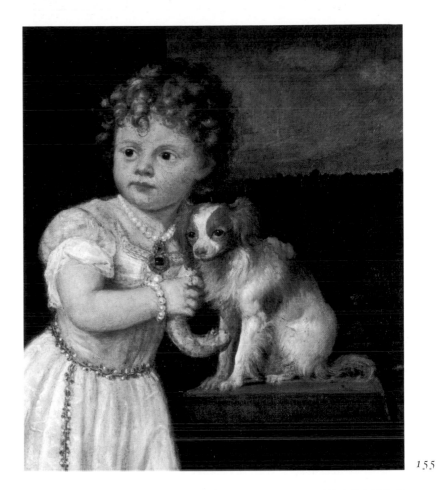

155

Titian's dogs

appear mostly in his portraits and are clearly
the darlings of their owners. Opposite (154):
the dog from *Giovanni dell' Acquaviva*, in
which the plainness and honesty of the dog
seem a mute criticism of the extravagantly
dressed man. Upper right (155): Clarice
Strozzi, aged two. Below right (156): the
small dog from *Venus and the Organ Player*,
one of many versions of this theme painted
by Titian. In both examples, as in several of
his portraits, the dog's eyes are the only ones
which look out directly at the spectator,
establishing a sort of secret contact.

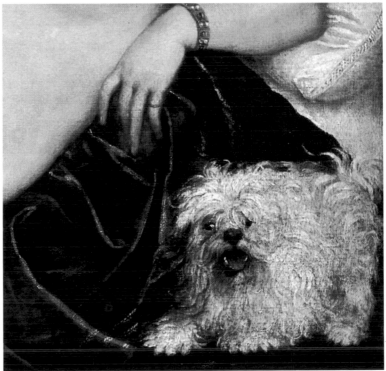

156

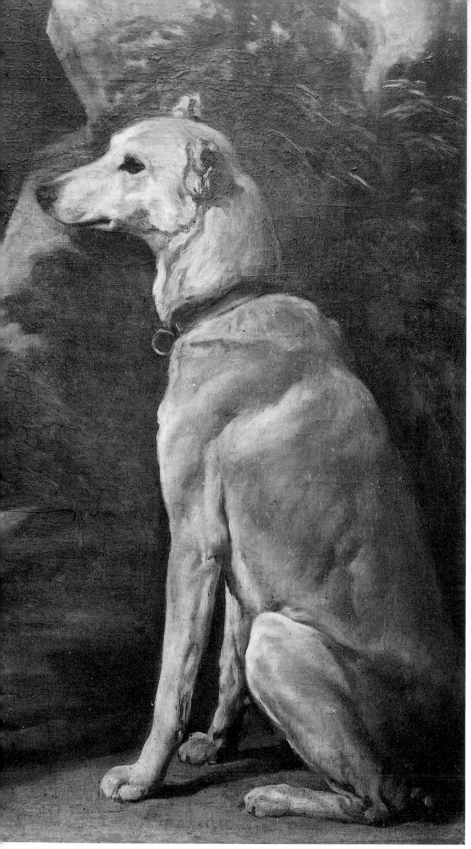

158

157

159

In Velasquez,

dogs play perhaps the most enigmatic role of all. It is easy to see them as implying a satirical commentary on the subjects of the paintings. 'Whoever is meant to be impressed by these royal personages,' they seem to say, 'we are not.' But this may be only the result of the very sturdy independent life that the artist has given them. The dogs on these pages accompany the Cardinal Infante Don Fernando (far left, *157*), Prince Baltasar Carlos (below left, *159*) and the assembled court in the painting known as *Las Meninas* (below, *160*). The little dog belonging to the two-year-old Prince Felipe Prospero (left, *158*) is in a different category. It mirrors the innocent curiosity of childhood.

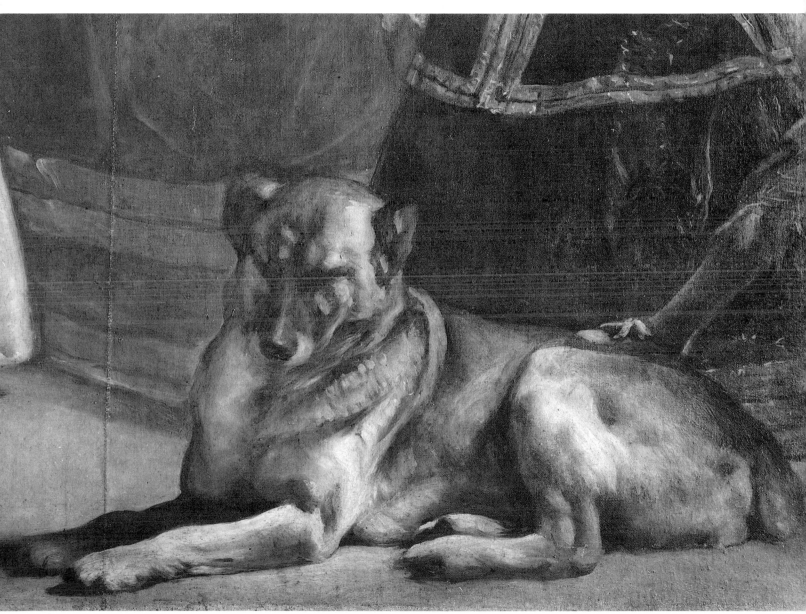

160

Hogarth's dog 'Trump'

was beloved by its master when alive and has been loved almost as much by the public ever since (*161*). Hogarth took this solid, four-square, down-to-earth pug as his emblem, and gives it a degree of reality – outside the frame, in the 'real' world – which he denies to his own portrait. 'It had been jocularly observed by him,' wrote Samuel Ireland, 'that there was a close resemblance between his own

countenance and that of his favourite dog, who was his faithful friend and companion for many years'. Surprisingly, Hogarth also painted what is perhaps the best cat in art – the one in the group portrait of *The Graham Children* (above, *162*). Clawing its way up the back of a chair, it terrifies a goldfinch in a cage suspended just out of its reach and apparently unnoticed by the children.

163

164

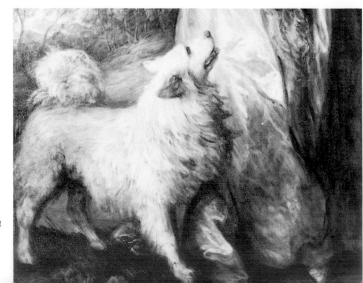

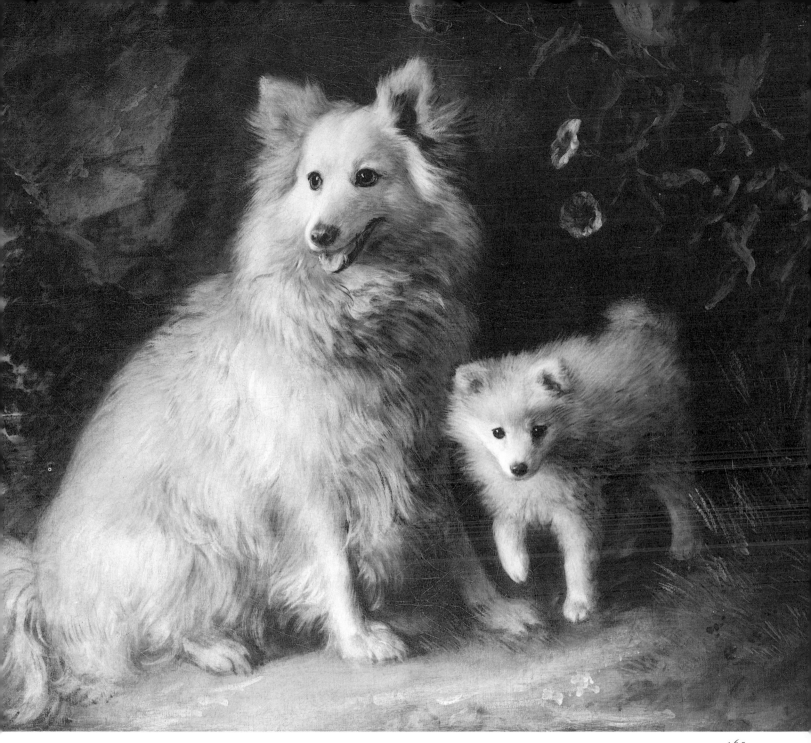

An air of breeding

surrounds Gainsborough's dogs, just as it does his human subjects. He was particularly fond of white Pomeranians, which a modern manual enthusiastically recommends as 'the best watchdog of all . . . absolutely incorruptible'. The same dog, or very similar ones, appear in the portrait of 'Perdita' Robinson (upper left, *163*), *The Morning Walk* (lower left, *164*) and the *Bitch and Puppy* (above, *165*). Gainsborough's use of dogs is neither symbolic nor satirical, nor do they particularly reflect the characters of the sitters. But they establish a pleasant informality of atmosphere, and he is said to have found them more sympathetic and easier to understand than their owners. The bitch and puppy belonged to the musician C. F. Abel; there is a tradition that Gainsborough painted their portrait in return for lessons on the viola da gamba.

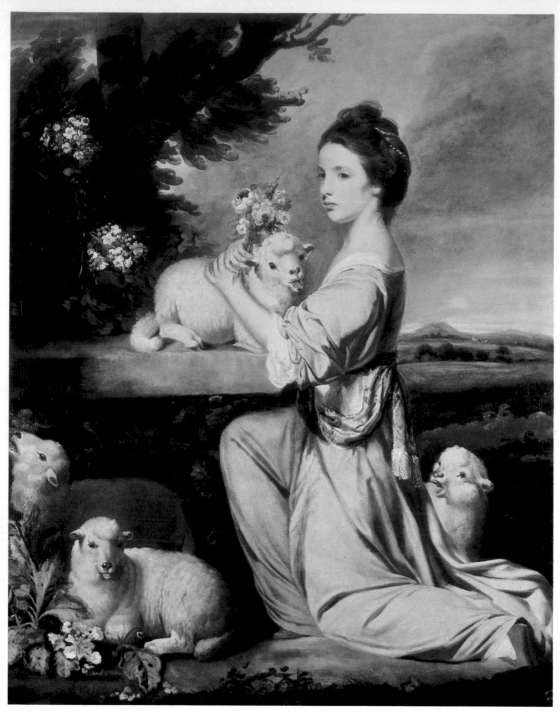

166

From artifice to nature.

These two portraits by Reynolds signal a
subtle but definite shift in taste. The first (*166*),
painted in 1764, shows the eleven-year-old
Lady Mary Leslie as a shepherdess adorning
her favourite lamb with flowers. The picture
fits into the tradition of the Classical portrait;
it is aristocratic, formal, deliberately artificial,
and looks back to a world of Rococo
sentiment that was almost at an end. The
other (*167*), painted eleven years later, in

1775, looks forward to a more natural
treatment of both children and animals. The
little girl is not an aristocrat but the daughter
of well-to-do middle-class parents – Miss
Jane Bowles, aged three. Where Lady Mary
is a dignified adult in miniature, Miss Bowles
is a child, and the great charm of the picture
resides in her childishness. There can be no
doubt that she loves her dog. The appeal to
our emotions is now direct.

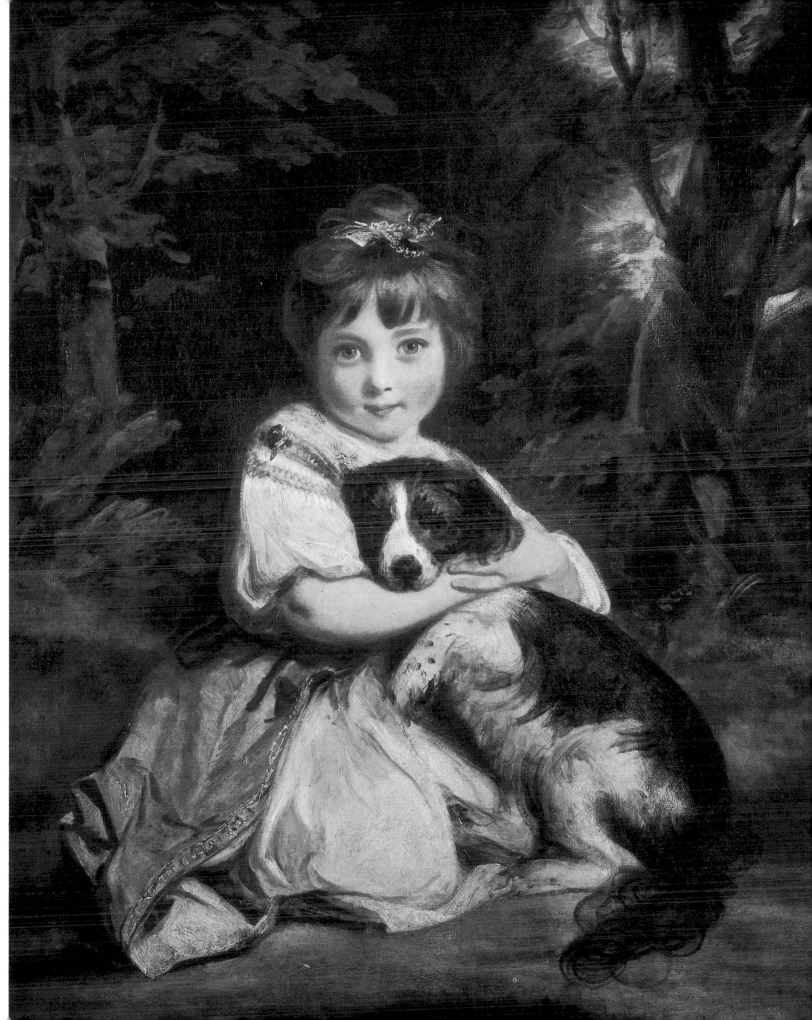

The ultimate sentimentality

is to invest animals with human characteristics and then give the pictures arch titles as if the painter is winking at the spectator. Landseer's *Dignity and Impudence* (left, *168*), for instance, would arouse less modern resistance if he had kept the original title, which was simply *Dogs*. *The Old Shepherd's Chief Mourner* (above, *169*), on the other hand, though equally direct in its assault on our emotions, does not falsify the animal's character in the same way. Ruskin loved this picture and analyses the details in moving terms: 'the close pressure of the dog's breast against the wood, the convulsive clinging of the paws, which has dragged the blanket off the trestle, the total powerlessness of the head laid, close and motionless upon the folds . . . '.

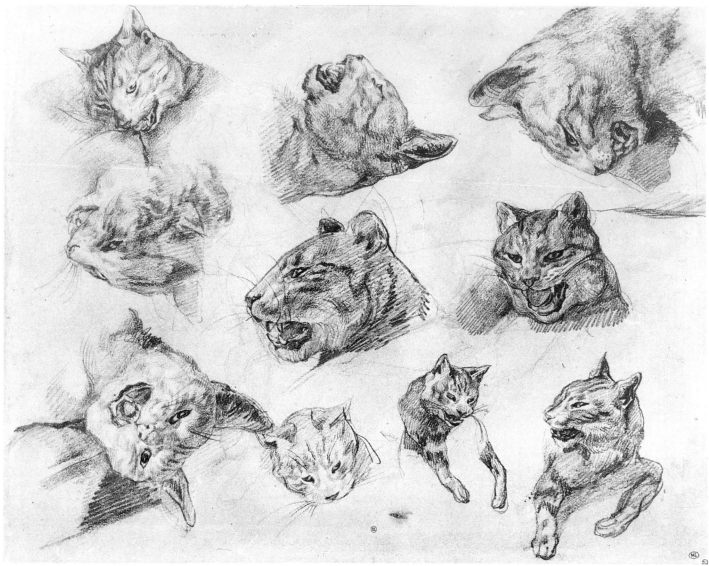

170

171

Why are cats,

as loved and as lovable as dogs, so greatly outnumbered by them in art? Perhaps their owners are less proud of them, perhaps they count less as one of the family, perhaps it is just harder to persuade them to sit still. Most of the best cat pictures have been done for the artist's own pleasure. Géricault's sheet of studies (above, *170*) puts him close to Delacroix and Barye; they all saw cats as miniature tigers. Théophile Steinlen's cats (left, *171*) are gentle and not at all aggressive; they were his favourite subjects, and admiration and pity never turned to sentimentality. For Renoir (right, *172*), one suspects there was something in common between cats and girls – the cat absorbed in the plant, the girl absorbed in the cat, both of them young, playful and sensuously appealing.

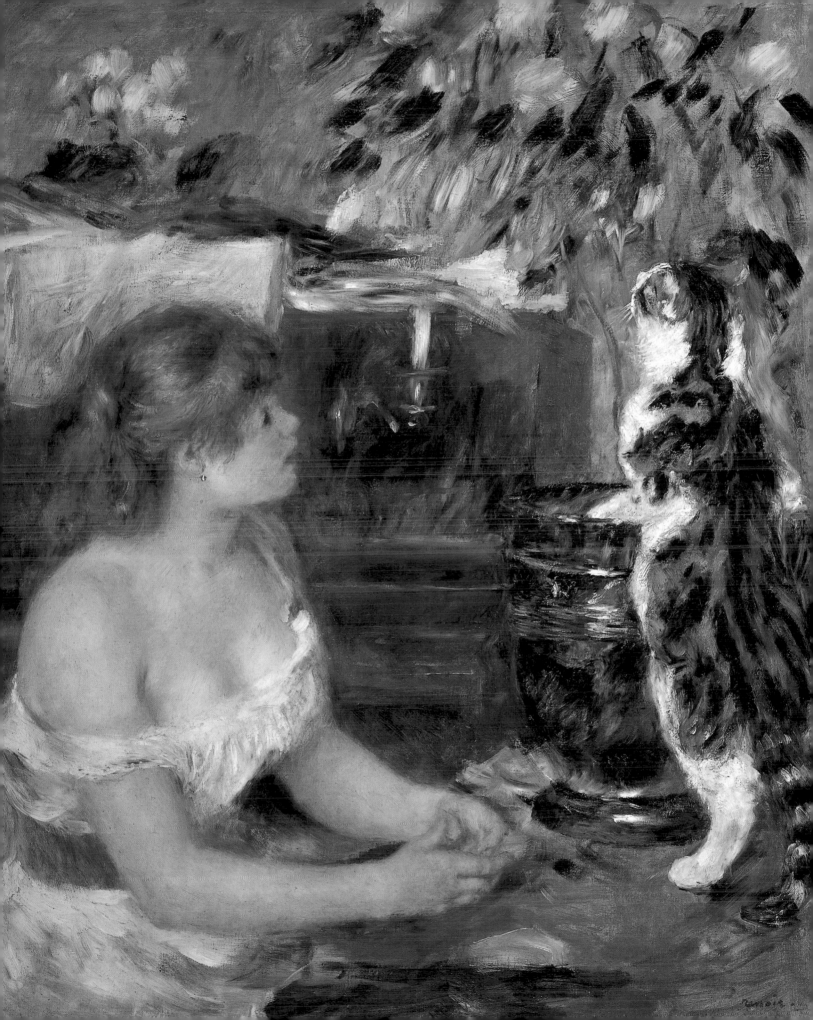

Animals Destroyed

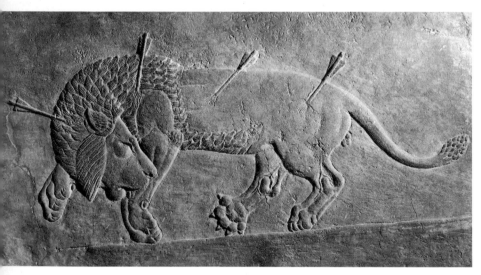

173

The death of animals

is the subject of the majority of animal
representations from ancient civilizations.
Many have to do with sacrifice. The Romans
delighted to dwell on the cruel pleasures of
the arena; while post-Renaissance art has
celebrated the hunt in endless and sometimes
wearisome detail. The only aspect of animal
killing that is almost entirely unillustrated is
that against which there are the fewest
objections, killing for food.

Roman state religion revolved round
animal sacrifice. Looking at the chaste
remains of a Classical altar, it is easy to forget
that it can rarely have been free from the
smell of blood. Vast numbers of animals were
involved. Besides the annual ceremonies and
festivals, there were sacrifices when the
Emperor had special need of the gods' favour
(for example, when embarking on a war), or
when he wished to show gratitude for
continued favours. The relief on the right
(*174*) probably celebrates Hadrian's
decennalia in AD 137, the twentieth anniversary
of his accession to power. Left (*173*), a dying
lion, detail from the Assyrian reliefs celebrating
Assurbanipal's lion-hunt. Two more details
are shown on pp. 200–201.

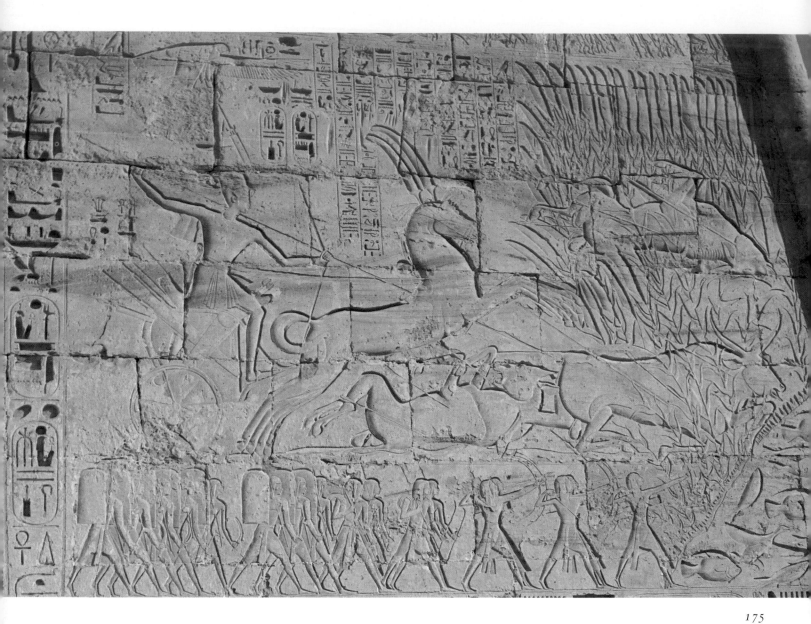

The royal hunt

of ancient Egypt was closely associated with religious ritual and was much more than a mere amusement. It was the pharaoh's pre-rogative and a symbol of his divine status. Above (175): Ramasses III hunts the wild bull, a relief from Medinet Habu. Above right (176): Seti I and his son lassoeing a bull for the god Wepwawet. Lower right (177): a hippopotamus hunt, from the Mastaba of Mereruka, Sakkara. It has been doubted whether any of these hunts are records of

actual events, and the hippo hunt is the most suspect of all. The boats are too flimsy, the method of spearing the hippos unlikely to be effective. It is more probably the memory of a ritual practice. An ancient legend relates how Horus triumphed over Seth who had assumed the form of a red hippopotamus; and at the time of the First Dynasty the priests of Horus at Edfu went into the middle of the Holy Lake on a raft and dismembered a cake cooked in the form of a hippopotamus.

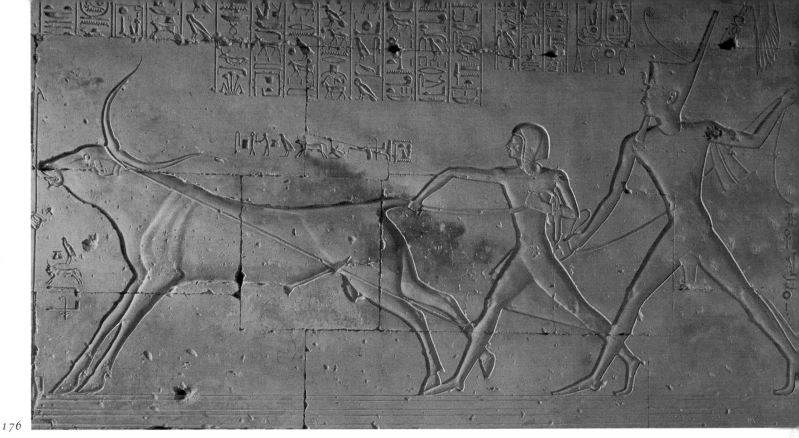

176

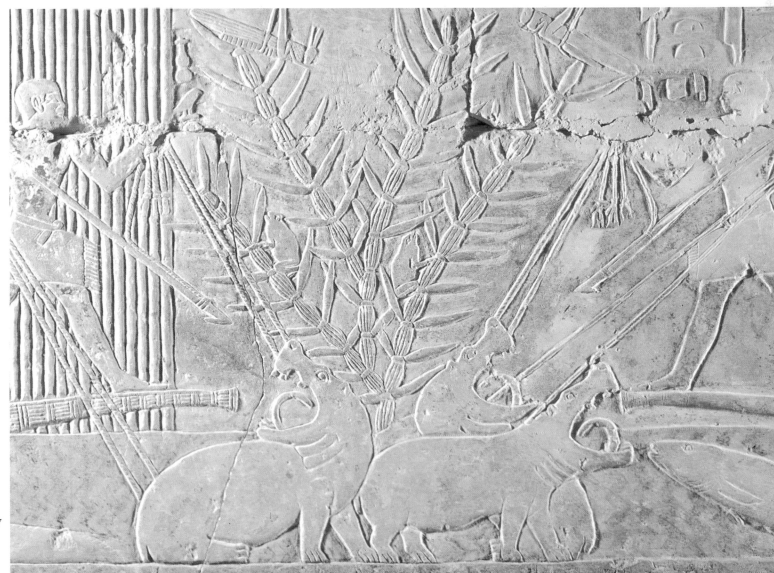

177

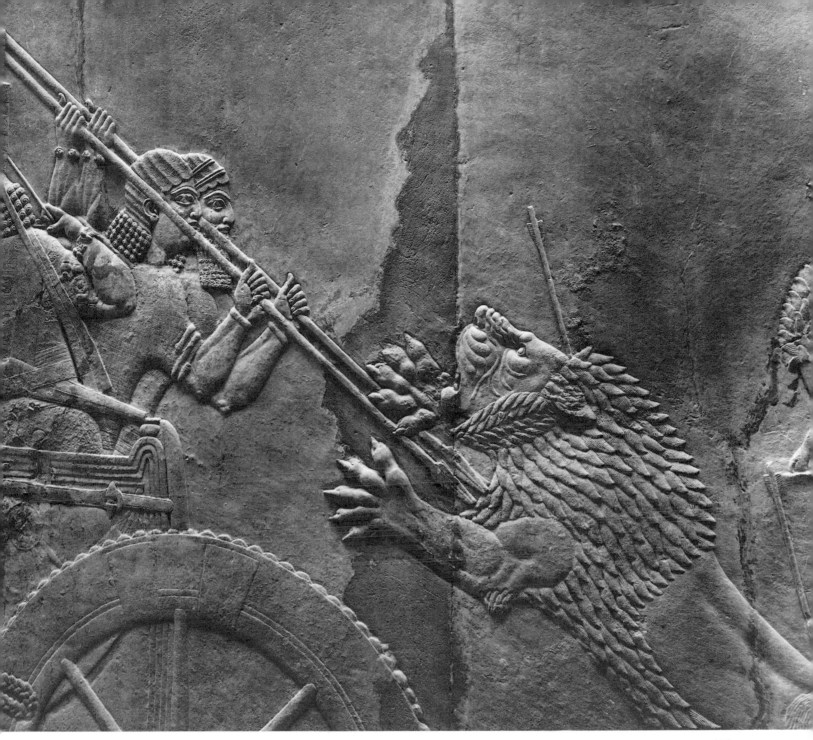

179

Compassion for the hunted

makes the magnificent lion-hunt reliefs of
Assurbanipal at Kyunjik into genuinely
tragic works of art. It is difficult to say how
far they are ritual scenes and how far they are
realistic. Are they records of Assurbanipal's
actual skill, which would have been a source
of pride and prestige? Are they a form of
flattery? Are they purely symbolic? One
cogent argument in favour of realism is that
the lions are shown emerging from the
wooden cages in which they were penned
before the hunt. Another is the truth to
nature with which the sculptor has depicted
their sufferings and death. (178, 179)

180

181

182

The full horror

of the Roman attitude comes through in the
mosaics at Piazza Armerina, in Sicily. They
form the floor decoration of the principal
rooms of a villa which possibly belonged to
a businessman who supplied animals for the
games. The theme is the hunting and capture
of wild animals in North Africa, their
transport to Rome and their exhibition in the
arena, where fights were staged between men
and animals or between animal and animal.
Above (180, 181): deer being devoured by

lions and tigers, and one of the hunters in
difficulties with a wounded lioness. Above
right (182): three stags are driven into a net.
Right (183): a captured buffalo is dragged
along by ropes.

The mosaics of Piazza Armerina are the
largest in scale and the best preserved of any
Roman mosaics in Europe. They cover the
floors of forty-six rooms, and animals are so
prominent in them that they were clearly of
special interest to the owner.

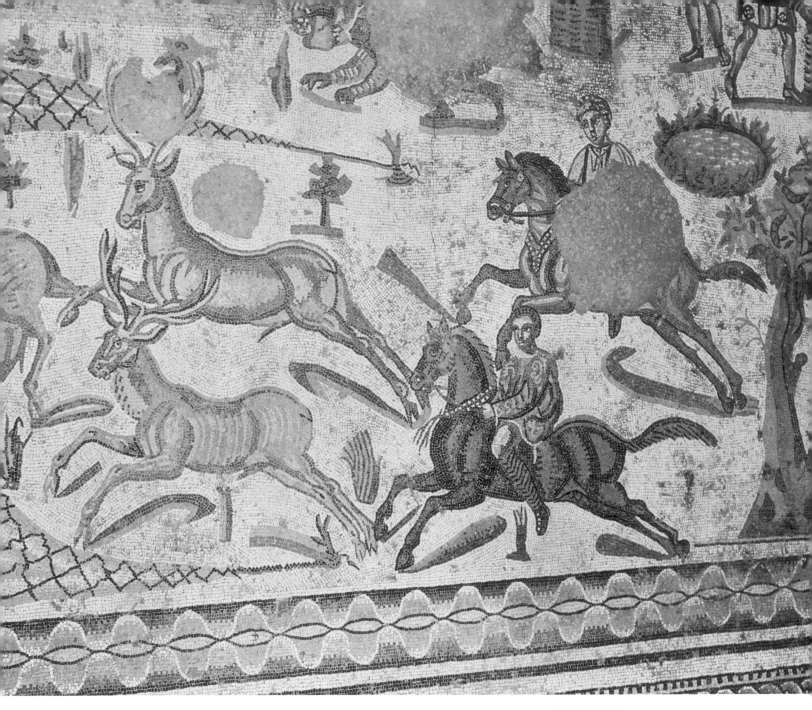

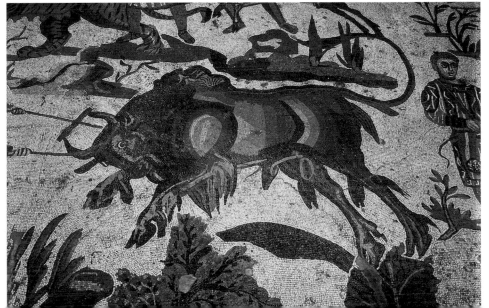

183

203

The lion devouring its prey

has exercised a fascination over artists that goes far beyond any conscious intention. It was not unusual for Early Christian sculptors and architects to re-use Roman motifs, and sometimes actual materials, giving them a new meaning. Roman art, as we have seen, includes powerful scenes of fighting animals like the lion attacking the deer on the previous page; and the fragment from a Roman sarcophagus (below right, *186*), incorporated into the Church of Santa Maria del' Anima, Rome, was no doubt originally a conventional image of death. Here it has been interpreted as the Church triumphing over the Devil, though the gentle deer is a strange symbol for the Devil. In the Pisa pulpits of Nicolo (below left, *185*) and Giovanni Pisano (left, *184*) it seems to gain a new dimension – the triumph of the soul over the body. The sheer physical power of the lion kept its suggestion of divinity right through from ancient Mesopotamia to Greek and Roman civilization and finally Christian Europe.

185

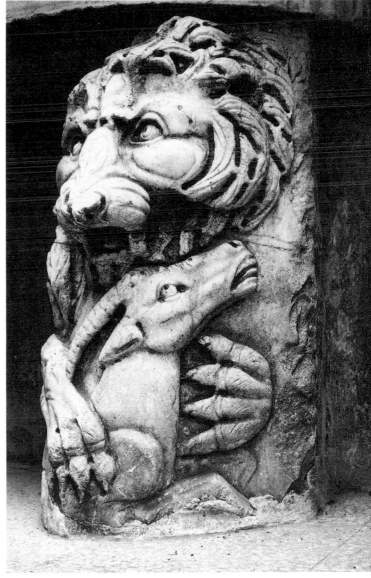

186

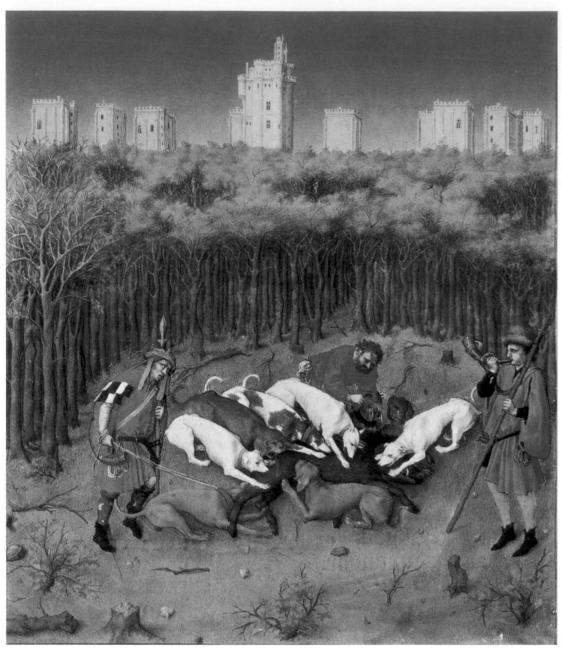

187

Medieval hunting

retained strong overtones of ritual, and remained a sign of royal, or at least noble, status until recent times. 'December' from the *Très Riches Heures* (above, *187*) shows the death of the boar; the man on the right blows the '*mort*'; in the background is the Château of Vincennes. All the details, including the well-observed posture of the dogs, point to the real world, though in fact the Limbourg brothers were copying a model *schema* also noted in the Grassi sketch book (see p. 52).

In the *Death of the Unicorn* (right, *188*) from the New York series, realism is still bound up with symbolism. The unicorn may well – as has generally been maintained – represent Christ, but the general satisfaction displayed by everyone makes it hard to react to the scene simply or unambiguously.

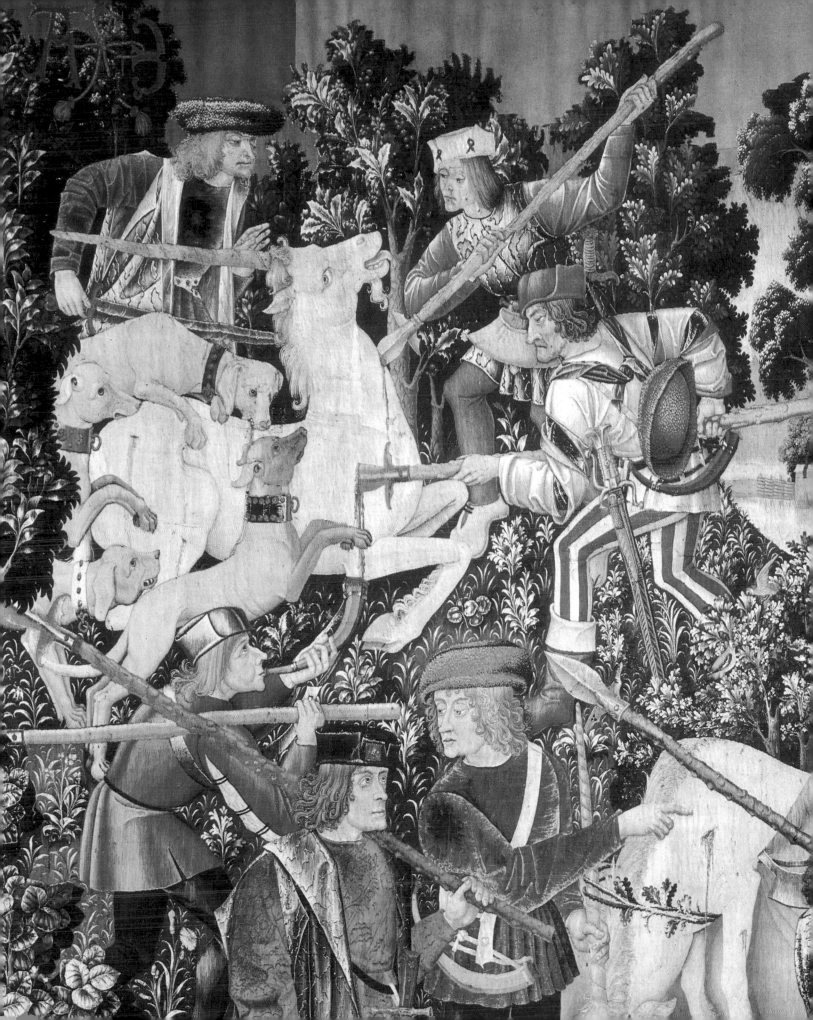

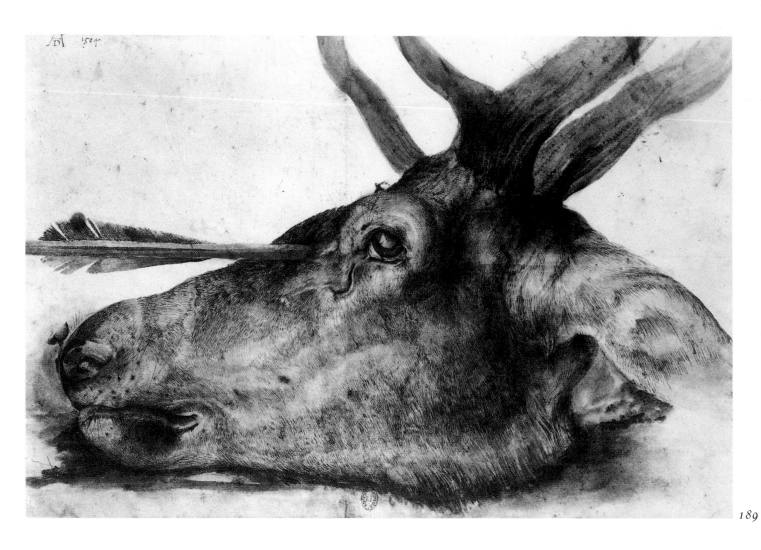

The joys of the chase

must always be a mystery to the uninitiated.
Up to modern times it was conventional
to enjoy it, and a spectacle such as that
depicted by Lukas Cranach (right, *190*)
would have given nothing but pleasure to
most normal men and women. The Elector of
Saxony and his men have succeeded in
driving a herd of deer on to a narrow spit of
land from which they can only escape by
swimming. Since men with cross-bows are
waiting for them on the other side they have

no chance. Some turn at bay, some struggle
with dogs in the water. In the background a
group of splendidly dressed ladies have come
out to watch the sport. It would have been
eccentric to feel pity for the animals,
and Dürer's drawing of a dying stag
(above, *189*), its skull pierced by just such a
cross-bow bolt, would presumably have
meant little to them. Dürer's was a rare
sympathy, all the more telling for not being
made explicit.

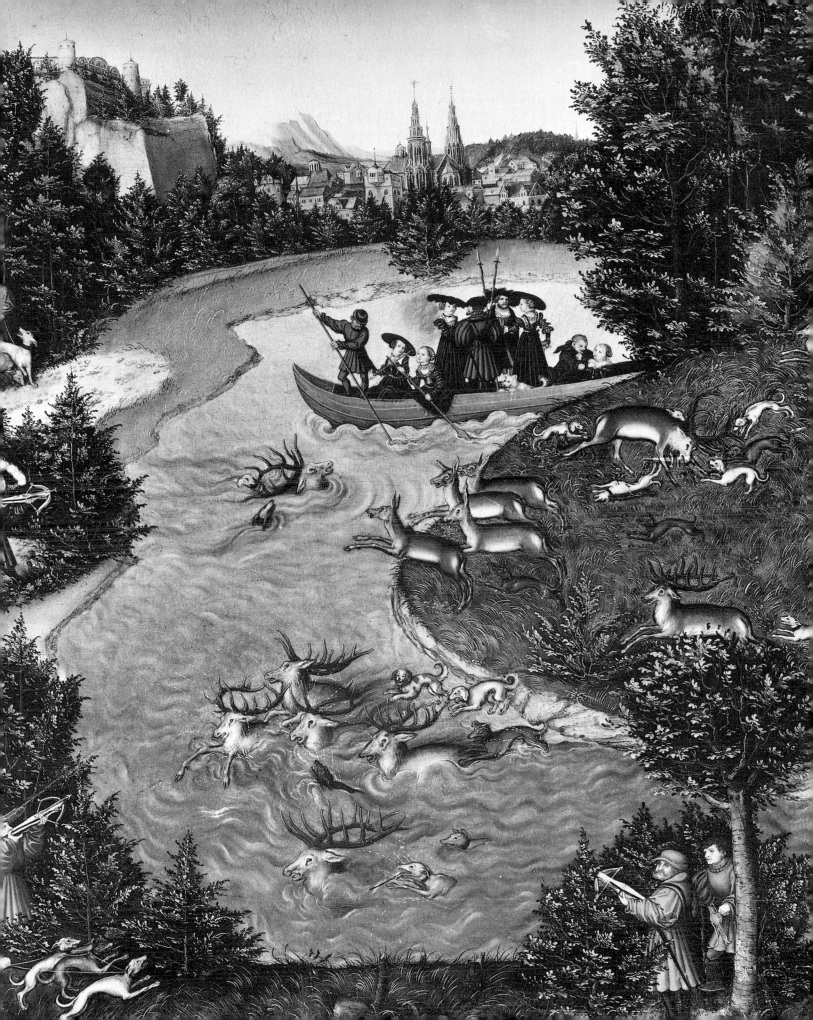

210 *Animals Destroyed*

191

But the chase has its poetry, nowhere better conveyed than in Paolo Uccello's *Hunt in the Forest*. There is no hint of brutality or death. The Florentine youths light up the darkness of the wood with their bright clothes. The hounds leap in a symmetrical recession, like dancers in an animal ballet, across a carpet of flowers. Here the union of man and nature comes curiously close to the image of the Golden Age with which this book began, and the forest has the mystery of a fairy tale. (*191*)

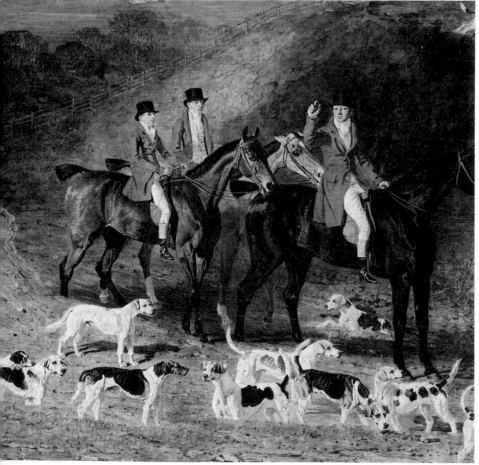

192

193

In England,

where wild boars were almost extinct by the
eighteenth century and even stags were
confined to remote areas or gentlemen's
parks, the most popular animal to hunt was
the fox. A whole genre of 'sporting' pictures
grew up, concentrating more on the
excitement of the ride and the general jollity
of the occasion than on the kill at the end of
it. Stubbs's *Grosvenor Hunt* (above, *194*) is an

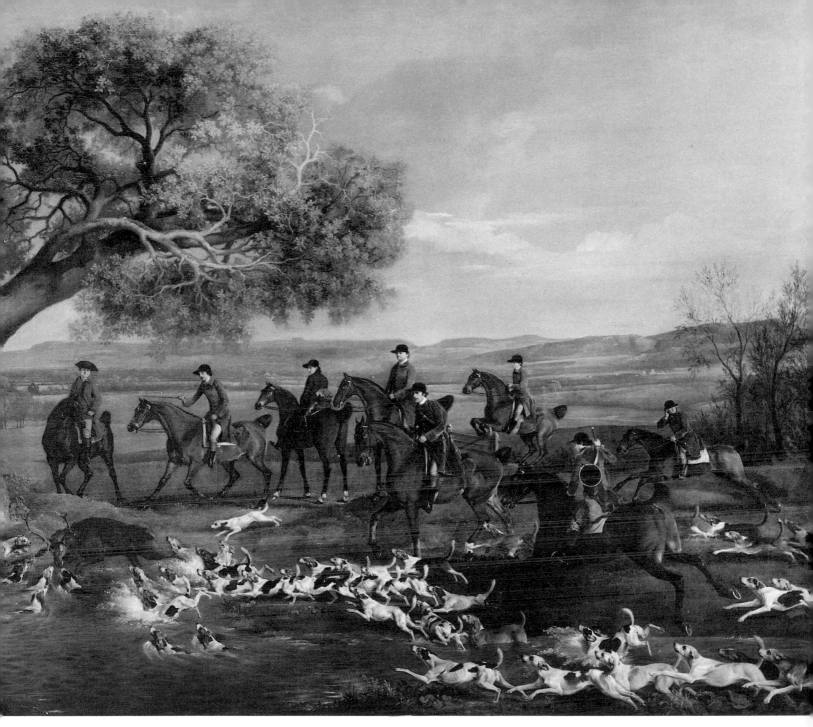

exception. The hounds have cornered a stag in the water and rush forward furiously to drag it down. Lord Grosvenor, who commissioned the painting, is the focal figure of the composition, immediately behind the stag; other figures are friends and retainers. The element of social class is usually a major one in sporting pictures. Left: two later, more conventional works, James Ward's *Lord Lambton and his Hounds* (top, *192*) and Ben Marshall's *Lord Sondes and his Brothers at Rockingham* (*193*). Both artists and patrons were connoisseurs of horses and hounds (very often every animal is an individual portrait), but there is little sense of movement, and the interest of the painting lies mainly in their relation of figures to the landscape.

'The wrath of the lion

is the wisdom of God,' said Blake. We return to the ancient image of the lion attacking its prey. Its emotional power undiminished by time, it surfaced again in the Romantic era, when the idea of universal destruction and the unleashing of violence was given perhaps its frankest expression. In Stubbs's *Lion Devouring a Horse* the horse is totally transformed from the proud animal of his portraits and sporting pictures. Its muscles are tense and exaggerated, the expression of the face distorted by fear. This is one of nearly twenty versions of the theme, forming a group quite outside the normal run of Stubbs's art. Although it is probably based on imagination rather than observation (the tradition that he had been to Africa and seen such an episode is unproven), Stubbs did all he could to achieve truth to nature. The lion was studied in Lord Shelburne's menagerie, the horse in the Royal Mews, and Stubbs deliberately frightened it to get the look of terror. In contrast to the medieval examples seen earlier, it is the horse and not the lion which dominates the picture. The lion, on the contrary, is small and almost grotesque. There are Classical sources (e.g. a group in the Palazzo dei Conservatori, Rome) which Stubbs used in spite of his contempt for Antiquity, but the final effect is far more in tune with Romantic values. (*195*)

214 *Animals Destroyed*

195

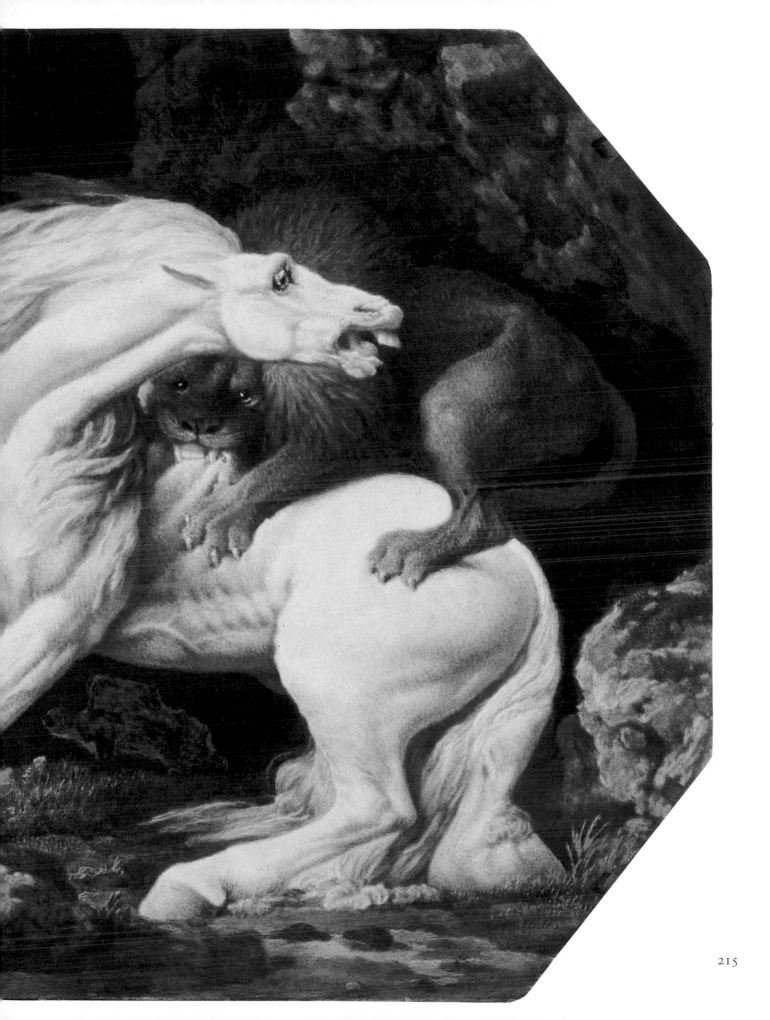

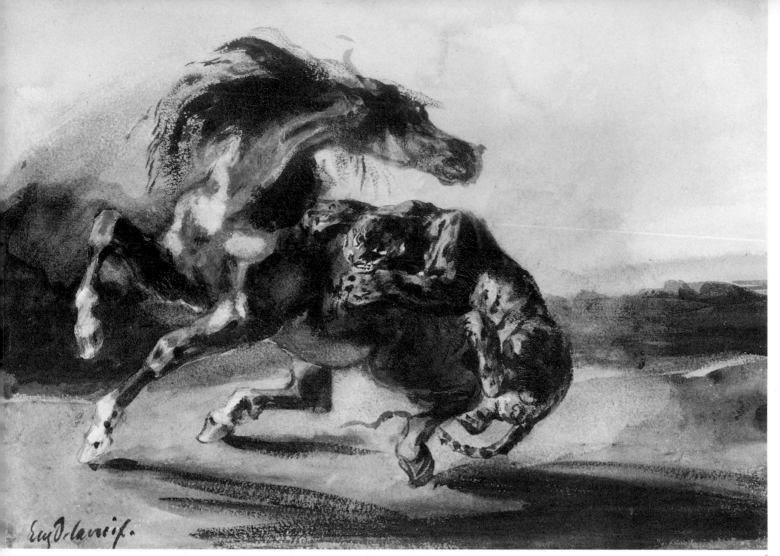

196

197

216 *Animals Destroyed*

Ferocity gave way to pathos

as the fire of Romanticism died down around the middle of the nineteenth century.
The *Horse Attacked by a Tiger* (left, *196*), Delacroix's variant on Stubbs's theme, and Barye's *Panther Devouring a Gazelle* (*197*) belong to the earlier period. For Delacroix the human and animal worlds were equally savage: 'Men are tigers and wolves, bent on destroying one another.' Barye's panther avoids exaggeration, and is Romantic only in the choice of an exotic animal. The movement towards realism was carried much further by Gustave Courbet and his contemporaries, for whom truth meant limiting oneself to one's own experience. Courbet knew the hunt well. He was himself a noted hunter and could paint it with the hunter's exhilaration (p. 223). But he could also put himself in the place of the hunted. In his *Hind forced down in the Snow* (below *198*), the animal is still alive. Helpless, exhausted, she waits for the hounds and death.

198

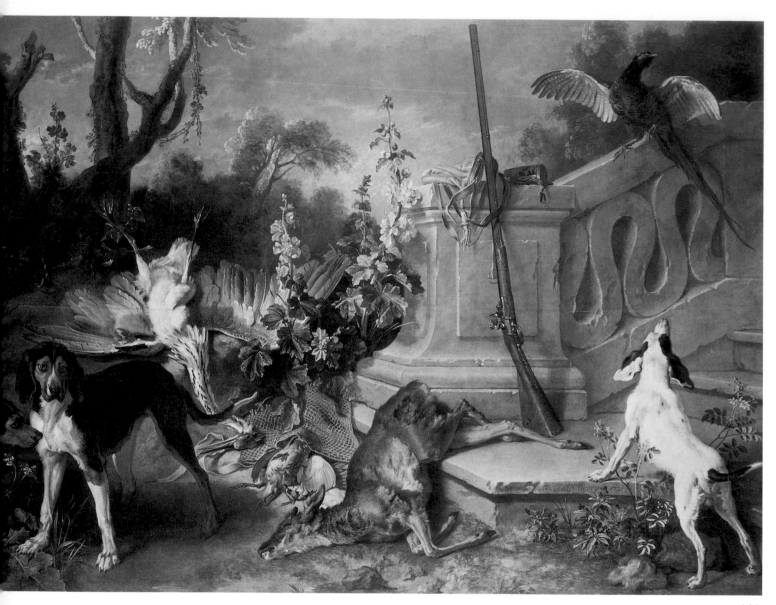

To be part of Nature

was surely one of the main attractions of
hunting in the eighteenth and nineteenth
centuries. Here man met animals on some-
thing like animal terms, and the heaps of slain
were his proof that he had conquered them.
In Oudry's *Dead Roe* (above, *199*), the
balustrade, the rifle and dogs evoke the
human presence; in the background, Nature
which is his domain. Alexandre Desportes's
Self-Portrait as a Huntsman (*200*) carries the
same overtones. It is a familiar paradox that
hunters are the only ones who really love
animals, and there is a sense in which this may
be true.

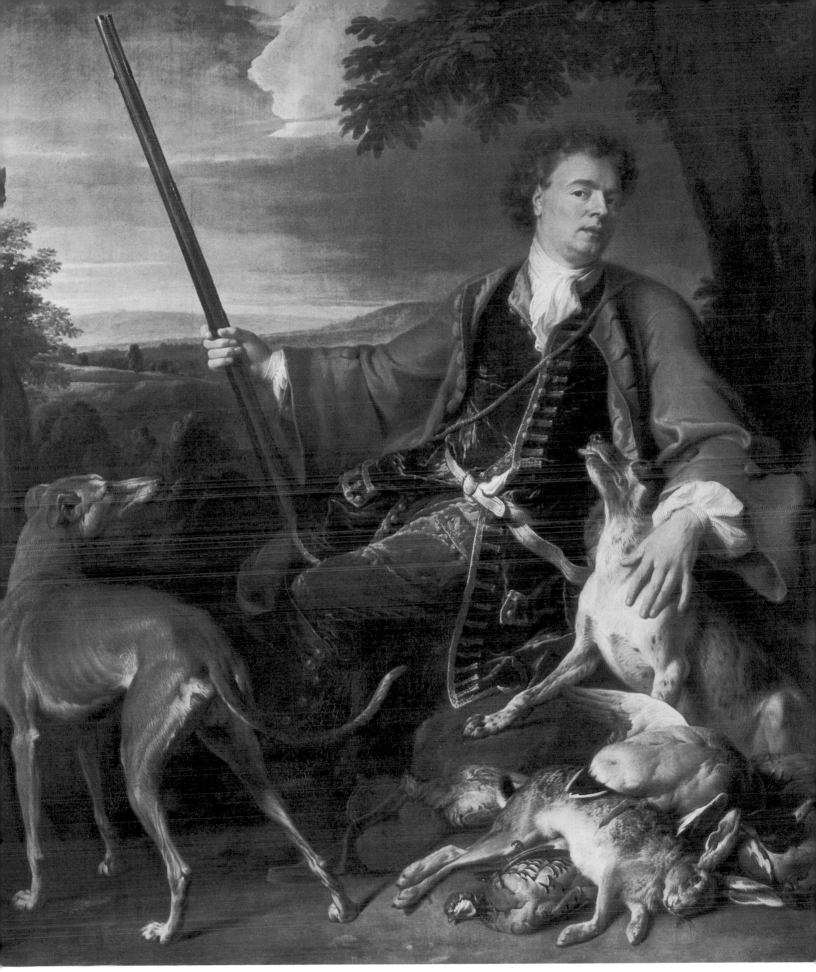

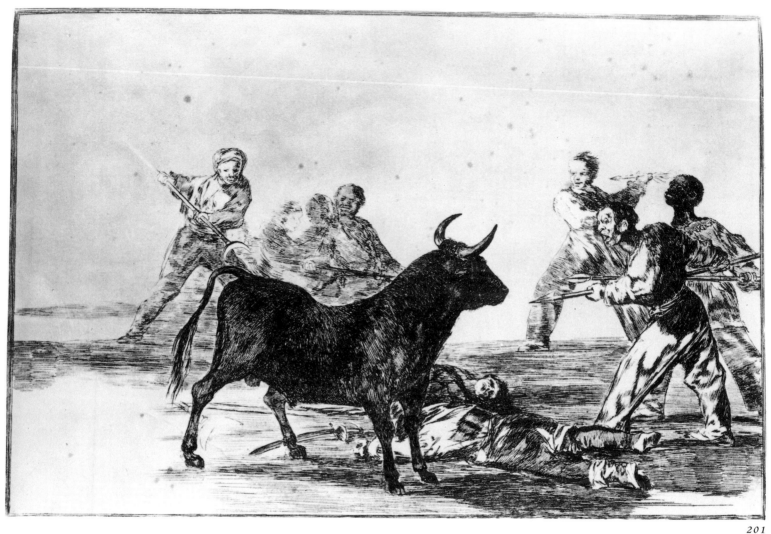

201

The bull-fight

is the chief surviving example of ritualized
conflict between men and animals. It has its
ceremonies, its rules, its symbolism. For some
it is an amusement, for others almost a
religious act. Goya's etchings in the
Tauromaquia and Picasso's bull-fight drawings
are ambivalent in the same way. It is tempting
to read them as commentaries on human
nature, but they defy easy analysis. On the
surface they are straightforward records of
stages in the history of bull-fighting. Above
(*201*): *The rabble hamstring the bull with lances,
sickles, bandarillas and other weapons.* The bull

has already killed two men; its assailants are
brutal and ugly. Right (*202*): *The celebrated
picador, Fernando del Toro, inciting the bull with
his pique.* The men in these etchings are
frequently inhuman and cruel, the bull
always noble. Yet Goya is not condemning
the bull-fight. It had too strong a hold on
his imagination, and was too powerful a
symbol, in Francis Klingender's words, 'of the
fierce contradictions that tormented the
Spanish people'. The drawing lower right
(*203*) is one of an extensive series of bull-
fight pictures made by Picasso in 1959.

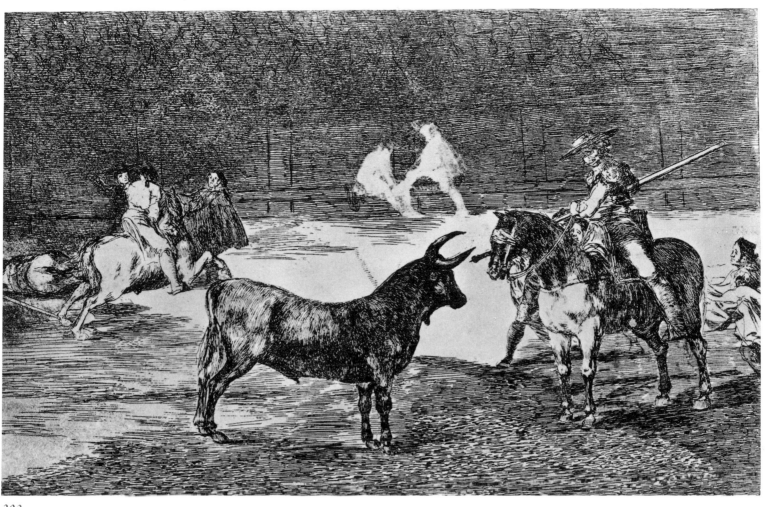

202

3.4.59.

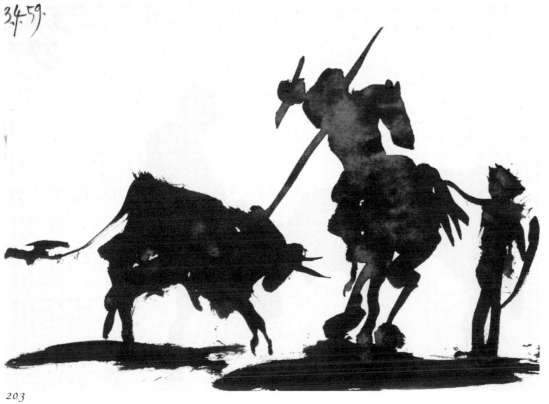

203

204

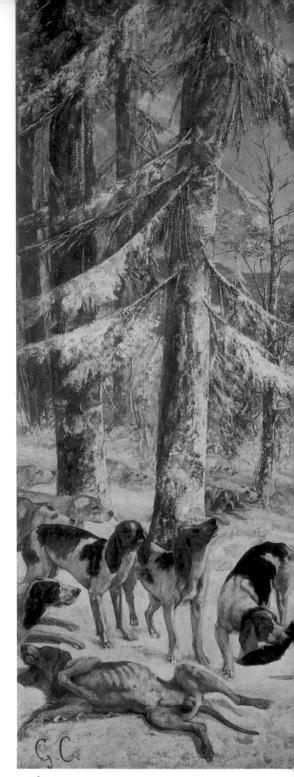

206

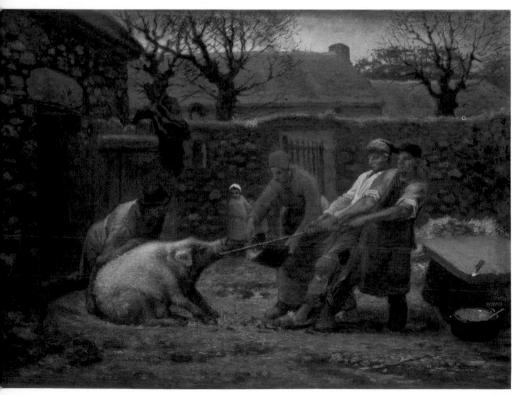

205

222 *Animals Destroyed*

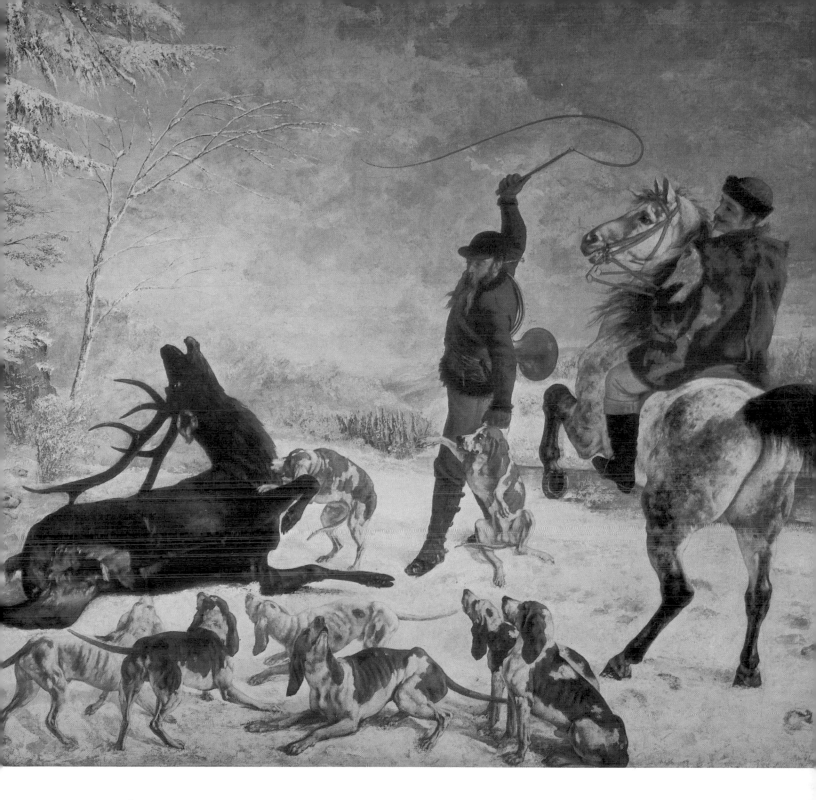

Death as an event to be accepted naturally, without fear or (its corollary) sadistic pleasure, is something which perhaps only those close to the soil can understand. Killing for food is part of such an existence, whether by the North American Indian (left, *204*, the *Buffalo Hunt* by George Catlin), or the French peasant. Millet's *Death of a Pig* (*205*) neither condemns the peasants nor sentimentalizes the pig. Courbet's *Hallali du Cerf* (above, *206*) is actually a celebration of death. Courbet's hearty appetite for every aspect of life makes him admire the stag but at the same time partake of the huntsman's victory. The *hallali* is the hunting cry or blast on the horn announcing the imminent kill.

Life. Millet's *Birth of a Calf* forms a companion picture to the *Death of a Pig*. As that looks at death dispassionately, this looks at birth. The mother cow follows, licking the baby, as in the Egyptian relief on p. 166. But Millet knew, as we perhaps choose to forget, that the calf too is probably destined for the slaughter. The reverend attitude of the bearers and the similarity of their pose to traditional processional bearers in religious paintings caused some critics to see symbolism here. Did it not allude to another nativity and another innocent victim? Van Gogh said it

was 'so powerful as to make me tremble', and it is true that Millet was accustomed to endowing ordinary scenes with religious overtones, on the theory that one should paint the doctrine of Christ, not His image. But in this case he denied any such intention. 'The expression of two men carrying something on a litter depends upon the weight which hangs from their arms. So, if the weight were the same, whether they had the Ark of the Covenant or a calf, a lump of gold or a stone, the same expression would be the result.' (*207*)

Sources of Illustrations

Measurements are given first in centimetres, then inches. Photographs have been supplied by the owners of the works unless otherwise stated.

Illustrations in the Text

Sacred and Symbolic Animals

Roman, 1st half of 3rd cent.
Mosaic pavement, 614 × 555
($241\frac{3}{4}$ × $218\frac{1}{2}$)
Museo Nazionale Archeologico, Palermo
Photo Leonard von Matt

6 PISANELLO (*c.* 1380/90–*c.* 1450)
St Eustace, *c.* 1440
Tempera on panel, 65 × 53 ($25\frac{5}{8}$ × $20\frac{7}{8}$)
National Gallery, London
Photo John Webb

7 LUCAS CRANACH THE ELDER (1472–1553)
Adam and Eve, 1526
Oil on panel, 117.1 × 80.5 ($46\frac{1}{8}$ × $31\frac{3}{4}$)
Courtauld Institute Galleries, London

8 Horses
Upper Palaeolithic cave painting,
c. 20,000 BC
Lascaux, Dordogne
Photo Jean Vertut

9 Two bison
Upper Palaeolithic cave painting,
c. 20,000 BC
Lascaux, Dordogne
Photo Archives Photographiques

10 Horus as a Falcon
Egyptian, 26th Dynasty, 672–525 BC
Granite, h. *c.* 305 (*c.* 120)
Courtyard of temple, Edfu
Photo Ronald Sheridan

11 Sarcophagus for an Ibis
Egyptian, Ptolemaic period, 332–330 BC
Silver and gilt wood, h. 38.4 × w.
19.4 × l. 58.7 (h. $15\frac{1}{8}$ × w. $7\frac{5}{8}$ × l. $23\frac{1}{8}$)
Brooklyn Museum, Charles Edwin
Wilbour Fund

12 Horus making a libation
Egyptian, 19th Dynasty, 1587–1375 BC
Bronze, h. 94 (37)
Louvre, Paris
Photo Giraudon

13 Toth, 'King Narmer's Ape'
Egyptian, *c.* 3000 BC
Alabaster, h. 53 ($20\frac{1}{2}$)
Staatliche Museen, Berlin (East)

14 The goddess Hathor and the Pharaoh
Psammetichus I

Egyptian, late 26th Dynasty, 572–525 BC
Dark grey greywacke, h. of cow to
horns, 84 (33), l. of base, 104 (41)
Cairo Museum
Photo Roger Wood

15 Good Shepherd
Early Christian, 5th cent.
Lunette mosaic above the entrance,
Mausoleum of Galla Placidia, Ravenna
Photo Scala

16 Lamb and Angels
Byzantine, *c.* 532–47
Vault mosaic in the choir, San Vitale,
Ravenna
Photo Scala

17 King and winged bull
Achaemenid, 590–330 BC
Cylinder seal impression
British Museum, London
Photo Werner Forman

18 Bull
Minoan, 1600 BC
Bronze, h. 11.4 ($4\frac{1}{2}$)
British Museum, London, ex Spencer-
Churchill collection

19 Vaphio cup
Minoan, *c.* 1500 BC
Gold, diam. 10.8 (diam. $4\frac{1}{4}$)
National Museum, Athens
Photo Josephine Powell

20 Mithras
Roman, 2nd cent. AD
Marble, 91 × 81 (35.8 × 31.9)
Museo Capitolino, Rome
Photo Antonello Perissinotto

21 Europa and the Bull
Greek, *c.* 490 BC
Red-figure bell krater by the Berlin
Painter, h. 28 (11), diam. 28.5 ($11\frac{1}{4}$)
Museo Nazionale, Tarquinia
Photo Hirmer

22 Bull from the Ishtar Gate, Babylon
Babylonian, *c.* 580 BC
Colour-glazed brick relief, h. *c.* 100 ($39\frac{3}{8}$)
Vorderasiatisches Museum, Staatliche
Museen, Berlin (East)

23 GIOVANNI PISANO (*c.* 1245/50–after 1314)
Lioness and cubs, 1297–1301
Detail from marble pulpit of Sant'Andrea, Pistoia
Photo I. Bessi

24 Lion
Egyptian, 27th Dynasty, 360–343 BC
Granite, l. 185 ($72\frac{7}{8}$)
One of a pair of lions which formerly protected the tomb of Nectanebo II at Serapeum
Museo Egizio, Vatican

25 Lions
Early Christian, 11th cent.
Marble bas-relief on choir screen, Torcello cathedral
Photo Edwin Smith

26 Lion of St Mark from the Echternach Gospels
Painted in Ireland or Northumbria, late 8th cent.
Vellum, 33 × 25.4 (13 × 10)
Bibliothèque Nationale, Paris, Ms. Lat. 9389, f. 75v.

27 Bull of St Luke from the Book of Kells
Painted in Ireland or Northumbria, late 8th or early 9th cent.
Vellum, 33 × 25.4 (13 × 10)
Detail from page showing Four Symbols of Evangelists
The Board of Trinity College, Dublin, Ms. 58 (A.I.6), f. 27v.

28 GIOVANNI PISANO (*c.* 1245/50–after 1314)
Bull of St Luke, 1285–95
Made for Siena Cathedral façade, original in cathedral museum
Photo I. Bessi

29 Lion of St Mark
Umbrian Romanesque, 1150–1200
Detail from Spoleto Cathedral façade
Photo Schroll

30 DONATELLO (*c.* 1386–1466)
Bull of St Luke, 1443–53
Bronze, h. 59 × 59 ($23\frac{1}{4}$ × $23\frac{1}{4}$)
Detail from High Altar, Santo, Padua
Photo Antonello Perissinotto

31 Lion of St Mark, 1490s

Clock tower, Venice
Photo Ronald Sheridan

32 Fabulous beast
French Romanesque, 1st half of 12th cent.
Detail of capital of St Pierre, Chauvigny (Vienne)
Photo Jean Roubier

33 Monsters devouring a deer
Italian Romanesque, 12th cent.
Detail from black marble pulpit of basilica of San Giulio, Isola di San Giulio, Lago d'Orta (Novara)
Photo Schroll

34 Blue boar
Sketch for an inn sign, from an eighteenth-century album by a pupil of Wootton
Private collection
Photo Eileen Tweedy

35 Black bull
Sketch for an inn sign, from an eighteenth-century album by a pupil of Wootton
Private collection
Photo Eileen Tweedy

36 Fighting cock
Sketch for an inn sign, from an eighteenth-century album by a pupil of Wootton
Private collection
Photo Eileen Tweedy

37 White Hart, badge of Richard II
French or English, *c.* 1395
Wood, 46 × 29 (18 × $11\frac{1}{2}$)
One of the back panels of the 'Wilton Diptych'
National Gallery, London

38 Dog from a bestiary
English, 12th cent.
Cambridge University Library, Ms. Ii. 4. 26, f. 20a

39 Whale from a bestiary
English, late 12th cent.
Bodleian Library, Oxford, Ms. Ashmole 1511, f. 86v.

40 Eagle from a bestiary
English, 12th cent.
Cambridge University Library,
Ms. Ii. 4. 26, f. 31a

41 Eagle and snake
Spanish, 11th cent.
Parchment.
Beatus's *Commentary of the Apocalypse*,
Bibliothèque Nationale, Paris,
Ms. Lat. 8878, f. 13

42 JAN ASSELIJN (1610–52)
Enraged Swan, mid-17th cent.
Canvas, 144 × 171 (56¾ × 67⅞)
Rijksmuseum, Amsterdam

43 FRANCIS BARLOW (*c.* 1626–1702)
Aesop surrounded by the Animals
Engraved frontispiece to Barlow's
Aesop's Fables with his life, 1665

44 FRANCIS BARLOW (*c.* 1626–1702)
Lion
Engraving from Barlow's *Aesop's
Fables with his life,* 1665

45 FRANCIS BARLOW (*c.* 1626–1702)
Porcupine and adders
Engraving from Barlow's *Aesop's
Fables with his life,* 1665

46 EDWIN LANDSEER (1802–73)
Monarch of the Glen, 1851
Canvas, 163.8 × 168.9 (64½ × 66½)
Messrs. John Dewar and Sons Ltd.
Photo courtesy John Dewar and Sons Ltd.

47 WILLIAM HOLMAN HUNT (1827–1919)
Scapegoat, 1854
Canvas, 85.7 × 138.5 (33¾ × 54½)
The Trustees of The Lady Lever Art
Gallery, Port Sunlight

Animals Observed

48 Sick greyhound, *c.* 200 BC
Marble, from Gabii
Louvre, Paris
Photo Giraudon

49 MATTHEW PARIS (d. 1259)
Elephant, 1st half of 13th cent.
Pen and watercolour on vellum

From Paris' *Lives of the Abbots of
St Albans,* British Library, London,
Ms. Cotton Nero D I, f. 169v.
Photo Courtauld Institute of Art, London

50 Birds from a medieval sketchbook
English, *c.* 1400
Colour wash on parchment, 24.9 × 19.8
(9⅞ × 7⅞)
Pepys Library, Ms. P.L. 1916
By permission of the Master and
Fellows, Magdalene College, Cambridge
Photo Edward Leigh

51 Mallard duck: detail from the Sherborne
Missal
English, 1396–1407
The Trustees of the Ninth Duke of
Northumberland, deceased

52 Chaffinch: detail from the Sherborne
Missal
English, 1396–1407
The Trustees of the Ninth Duke of
Northumberland, deceased

53 Black-winged kite, goldfinch, green
parrot from the Bergamo sketchbook
North Italian, *c.* 1400
Parchment, approx. 26 × 17 (10 × 7)
Biblioteca Civica, Bergamo, Codex Δ
VII, 14, f. 13v.
Photo Courtauld Institute of Art, London

54 Circle of PISANELLO, *c.* 1400–50
Eagle
Pen and watercolour, on white paper,
13.7 × 23.3 (5⅜ × 9⅛)
Vallardi Codex, Louvre, Paris
Photo Giraudon

55 Circle of PISANELLO, *c.* 1400–50
Stork
Pen and watercolour on parchment,
18.3 × 27 (7 × 10⅝) (whole page)
Detail from Vallardi Codex, Louvre,
Paris
Photo Giraudon

56 Circle of PISANELLO, *c.* 1400–50
Two hoopoes
Pen and watercolour over chalk on white
paper, 16.2 × 21.7 (6⅜ × 8½)
Vallardi Codex, Louvre, Paris
Photo Giraudon

57 JOHN JAMES AUDUBON (1785–1851)
Chuck Will's Widow, 1822
Watercolour for lithograph;
pl. 52, *Birds of America*, 1838
Courtesy of The New York Historical
Society, New York City

58 PAOLO UCCELLO (*c.* 1397–1475)
Rout of San Romano, 1450s
Wood, 183 × 319.5 (72 × 125¾)
National Gallery, London
Photo Godfrey New

59 Attributed to a pupil of GIOVANNINO
DE' GRASSI (d. 1398)
Stag, profile and head averted
Pen and watercolour on parchment,
26 × 17.3 (10¼ × 6⅞)
Bergamo sketchbook, Codex Δ VII,
14, f. 1v.
Biblioteca Civica, Bergamo
Photo Courtauld Institute of Art, London

60 Circle of PISANELLO, *c.* 1400–50
Bull
Metalpoint on white prepared parchment,
17 × 31.1 (6⅝ × 12½)
Vallardi Codex, Louvre, Paris
Photo Giraudon

61 Attributed to GIOVANNINO DE' GRASSI
(d. 1398)
Mouse, *c.* 1400
Watercolour on parchment, approx.
26 × 17.3 (10¼ × 6¾)
Bergamo sketchbook, Codex Δ VII, 14,
f. 9v.
Biblioteca Civica, Bergamo
Photo Courtauld Institute of Art, London

62 PISANELLO (*c.* 1395–*c.* 1455)
Horse with slit nostrils, front and back
views
Pen, traces of black chalk on white paper,
20 × 16.5 (4⅛ × 6½)
Louvre, Paris
Photo Bulloz

63 ALBRECHT DÜRER (1471–1528)
Lion, 1494
Gouache heightened with gold,
12.6 × 17.2 (5 × 6¾)
Kunsthalle, Hamburg

64 ALBRECHT DÜRER (1471–1528)

Ostrich, *c.* 1508
Pen and watercolour, 28 × 19.6 (11 × 7¾)
Kupferstichkabinett, Staatliche Museen
Preussische Kulturbesitz, Berlin (West)
Photo Jörg P. Anders

65 ALBRECHT DÜRER (1471–1528)
Hare, 1502
Watercolour and gouache, 25.1 × 22.6
(10 × 9)
Albertina, Vienna

66 ALBRECHT DÜRER (1471–1528)
Walrus, 1521
Pen and watercolour, 20.6 × 31.5
(8 × 12⅜)
British Museum, London

67 ALBRECHT DÜRER (1471–1528)
Crab, *c.* 1495
Watercolour and gouache, 26.3 × 35.5
(10⅜ × 14)
Private collection

68 ALBRECHT DÜRER (1471–1528)
Indian Rhinoceros, 1515
Pen and ink, 27.4 × 42 (10⅞ × 16½)
British Museum, London

69 GEORGE STUBBS (1724–1806)
Indian Rhinoceros
Canvas, 69 × 93 (27½ × 36½)
By kind permission of the President and
Council of the Royal College of
Surgeons of England

70 FRANCESCO DA PONTE called BASSANO
(1549–92)
Departure of Abraham for the Promised
Land
Canvas, 82 × 113 (32¼ × 44½)
Kunsthistorisches Museum, Vienna

71 JACOPO BASSANO (*c.* 1510–93) and
FRANCESCO BASSANO (1549–92)
The Earthly Paradise: detail
Canvas, 75 × 107 (29½ × 42⅛)
Doria-Pamphily Gallery, Rome
Photo Scala

72 LEONARDO (1452–1519)
Studies of cats and of a dragon, probably
after 1513
Pen and ink and some wash over black
chalk, 27 × 21 (10⅝ × 8¼)

Royal Library, Windsor, no. 12363
Reproduced by gracious permission of
Her Majesty Queen Elizabeth II

73 ALBRECHT DÜRER (1471–1528)
Greyhound, c. 1500
Brush and black ink, 14.5 × 19.6 ($5\frac{3}{4}$ × $7\frac{3}{4}$)
Royal Library, Windsor, no. 12177
Reproduced by gracious permission of
Her Majesty Queen Elizabeth II

74 AUGUSTUS JOHN (1878–1961)
Whippet
Pencil on paper, 35.5 × 28.9 (14 × $11\frac{3}{8}$)
Cooper Art Gallery, Barnsley
Photo Eddie Jones

75 ADRIAEN VAN DER VELDE (1636–72)
Goat and Kid
Canvas, 42.5 × 50.5 ($16\frac{3}{4}$ × $19\frac{7}{8}$)
National Gallery, London
Photo John Webb

76 AELBERT CUYP (1620–91)
A distant view of Dordrecht: detail
Canvas, 157.4 × 197 (62 × $77\frac{1}{2}$)
National Gallery, London
Photo John Webb

77 PAULUS POTTER (1625–54)
Young Bull: detail, 1647
Canvas, 235.5 × 339 ($92\frac{3}{4}$ × $133\frac{1}{2}$)
Mauritshuis, The Hague

78 REMBRANDT VAN RIJN (1606–69)
Elephant, c. 1637
Black chalk, 17.8 × 25.6 (7 × 10)
British Museum, London

79 REMBRANDT VAN RIJN (1606–69)
Lion, lying down, facing left, 1650–52
Pen and brush and brown ink, with wash,
heightened with white on brownish
paper, 14 × 20.3 ($5\frac{1}{2}$ × 8)
Boymans-van Beuningen Museum,
Rotterdam

80 REMBRANDT VAN RIJN (1606–69)
Hog, 1643
Etching, 1st state, 14.3 × 15.4 ($5\frac{5}{8}$ × 6)
British Museum, London

81 EDVARD MUNCH (1863–1944)
Tiger, 1909
Lithograph, 35 × 25.5 ($13\frac{3}{4}$ × 10)
Munch Museet, Oslo

82 EDVARD MUNCH (1863–1944)
Mandrill, c. 1909
Lithograph, 260 × 147 ($102\frac{3}{8}$ × $57\frac{7}{8}$)
Munch Museet, Oslo

83 EDWIN LANDSEER (1802–73)
Studies of a Young Hippopotamus, 1850
Pen and brown wash, 16.5 × 21.9
($6\frac{1}{2}$ × $8\frac{5}{8}$)
Royal Library, Windsor, no. 14061
Reproduced by gracious permission of
Her Majesty Queen Elizabeth II

84 GEORGE STUBBS (1724–1806)
Hambletonian, Rubbing Down,
exhibited at RA, 1800
Oil on canvas, 209.5 × 397 ($82\frac{1}{2}$ × $144\frac{1}{2}$)
National Trust (from the estate of the
Dowager Marchioness of Londonderry)

85 RINALDO MANTOVANO (and BENEDETTO
PAGNI DE PESCIA) after GIULIO ROMANO
(according to Vasari)
Horse, 1527–29
Fresco, Sala dei Cavalli, Palazzo del Tè,
Mantua
Photo Alinari

86 GEORGE STUBBS (1724–1806)
Mambrino, 1779
Oil on panel, 63.5 × 76.2 (25 × 30)
Trustees of the Grosvenor Estate

87 THÉODORE GÉRICAULT (1791–1824)
Grey Horse: At the Blacksmith, c. 1820
Pencil, grey and brown washes on paper,
16.5 × 24.9 ($6\frac{1}{2}$ × $9\frac{1}{8}$)
Courtesy Museum of Fine Arts, Boston,
Mary L. Smith Fund

88 GEORGE STUBBS (1724–1806)
Green Monkey, 1798
Canvas, 69.8 × 55.8 ($27\frac{1}{2}$ × 22)
Walker Art Gallery, Liverpool

89 ROSA BONHEUR (1822–99)
Brizo, a shepherd's dog, 1864
Canvas, 46 × 38 ($18\frac{1}{4}$ × 15)
Reproduced by permission of the
Trustees of the Wallace Collection,
London

90 OSKAR KOKOSCHKA (b. 1886)
Mandrill, 1926
Canvas, 127 × 102 (50 × 40)

Boymans-van Beuningen Museum,
Rotterdam

The Beauty and Energy of Animals

91 Head of a Horse
Egyptian, 18th Dynasty, *c.* 1350 BC
Limestone, l. 11.7 (4$\frac{3}{8}$)
Aegyptisches Museum, Berlin (West)
Photo Bildarchiv Preussischer Kulturbesitz

92 THÉODORE GÉRICAULT (1791–1824)
Charging Chasseur, 1812
Oil sketch, 43.2 × 35.6 (17 × 14)
Musée des Beaux Arts, Rouen
Photo Giraudon

93 Assurbanipal leading horses: detail from
the Great Lion Hunt
Assyrian, 7th cent. BC
Limestone relief from the North Palace of
King Assurbanipal, Kuyunjik (Nineveh)
British Museum, London
Photo Ronald Sheridan

94 Horseman: detail from the Great Lion
Hunt
Assyrian, 7th cent. BC
Limestone relief from the North Palace of
King Assurbanipal, Kuyunjik (Nineveh)
British Museum, London
Photo Ronald Sheridan

95 Horse
Greek, 1st half of 5th cent. BC
Marble, h. 113 (44$\frac{1}{2}$)
Acropolis Museum, Athens
Photo Hirmer

96 Horseman preparing for Panathenaic
procession
Greek, *c.* 440 BC
Pentelic marble, h. 107 (42)
From the west frieze of the Parthenon,
Athens
British Museum, London
Photo Hirmer

97 Quadriga
Greek, *c.* 525 BC
Parian marble, h. *c.* 63 (25)
From the south frieze of the Siphnian
Treasury, Delphi

Delphi Museum
Photo Hirmer

98 Hind
Roman, 1st half of 1st cent.
Bronze, h. 95 (37$\frac{1}{2}$)
Fountain ornament from Herculaneum
Museo Nazionale, Naples
Photo Scala

99 Horses
5th cent. Greek, or Roman, 1st cent. BC
Bronze, h. *c.* 198 (*c.* 78)
St Mark's, Venice
Photo Park and Roche Establishment

100 Crab and sea monster
Greek tetradrachm, 413–406 BC
Silver
From Greek Sicilian colony of
Agrigentum
Photo Leonard von Matt

101 Horse
Greek coin, 5th cent. BC
Silver
From Syracuse
Photo Hirmer

102 Bull and fish
Greek coin, 1st half of 4th cent. BC
Silver
From South Italian Greek colony of
Thurium
Photo Leonard von Matt

103 Four-horsed chariot (*quadriga*) with
winged Victory
Greek decadrachm, 425–406 BC
Silver
Syracuse type
Photo Hirmer

104 Unicorn at the Fountain (Hunt of the
Unicorn series)
French or Flemish, late 15th cent.
Tapestry, wool and silk, 368.3 × 378.5
(145 × 149)
From the Château of Verteuil
Metropolitan Museum of Art, The
Cloisters Collection, Gift of John D.
Rockefeller Jr. 1937

105 Sight (Lady and the Unicorn series)
French, late 15th cent.

Tapestry, wool and silk,
309.9 × 330.2 (122 × 130)
Cluny Museum, Paris
Photo Lauros–Giraudon

106 Touch (Lady and the Unicorn series)
French, late 15th cent.
Tapestry, wool and silk, 375 × 358
(147$\frac{5}{8}$ × 141)
Cluny Museum, Paris
Photo Lauros–Giraudon

107 Hearing (Lady and the Unicorn series)
French, late 15th cent.
Tapestry, wool and silk, 370 × 290
(146 × 114)
Cluny Museum, Paris
Photo Ronald Sheridan

108 DOMENICHINO (1581–1641) after a cartoon
by ANNIBALE CARRACCI
Virgin embracing a unicorn, early 17th
cent.
Fresco, Palazzo Farnese, Rome
Photo Guidotti–Grimoldi

109 Unicorn in captivity (Hunt of Unicorn
series)
French or Flemish, late 15th cent.
Tapestry, wool and silk, 368.3 × 251.5
(145 × 99)
From the Château of Verteuil
Metropolitan Museum of Art, The
Cloisters Collection, Gift of John D.
Rockefeller Jr., 1937

110 LEONARDO (1452–1519)
A rider on a rearing horse, c. 1490
Silverpoint, reinforced with pen and
ink, on pinkish prepared surface,
14.1 × 11.9 (5$\frac{1}{2}$ × 4$\frac{3}{8}$)
Private collection
Photo Courtauld Institute of Art, London

111 LEONARDO (1452–1519)
A horseman trampling on a fallen foe,
c. 1485
Silverpoint on blue prepared surface,
14.8 × 18.5 (5$\frac{7}{8}$ × 7$\frac{1}{4}$)
Royal Library, Windsor, no. 12358
Reproduced by gracious permission of
Her Majesty Queen Elizabeth II

112 LEONARDO (1452–1519)
A horse in profile to the right and its
forelegs, c. 1491

Silverpoint on blue prepared surface,
21.4 × 16 (8$\frac{1}{2}$ × 6$\frac{3}{8}$)
Royal Library, Windsor, no. 12321
Reproduced by gracious permission of
Her Majesty Queen Elizabeth II

113 PETER PAUL RUBENS (1577–1640)
Copy after Leonardo's Battle of Anghiari,
1600–08
Black chalk, pen and ink, heightened
with grey and white, 45.2 × 63.7
(17$\frac{7}{8}$ × 25)
Louvre, Paris
Photo Giraudon

114 LEONARDO (1452–1519)
Studies for the Battle of Anghiari,
c. 1503–04
Studies of horses' heads and of a rearing
horse
Pen and ink, 19.6 × 30.8 (7$\frac{3}{4}$ × 12$\frac{1}{8}$)
Windsor, Royal Library, no. 12326
Reproduced by gracious permission of
Her Majesty Queen Elizabeth II

115 PETER PAUL RUBENS (1577–1640)
Lion Hunt, 1617–18
Canvas, 249 × 375.5 (98 × 147$\frac{7}{8}$)
Alte Pinakothek, Munich

116 GEORGE STUBBS (1724–1806)
Whistlejacket, 1761–62
Canvas, 325.1 × 259.1 (128 × 102)
The Greater London Council as Trustees
of the Iveagh Bequest, Kenwood

117 GEORGE STUBBS (1724–1806)
Mares and Foals in Landscape: detail
Oil, 101.6 × 162 (40 × 63$\frac{3}{4}$)
Tate Gallery, London

118 ANTOINE-LOUIS BARYE (1795–1875)
Tiger searching for prey
Watercolour, 24.1 × 32.7 (9$\frac{1}{2}$ × 12$\frac{7}{8}$)
Cabinet des Dessins, Louvre, RF. 4027
Photo Musées Nationaux

119 EUGÈNE DELACROIX (1798–1863)
Head of a cat, 1825
Watercolour, 15.8 × 14.1 (6$\frac{1}{4}$ × 5$\frac{1}{2}$)
Cabinet des Dessins, Louvre, no. 794
Photo Musées Nationaux

120 EUGÈNE DELACROIX (1798–1863)
Young Tiger with its Mother, 1830

Canvas, 130.5 × 195 (51$\frac{3}{8}$ × 76$\frac{3}{4}$)
Louvre, Paris
Photo Musées Nationaux

121 EUGÈNE DELACROIX (1798–1863)
White Horse frightened by a Storm, 1824
Watercolour, 23.6 × 32 (9$\frac{1}{4}$ × 12$\frac{1}{2}$)
Museum of Fine Arts, Budapest

122 EUGÈNE DELACROIX (1798–1863)
Horses fighting in a Stable, 1860
Canvas, 64 × 81 (25$\frac{1}{2}$ × 32)
Louvre, Paris
Photo Archives Photographiques

123 THÉODORE GÉRICAULT (1791–1824)
Race of the Riderless Horses, 1816
Oil sketch, 45.1 × 60 (17$\frac{3}{4}$ × 23$\frac{5}{8}$)
Musée des Beaux Arts, Lille
Photo Giraudon

124 EUGÈNE DELACROIX (1798–1863)
Lion Hunt: fragment, 1855
Canvas, 260 × 359 (102 × 141)
Musée des Beaux Arts, Bordeaux

125 EUGÈNE DELACROIX (1798–1863)
Lion hunt: detail, 1861
Canvas, 73.6 × 98 (29 × 38$\frac{1}{2}$)
Art Institute of Chicago, Potter Palmer
Collection

126 ROSA BONHEUR (1822–99)
Horse Fair, 1853–55
Canvas, 244.5 × 506·7 (94$\frac{1}{4}$ × 199$\frac{1}{2}$)
Metropolitan Museum of Art, Gift of
Cornelius Vanderbilt, 1887

127 EDGAR DEGAS (1834–1917)
False Start, *c.* 1870
Oil on canvas, 32.1 × 40.1 (12$\frac{5}{8}$ × 15$\frac{3}{4}$)
John Hay Whitney collection, New York

Animals Beloved

128 PAOLO VERONESE (1528–88)
Supper at Emmaus: detail, 1570–75
Canvas, 290 × 448 (114$\frac{1}{8}$ × 176$\frac{3}{8}$)
Louvre, Paris
Photo Giraudon

129 HENRY MOORE (b. 1898)
Page from Sheep Sketchbook, 1972
Black ballpoint pen, 21 × 25 (8$\frac{1}{4}$ × 9$\frac{7}{8}$)
Collection the Artist

130 Return of the herd
Egyptian, *c.* 2300 BC
Limestone relief with traces of painting
Tomb of Ti, Sakkara
Photo Roger Wood

131 Calf bearer
Greek, *c.* 570 BC.
Marble, from Mount Hymettus, h. 166
(65$\frac{1}{2}$)
Acropolis Museum, Athens
Photo Hirmer

132 Good Shepherd
Early Christian, late 3rd or early 4th cent.
Marble
Vatican Museums, Rome
Photo Leonard von Matt

133 Hippopotamus
Egyptian, 12th Dynasty, 1991–1786 BC
Faience, 11 × 20 (4$\frac{3}{8}$ × 7$\frac{7}{8}$)
From Tomb of Senbi, Meir
Metropolitan Museum of Art, New
York, Gift of S. Harkness 1917

134 Owl
Greek, 7th cent. BC
Terra-cotta vase, h. 5 (2)
Louvre, Paris
Photo Musées Nationaux

135 Pig
Roman, 1st half of 1st cent.
Bronze
From Herculaneum
Museo Nazionale, Naples
Photo Alinari

136 Cat
Egyptian, 26th Dynasty, *c.* 664–525 BC
Bronze
Louvre, Paris
Photo Giraudon

137 Tomb of William Canynge
English, later half of 15th cent.
Freestone, St Mary Redcliffe, Bristol
Photo H. A. Nieboer

138 Tomb of John Beauchamp and his wife:
detail
English, 1st half of 15th cent.
Stone, Worcester Cathedral
Photo H. A. Nieboer

139 Tomb of Lord Hungerford: detail
English, 2nd half of 15th cent.
Alabaster, Salisbury cathedral
Photo Edwin Smith

140 LIMBOURG BROTHERS
'January' from Très Riches Heures of the
Duke of Berry: detail
French, 1413–16
Vellum, 29 × 21 (11½ × 8¼)
Musée Condé, Chantilly
Photo Giraudon

141 VITTORE CARPACCIO (*c.* 1460/5–1523/6)
Two Courtesans: detail, 1495–1500
Wood, 164 × 94 (64¼ × 37)
Museo Correr, Venice
Photo Scala

142 VITTORE CARPACCIO (*c.* 1460/5–1523/6)
Vision of St Augustine: detail, *c.* 1502
Canvas, 144 × 208 (56¾ × 81⅞)
Scuola di S. Giorgio degli Schiavoni,
Venice
Photo Scala

143 A mon seul désir (Lady and Unicorn
series)
French, late 15th cent.
Tapestry, wool and silk, 380 × 464
(149⅝ × 182⅞)
Cluny Museum, Paris
Photo Ronald Sheridan

144 JAN VAN EYCK (active 1422–d. 1441)
Arnolfini Marriage: detail, 1434
Panel, 81.9 × 59.7 (32¼ × 23½)
National Gallery, London
Photo John Webb

145 PIERO DI COSIMO (1462–1521)
Forest Fire: detail, *c.* 1487–89
Panel, 71 × 203 (28 × 80)
Ashmolean Museum, Oxford

146 SANDRO BOTTICELLI (*c.* 1445–1510)
Minerva and the Centaur, *c.* 1485
Canvas, 207 × 148 (81½ × 58¼)
Uffizi, Florence
Photo Anderson

147 PIERO DI COSIMO (1462–1521)
Death of Procris: detail
Panel, 65 × 183 (25¾ × 72¼)
National Gallery, London

148 PIERO DELLA FRANCESCA (1410/20–92)
Sigismondo Malatesta kneeling before
his patron saint: detail, 1451
Fresco
Tempio Malatestiano, Rimini
Photo Scala

149 ANDREA MANTEGNA (*c.* 1430/1–1506)
Hunting scenes of the Gonzaga family:
detail, *c.* 1474
Fresco
Camera degli Sposi, Palazzo Ducale,
Mantua
Photo Scala

150 PAOLO VERONESE (1528–88)
Feast in the House of Simon the
Pharisee: detail
Canvas, 315 × 451 (124 × 177½)
Regia Pinacoteca, Turin
Photo Anderson

151 PAOLO VERONESE (1528–88)
Madonna of the Cuccina Family: detail,
1578
Canvas, 147 × 416 (57⅞ × 163¾)
Staatliche Kunstsammlungen, Dresden

152 PAOLO VERONESE (1528–88)
Esther before Ahasuerus: detail
Canvas, 114 × 178 (45 × 70)
Uffizi, Florence
Photo Brogi

153 PAOLO VERONESE (1528–88)
Marriage at Cana: detail, 1563
Canvas, 666 × 990 (262¼ × 389¾)
Louvre, Paris
Photo Scala

154 TITIAN (*c.* 1487/90–1576)
Giovanni dell' Acquaviva, *c.* 1552
Canvas, 224 × 152 (88 × 59¾)
Gemäldegalerie, Cassel

155 TITIAN (*c.* 1487/90–1576)
Clarice Strozzi: detail, 1542
Canvas, 115 × 98 (45¼ × 38½)
Gemäldegalerie, Staatliche Museen,
Preussischer Kulturbesitz, Berlin (West)
Photo Jörg P. Anders

156 TITIAN (*c.* 1487/90–1576)
Venus and the Organ Player: detail,
1548–49

Canvas, 115 × 210 (45¼ × 82¾)
Gemäldegalerie, Staatliche Museen,
Preussischer Kulturbesitz, Berlin (West)
Photo Jörg P. Anders

157 DIEGO VELASQUEZ (1599–1660)
Cardinal Infante Don Fernando: detail,
1632–33
Canvas, 191 × 107 (75¼ × 42⅛)
Prado, Madrid
Photo Mas

158 DIEGO VELASQUEZ (1599–1660)
Prince Felipe Prospero: detail, 1659
Canvas, 129 × 99.5 (50¾ × 39⅛)
Kunsthistorisches Museum, Vienna

159 DIEGO VELASQUEZ (1599–1660)
Prince Baltasar Carlos: detail, c. 1635–36
Canvas, 191 × 103 (75¼ × 40½)
Prado, Madrid
Photo Mas

160 DIEGO VELASQUEZ (1599–1660)
Las Meninas: detail, c. 1656
Canvas, 318 × 276 (125¼ × 108⅝)
Prado, Madrid
Photo Mas

161 WILLIAM HOGARTH (1697–1764)
The Painter and his Pug, 1745
Canvas, 90.2 × 69.8 (35½ × 27½)
Tate Gallery, London
Photo John Webb

162 WILLIAM HOGARTH (1697–1764)
Graham children: detail, 1742
Canvas, 162 × 181 (63¾ × 71¼)
Tate Gallery, London
Photo John Webb

163 THOMAS GAINSBOROUGH (1727–1788)
Mrs 'Perdita' Robinson: detail, 1781–82
Canvas, 228.6 × 148 (90 × 58¼)
Reproduced by permission of the
Trustees of the Wallace Collection,
London

164 THOMAS GAINSBOROUGH (1727–1788)
Morning Walk: detail, 1785
Canvas, 236.2 × 177.8 (93 × 70)
National Gallery, London

165 THOMAS GAINSBOROUGH (1727–1788)
Pomeranian Bitch and Puppy, 1777

Canvas, 83.2 × 111.8 (32¾ × 44)
National Gallery, London

166 JOSHUA REYNOLDS (1723–92)
Lady Mary Leslie, 1764
Canvas, 139.7 × 111.7 (55 × 44)
The Greater London Council as Trustees
of the Iveagh Bequest, Kenwood

167 JOSHUA REYNOLDS (1723–92)
Miss Jane Bowles, 1775
Canvas, 92 × 71 (36¼ × 28)
Reproduced by permission of the
Trustees of the Wallace Collection,
London

168 EDWIN LANDSEER (1802–73)
Dignity and Impudence, 1839
Canvas, 89 × 69.2 (35 × 27¼)
Tate Gallery, London

169 EDWIN LANDSEER (1802–73)
Old Shepherd's Chief Mourner, 1837
Panel, 45.7 × 61 (18 × 24)
Victoria and Albert Museum, London

170 THÉODORE GÉRICAULT (1791–1824)
Sketches of a wild striped cat, 1812–15
Pencil on paper, 32 × 40 (12⅝ × 15¾)
Cabinet des Dessins, Louvre, RF 1696
Photo Musées Nationaux

171 THÉOPHILE-ALEXANDRE STEINLEN
(1859–1923)
Cat, 1920
Black chalk, 38 × 51.5 (15 × 20¼)
British Museum, London

172 PIERRE-AUGUSTE RENOIR (1841–1919)
Girl with a cat, 1882
Canvas, 100 × 81 (39⅜ × 32)
Private collection, New York
*Photo Metropolitan Museum of Art,
New York*

Animals Destroyed

173 Wounded Lion: detail from the Great
Lion Hunt
Assyrian, 7th cent. BC
Limestone relief from the North Palace of
King Assurbanipal, Kuyunjik (Nineveh)
British Museum, London
Photo Werner Forman

174 Relief, probably celebrating Hadrian's
decennalia in AD 137
Roman, *c.* 137
Marble, 120 × 167 (47¼ × 65¾)
Uffizi, Florence
Photo Mansell-Alinari

175 Ramasses III hunting wild bulls: detail
Egyptian, 20th Dynasty, 1200–1085 BC
Relief, funerary temple of King
Ramasses III, Medinet Habu
Photo Roger Wood

176 King Seti I and his son, later Ramasses II,
capturing a bull
Egyptian, 19th Dynasty, 1320–1200 BC
Limestone relief
Temple of King Seti I, Abydos
Photo Roger Wood

177 Hippopotamus Hunt
Egyptian, 6th Dynasty, 2350–2190 BC
Limestone relief with traces of painting
Mastaba of Mereruka, Sakkara
Photo Roger Wood

178 Great Lion Hunt: detail
Assyrian, 7th cent. BC
Limestone relief from the North Palace of
King Assurbanipal, Kuyunjik (Nineveh)
British Museum, London
Photo Werner Forman

179 Great Lion Hunt: detail
Assyrian, 7th cent. BC
Limestone relief from the North Palace of
King Assurbanipal, Kuyunjik (Nineveh)
British Museum, London
Photo Werner Forman

180 Lion devouring a deer: detail from the
'Great Hunt' mosaic
Roman, 4th cent.
Imperial Villa, Piazza Armerina, Sicily
Photo Scala

181 Wounded lioness: detail from the
'Great Hunt' mosaic
Roman, 4th cent.
Imperial Villa, Piazza Armerina, Sicily
Photo Scala

182 Three stags driven into a net: detail
from the 'Great Hunt' mosaic
Roman, 4th cent.
Imperial Villa, Piazza Armerina, Sicily
Photo Scala

183 Captured bison dragged by ropes: detail
from the 'Great Hunt' mosaic
Roman, 4th cent.
Imperial Villa, Piazza Armerina, Sicily
Photo Scala

184 GIOVANNI PISANO (*c.* 1245/50–after 1314)
Lion and horse, 1302–10
Detail from marble pulpit, Pisa cathedral
Photo I. Bessi

185 NICOLO PISANO (*c.* 1220/25–*c.* 1284)
Lion and deer, 1260
Detail from pulpit, Pisa baptistry
*Photo Gabinetto Fotografico Nazionale,
Rome*

186 Lion and deer: detail
Roman sarcophagus
Santa Maria dell'Anima, Rome
*Photo German Archaeological Institute,
Rome*

187 LIMBOURG BROTHERS
'December' from Très Riches Heures of
the Duke of Berry
French, 1413–16
Vellum, 29 × 21 (11½ × 8¼)
Musée Condé, Chantilly
Photo Giraudon

188 Death of the Unicorn: detail (Hunt of the
Unicorn series)
French or Flemish, late 15th cent.
Tapestry, wool and silk, 368.3 × 388.6
(145 × 153) (whole tapestry)
From the Château of Verteuil
Metropolitan Museum of Art, The
Cloisters Collection, Gift of John D.
Rockefeller Jr., 1937

189 ALBRECHT DÜRER (1471–1528)
Head of a stag, 1504
Watercolour and gouache on paper,
25.2 × 39.1 (10 × 15⅜)
Bibliothèque Nationale, Paris

190 LUCAS CRANACH THE ELDER (1472–1553)
Staghunt of Frederick the Wise of
Saxony, 1544
Oil on wood, 117 × 177 (46⅛ × 69⅝)
Kunsthistorisches Museum, Vienna

191 PAOLO UCCELLO (1396/7–1475)
Hunt in the Forest, c. 1460–70
Panel, 65 × 165 (25⅝ × 65)
Ashmolean Museum, Oxford

192 JAMES WARD (1769–1859)
Ralph Lambton and his Hounds
Canvas, 137 × 213 (54 × 83⅞)
Duke of Northumberland, Alnwick
Castle
Photo Paul Mellon Centre

193 BEN MARSHALL (1767–1835)
Lord Sondes and his Brothers with their
Hounds in Rockingham Park, 1815
Canvas, 144.8 × 216 (57 × 85)
Commander L. M. M. Saunders Watson,
Rockingham Castle
Photo Jeremy Whitaker

194 GEORGE STUBBS (1724–1806)
Grosvenor Hunt, 1762
Canvas, 150 × 242.5 (60 × 96)
Trustees of the Grosvenor Estate
Photo Sydney W. Newbery

195 GEORGE STUBBS (1724–1806)
Lion devouring a Horse, 1769
Enamel on copper, octagonal, 24.3 × 28.2
(9½ × 11⅛)
Tate Gallery, London

196 EUGÈNE DELACROIX (1798–1863)
Horse attacked by a Tiger, c. 1825
Watercolour, 19 × 27 (7½ × 10½)
Cabinet des Dessins, Louvre, Paris

197 ANTOINE-LOUIS BARYE (1796–1875)
Panther devouring a Gazelle
Watercolour, 23.5 × 29.8 (9¼ × 11¾)
Cabinet des Dessins, Louvre, RF 4204
Photo Musées Nationaux

198 GUSTAVE COURBET (1819–73)
Hind forced down in the Snow, 1856–57
Canvas, 90 × 147 (35¼ × 57⅞)
Private collection
Photo Bulloz

199 JEAN-BAPTISTE OUDRY (1686–1755)
Dead Roe, 1721

Canvas, 196.5 × 261 (77⅜ × 102⅞)
Reproduced by permission of the
Trustees of the Wallace Collection,
London

200 ALEXANDRE-FRANÇOIS DESPORTES
(1661–1743)
Self-portrait as Huntsman, c. 1699
Canvas, 197.2 × 162.9 (77⅝ × 64⅛)
Louvre, Paris
Photo Musées Nationaux

201 FRANCISCO GOYA (1746–1828)
A crowd hamstrings the bull, 1816
Etching and aquatint, 24.5 × 35 (9⅝ × 13¾)
From *La Tauromaquia*, 1815–16

202 FRANCISCO GOYA (1746–1828)
The famous Fernando del Toro
provoking the bull with his pike, 1816
Etching and aquatint, 25 × 35 (9⅞ × 13¾)
From *La Tauromaquia*, 1815–16

203 PABLO PICASSO (1881–1973)
Bullfight, 1959
Wash drawing from sketchbook
Collection the Artist

204 GEORGE CATLIN (1796–1876)
Buffalo Hunt, 1855
Canvas, 47 × 65.5 (18½ × 25¾)
Courtesy of the American Museum of
Natural History, New York

205 JEAN-FRANÇOIS MILLET (1814–75)
Death of a Pig, 1869
Canvas, 73 × 92.7 (28¾ × 36½)
*Photograph courtesy of Wildenstein and
Company*

206 GUSTAVE COURBET (1819–1877)
Hallali du Cerf, 1867
Canvas, 355 × 505 (139 × 198)
Musée de Besançon
Photo Lauros–Giraudon

207 JEAN-FRANÇOIS MILLET (1814–75)
Birth of a Calf, c. 1864
Canvas, 81.6 × 100 (32⅛ × 39⅜)
Courtesy of the Art Institute of Chicago,
Henry Field Memorial Collection

Index of Artists and Works

Index of Animals and Birds

This index has been compiled purely for convenience and makes no claims to scientific respectability.